Nantucket

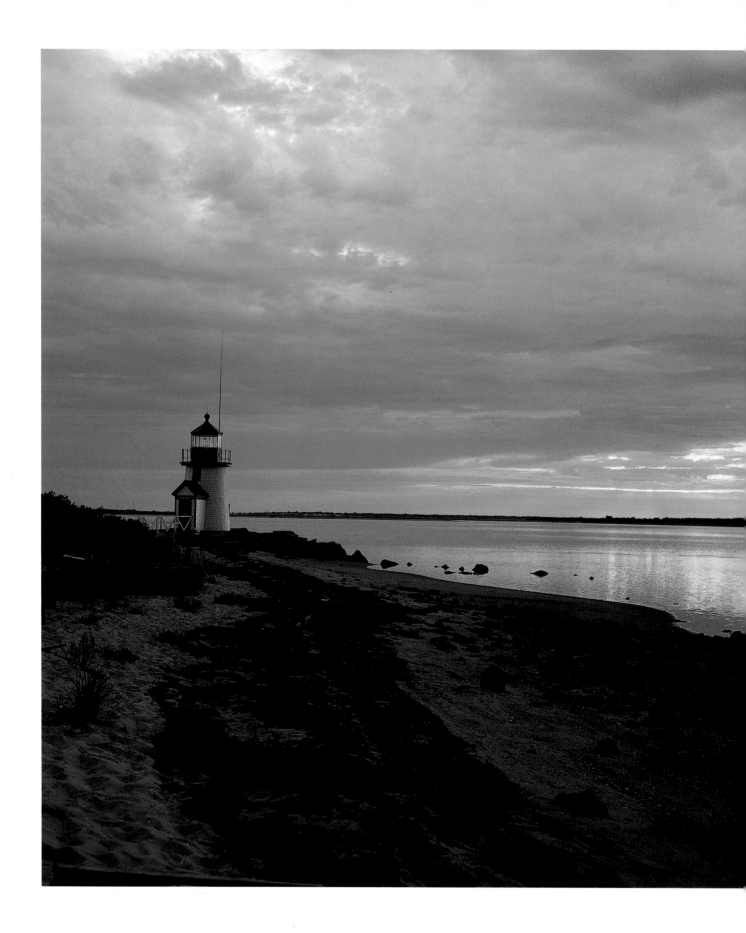

ROBERT GAMBEE

NANTUCKET

W. W. Norton & Company

New York • *London*

*For dear Robert and Claire
and their happy Nantucket future*

Library of Congress Catalogue Card Number: 92-22199

Third Printing

Printed in Hong Kong
by Dai Nippon Printing Company Ltd.

Typography by U.S. Lithograph, New York

Designed by Jackie Schuman

Frontispiece: Rounding Brant Point Lighthouse. This is the site of the second lighthouse built in America (1746) after Boston's Beacon Light. Its familiar occulating red light indicates that it is on the starboard or right side of the channel, proceeding from seaward. A green beacon would have to be located on Coatue. In fact Brant Point's twin at the entrance to Hyannis Harbor does have a green light because it is on the west or port side of the channel.

Introduction

We are pleased to open the door to this photographic portfolio of our beloved Island. Robert Gambee's images reflect a sensitivity that is particularly appreciated by the Nantucket Historical Association and the Nantucket Conservation Foundation.

With their voluntary and unselfish financial contributions, the supporters of our organizations have dramatically advanced the causes of historic preservation and land conservation. They have done so to protect Nantucket's distinctive cultural and natural qualities for the enjoyment and education of current and future generations.

The Nantucket Historical Association was incorporated 100 years ago in 1894 to preserve the valuable knowledge of the Island's history for its citizens, visitors and scholars. The Association administers twenty-two properties, including the Whaling Museum, Peter Foulger and Fair Street Museums, Quaker Meetinghouse, Oldest House, 1800 House, Greater Light, Hadwen House, Macy-Christian House, Thomas Macy House, Old Mill, Museum of Nantucket History, a Research Center and a number of historic sites.

The much younger Nantucket Conservation Foundation, established in 1963, plays an equally important role in protecting Nantucket's open spaces. Presently it owns and manages more than 8,200 acres representing twenty-seven percent of the Island. The Foundation's ongoing mission is to preserve for public benefit Nantucket's unusual character, acquiring and managing for conservation purposes places of natural interest and importance, including moors, grasslands, beaches, dunes, forests, and wetlands.

The unique riches entrusted to our organizations and the Island speak for themselves and are eloquently presented by Mr. Gambee. We invite you to stroll leisurely through these pages, stopping to examine the carefully selected scenes that are so representative of Nantucket's abundance of historic and natural treasures.

James F. Lentowski, *Executive Secretary*
Nantucket Conservation Foundation, Inc.

Maurice E. Gibbs, *Executive Director*
Nantucket Historical Association

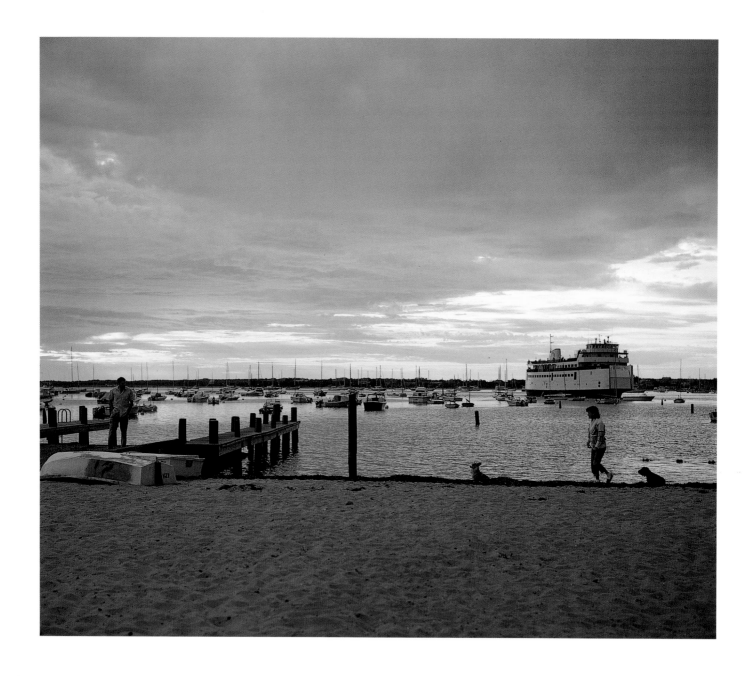

The morning boat. Nantucket has had scheduled steamer service to America since 1818. Presently the island is served by the *Uncatena* (1965, 1973) and the *Eagle* (1987) as well as two Hy-Line vessels, the *Brant Point* (1973) and the *Great Point* (1988).

The first ship built by the Nantucket Steamship Company was the *Telegraph* in 1832. Its hull was fortified to battle the ice, and on occasional winter runs passengers were asked to gather at the stern when the ship ran onto an ice floe. Then they ran to the bow and added their weight to the ship in breaking the ice. Sidewheelers prevailed until the 1920s including the first *Uncatena* built in 1902.

This view is from Children's Beach which has been owned by the town since 1914. It has been a bathing spot since 1869 when Charles Hayden set up his Clean Shore Bathing Rooms, offering direct competition to Eben Allen's Bathing House near Cliffside. When hotels were established along Brant Point, the popularity of Hayden's establishment waned and eventually it closed. But true to their tradition, Nantucketers salvaged the buildings, one of which became part of the new Nantucket Athletic Club (now Yacht Club) and today serves as a summer-employee bunkhouse.

Contents

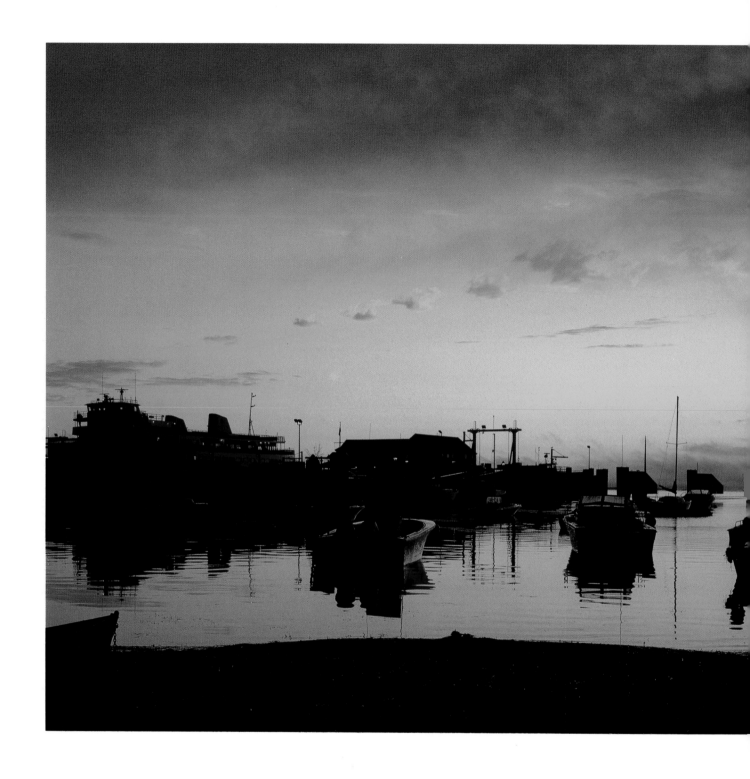

Easy Street Basin. This lovely basin is named after the street that was put through after the railroad that used to take passengers from Steamboat Wharf to points south and east was taken up. The view of the harbor has changed over the years. North Wharf used to extend out and to the left. At low tide the foundation fill is still clearly visible. The tide at this spot varies from that at Great Point by about an hour, rising and falling approximately 12" according to the lunar day of 24 hours 50 minutes. The futuristic Steamship Authority concrete dolphins were completed in 1985.

At the left of the photo, where Catboat Basin used to lie, was the famous Skipper Restaurant. This had its origins in 1921 when a tired schooner, *Allen B. Garvey,* brought her last load to the island and became the Skipper Tea Room. Gladys Wood was one of the enterprising ladies who created a successful waterside

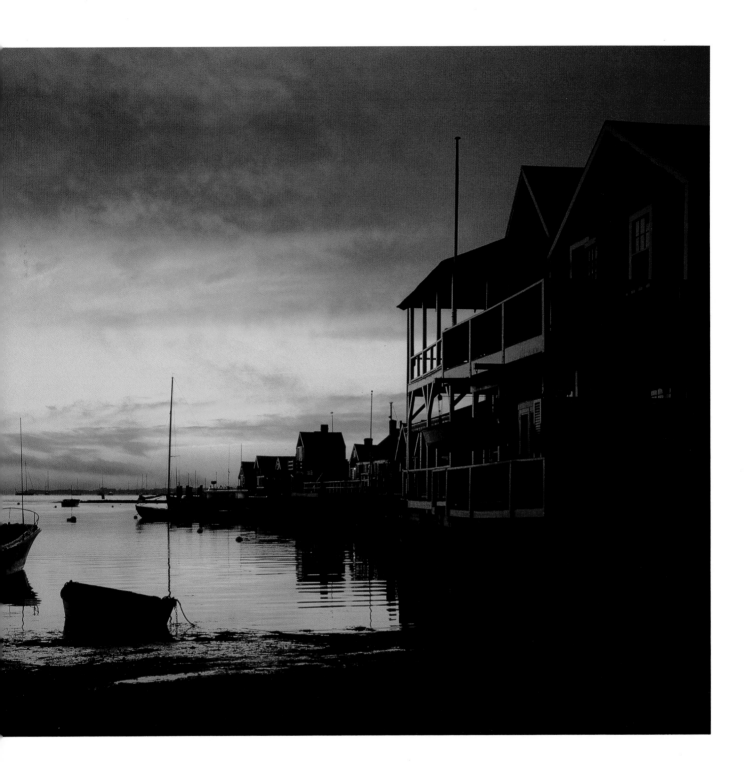

restaurant that prospered for almost 70 years.

This is a gentle spot, a view framed by lofts and boat houses, with dories and sailboats bobbing in the water, the wharves reaching out to embrace the scene with the vast harbor stretching beyond. It is a place to sit and watch the sunlight's changing patterns from dawn until dusk, a place to rest one's back easily against Main Street's bustling activities.

9

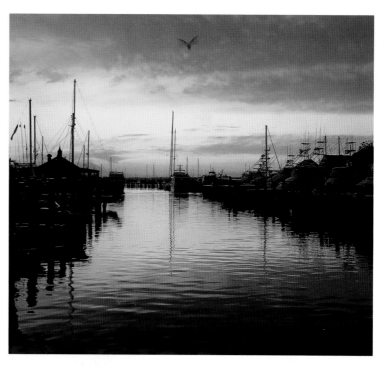

Above: Morning light at the Nantucket Boat Basin. This marina was built between 1967 and 1969 and presently has 243 slips attracting pleasure craft from the entire East Coast.

Left: Sailboats for hire include a Friendship sloop, one of a fleet of gaff-rigged fishing craft with a long bowsprit and lots of sails.

Nantucket, Faraway Island

When my family first came to Nantucket almost sixty years ago, they sought a place to get away to—something just a bit farther away and lesser known. And they were right. When they got home friends asked about their summer on the Cape. They still do. Other friends have always confused Nantucket with the Vineyard.

Nantucket is not the secret it was in the 1920s and 1930s. And yet it still retains its treasured isolation. Being just a little farther away and harder to get to has protected it over the years. While this book seeks to portray Nantucket as it appears today, one can never forget the tremendous history that it enjoys—unique, in many ways, from all other communities in America.

For this was an island that was once, and for almost a hundred years held the honor of being, the greatest whaling center in the world. It was one of the most populous communities in the early days of our country. No other town in America today has as many homes (over eight hundred) built in the period 1740 to 1840, almost all of which are located in their original settings. During a hundred-year span, Orange Street was the home of over 125 whaling captains—a record of any such port in the country. At its peak, there were eighty-eight Nantucket whalers sailing around the world, often on voyages lasting two years or more. Their quest was for whale oil to light the lamps of England and the colonies.

Then came the decline, and rapid it was. It began with the Great Fire in 1846, which eliminated a third of the town and, more important, vast stores of whale oil and related items in the warehouses. The California Gold Rush siphoned off many able-bodied sailors as did the Civil War. When the shifting sands made the harbor entrance unnavigable, things looked bad enough. But the discovery of petroleum and its refinement into kerosene put an end to the need for whale oil—the island's only major economy.

By 1870, hardly thirty years from the peak of prosperity, the town was an empty shell. Houses had no market value, no taxes were collected, and the island was badly in debt. The population was about a third of what it had been before. In retrospect it is fortunate that the decline was so swift and thorough. For the island was unable to experience even a small measure of the industrial revolution and the accompanying Victorian architecture that swept across the mainland.

Nantucket, which is the Indian term for "land far out to sea," has returned again out of the fog and past, waiting for you to discover it.

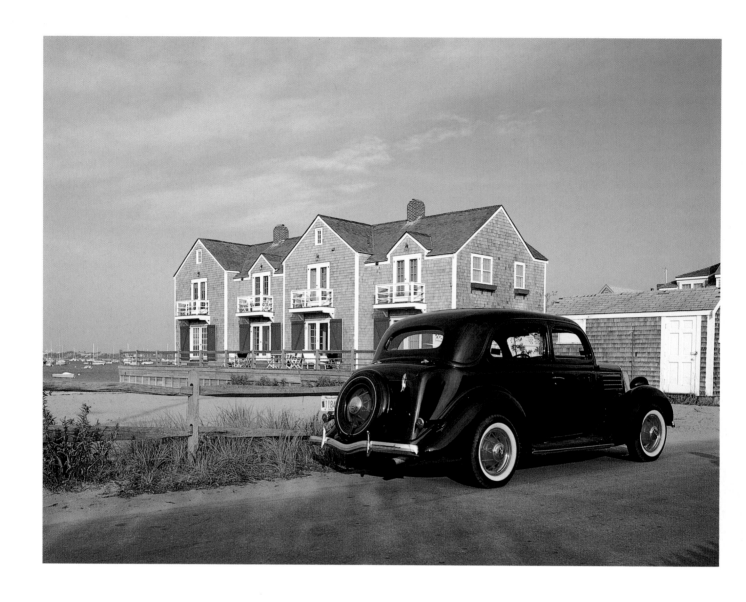

Washington Street. These condominiums next to Francis Street
Beach offer splendid views. They were completed in 1989. The
car is a 1935 Ford, an unusually graceful Tudor model with
double taillights, a luggage trunk and wire wheels. At the begin-
ning of the 1930s many cars still had wooden-spoked wheels (see
page 112) which were replaced by wire wheels. By 1936 Ford
dropped the wire wheels in favor of today's large pressed steel
wheel.

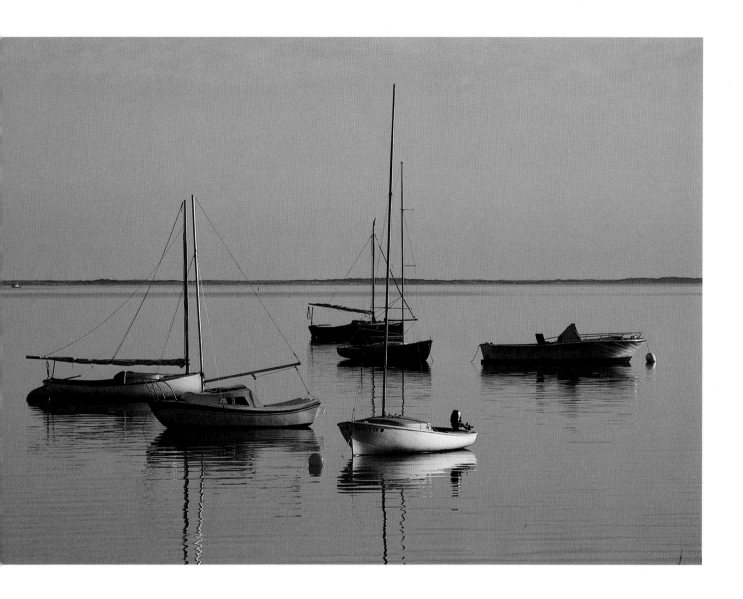

Pleasure craft off Monomoy come in all types. Pictured here are a Marshall cat, a Rhodes 19, an O'Day Sailor and a Mako power boat. Catboats have been popular in Nantucket and Cape Cod waters for over a century. The O'Day Sailors and Rhodes 19s are newcomers, with the latter being one of several classes represented at the Nantucket Yacht Club.

One hundred and fifty years ago the scene from Monomoy was quite different—many sailing and whaling craft filling the panorama plus a new harbor animal: the camel. Because of the sandbar that was building up across the channel leading to the harbor, and the increased size and draw of whaleships venturing on longer voyages each time, a "camel" was invented to transport the ships over to deeper water. The camels were sunk low enough for the vessel to pass over the chains joining them. When the water in the storage tanks was emptied by steam power, the floating system could support 800 tons and draw only seven feet. The term "camel" is believed to derive from the Middle Eastern practice of placing a load too heavy for one camel between two and letting it be supported from the camels' sides. Nantucket camels were last used in 1849.

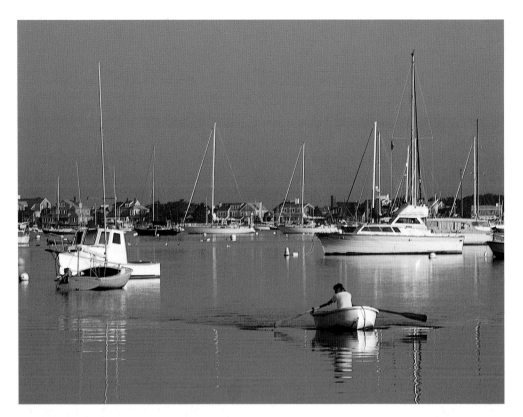

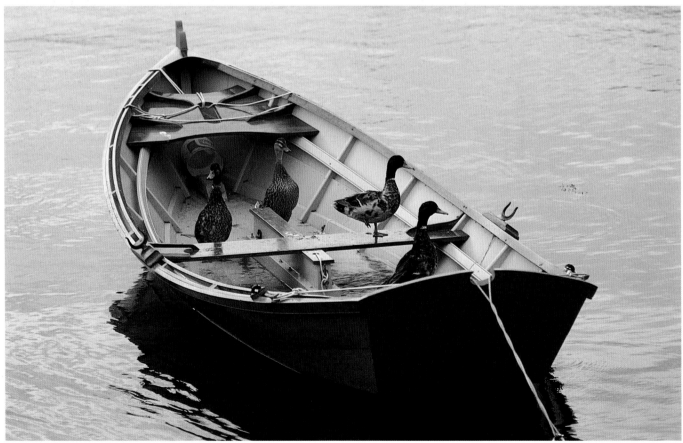

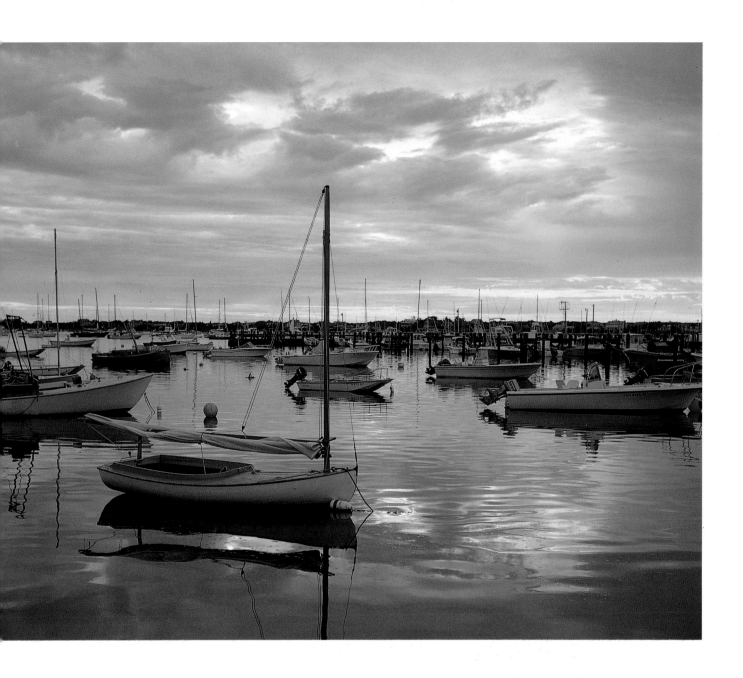

Above: A Nantucket Beetle cat, familiarly known as a Rainbow. These catboats have a centerboard hull, a wide beam and a single, large gaff sail. They are easy for one person to sail and do well in a light wind. Originally they were used for lobstering and hand line fishing. Most of the larger catboats have been built by the Crosby family of Osterville beginning in 1881, one of which was the *Lilian*, a 70-foot passenger boat running from Straight Wharf to Wauwinet. They so populated the harbor that the spot near Steamship Wharf that was indented before it became a parking area was referred to as Catboat Basin. In 1921 sailor/manufacturer John Beetle introduced a small 12-foot catboat with a wide beam that became immensely popular. The Nantucket Yacht Club tried various classes of boats, including a 16-foot catboat, but found them lacking in one aspect or another. But in 1925 it settled on the Beetle cats and, with a wide variety of colored sails, they became known as the Rainbow fleet. They have been Nantucket's favorite ever since, with as many as 80 in the fleet at one time.

Opposite, top: All seems quiet at daybreak but skippers and crew are getting set for the day's journey. These boats are on the town's moorings, indicating a full house at the Boat Basin

Opposite, bottom: Ducks on a dory, waiting for the next free ride. Dories have been especially popular in New England—their high, flared sides and V-shaped transoms enabling them to ride the seas. The word comes from *dori* or dugout in the language of Atlantic coastal natives of Nicaragua and Honduras. And dinghy is a word of Bengali origin—one of the little boats popular along the coasts of India.

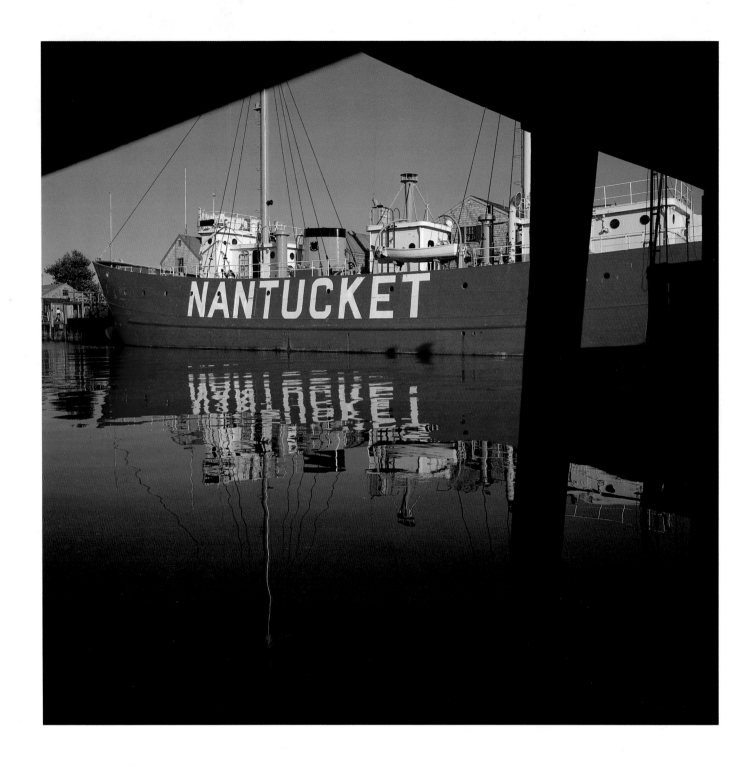

The lightship *Nantucket* is the largest lightship ever built. It was stationed for 40 years at the southern end of the Nantucket Shoals and the eastern approach to the crowded shipping lanes to New York. This ship was built in 1936 to replace one destroyed by the faulty navigation of a British captain on the *Olympic*, the sister ship of the *Titanic*. It is presently in Maine. The first light-ship was a retired Nantucket whaler, painted red with yellow masts and named the *South Shoal*. It was placed in service in 1854 on the Davis Shoal, about 25 miles offshore. The whale lamps in the mastheads were visible for 15 miles on a clear evening. Navigational buoys have taken the place of lightships today, and lightship baskets are now made at home.

The History of Nantucket

Of the many circumstances that shaped Nantucket's history, three principal factors were: 1) whaling, around which the island's entire economy revolved, taking its citizens to all the great seas of the globe and resulting in a prosperity that had few rivals on the mainland; 2) the isolation of the sea; and 3) the Quaker religion. The last provided the simple faith and stability that enabled Nantucketers to survive the whaling difficulties.

The history of Nantucket may be divided into three chapters, each one ending with a major climax: the Revolution, the War of 1812, and the grand finale of the late 1840s. And everything was centered on whaling, which Nantucketers discovered by accident and were forced to pursue because there were no resources on the island. The land was sandy, had no wood to speak of, and was filled with hills, marshes, and swamps. Farming and sheep raising were tried (the sheep population in 1800 was about sixteen thousand) but were not very profitable.

As early as 1730 Nantucket had twenty-five whaleships. By 1840 there were over eighty Nantucket-owned brigs sailing around the world. There were five wharves in the harbor, thirty-six candle factories, rope walks, sail lofts, and shipyards. Almost everyone was connected with whaling—either going to sea directly or helping others to do so and waiting for their return. Because of their devotion to a single industry, these people became the most knowledgeable about whaling in the world. And this helps explain why Nantucket surpassed even the British, their only serious competitors, in this livelihood for many years. The British lacked the determination, energy (at least as far as whaling was concerned), and courage that Nantucket men were forced to assume. Whaling was their only business, whereas the British (and the Dutch) had commercial trade. The courage these people possessed is all but forgotten, most likely because we cannot fully appreciate what they were up against. The basic equation was: a group of sailors plus harpoon plus eighteen-foot whaleboat equals one whale (about a hundred feet or more in length). These animals are literally giants of the sea—among the largest animals in history. Their jaws are large enough and open wide enough to consume an entire whaling party and boat in one piece. And they are not known for their tranquillity— especially when harpooned. The speed with which an angry whale could take the whalers for a "Nantucket sleigh ride" was frightening. Of greater concern was its diving or ramming either the whaleboat or the ship. In short, whaling was a risky and arduous profession.

The First Hundred Years

It is believed that Nantucket was first sighted by Bartholomew Gosnold in 1602, when he was blown off course on his way to Virginia from England. It is fortunate he did not settle here because he might have subsequently chosen to name the island for himself. In 1653 the Earl of Sterling received a grant for the island from King Charles I, and in turn sold it to Thomas Mayhew, a Puritan merchant in Massachusetts.

In 1659 a group of nine men purchased the island from Thomas Mayhew II for thirty pounds and two hats. These non-Puritans sought refuge offshore from the bitter hostility that had arisen in Massachusetts against Baptists and Quakers. Thomas Macy had received a fine for giving shelter to some Quakers during a severe thunderstorm. Further assistance could have resulted in his being hanged. The original group of nine were: Thomas Barnard, Tristram and Peter Coffin, Stephen Greenleaf, Christopher Hussey, Thomas Macy, William Pike, and John and Richard Swain. Before the purchase of the island was completed each member decided to take a partner (known as halfshare men), among whom were Edward and Nathaniel Starbuck. All of them were planters who lived in Salisbury, a community north of Boston. Thomas and Sarah Macy were among the first to arrive in the fall of 1659. They sailed around Cape Cod and first settled in Madaket. By the next year, there were over sixty settlers (including Tristram and Dionis Coffin, whose daughter, Mary Starbuck, was the first white child born on the island and a leader in organizing the regular monthly meetings of Friends). The next year they moved away from Madaket, which means "sandy soil," to more fertile sites between Capaum and Hummock Pond. The community was officially named Sherburne in 1673.

In the early 1700s the typical acre of Nantucket farmland yielded fifty bushels of corn. Fifty years later the yield was half of that due to poor soil conditions and overworked land. Farms on the mainland were yielding eighty to one hundred bushels an acre. Sheep raising was not much better; the animals were small and yielded little wool. Just before the Revolution there were over five thousand people on the island with only enough local produce to support ten percent of them. This forced the islanders to start plowing the sea around them at a much earlier stage than they would have had their land been like Virginia.

One day a whale strayed into the harbor and by the end of the week was captured, although beached whales had been discovered before at Siasconset. In 1672 the islanders thought they should get a professional to teach them about whaling and by 1690 they were off on a remarkable pursuit. In 1712, Chris Hussey came across a school of whales and in 1715 the farmers launched six ships cautiously seeking whales. Gradually they took longer and longer trips and by the turn of the century they were sailing around Cape Horn. The quest was for whale oil—primarily for England which consumed over four thousand tons of oil annually in homes and street lights. London and Birmingham had decided to keep the street lamps burning all night for the safety of their citizens.

In 1745 Nantucket merchants sent a load of whale oil to London and returned with a cargo of hardware, for the first time without going through the expense of a Boston broker. This episode convinced the islanders that they could become a leading whaling port and handle their own trading affairs without the assistance of off-island merchant bankers. Because of the close relationship between Nantucket and England, the former was granted a somewhat favorable status and, among other things, was exempted from the Massachusetts Restraining Bill of 1774 which restricted commerce elsewhere in New England.

In 1773, two Nantucket ships owned by William Rotch, the *Dartmouth* and the *Beaver*, were chartered in London by the East India Company to deliver a cargo of tea to Boston. While the cargo was subsequently dumped overboard on arrival by "Indians," none of the ships was affected. But when the Revolutionary War broke out, Nantucket was not in an enviable position. Because of her dependence on Britain, she could offer neither resistance nor support and, as a result, her vessels were destroyed by both sides, depending on which group had issued a sailing permit. They were at the mercy of both the British Navy and the American privateers and, for a short while, tried to substitute other businesses (including cod fishing and farming).

But the island did not have enough food to feed itself nor enough firewood for fuel. By 1779 two-thirds of the families were out of firewood. When the harbor froze during the cold winter of 1779–1780 people walked to Coatue and Coskata in search of juniper and cedar to burn. All usable timber on the island had been consumed by the end of the war. The hardship of the Revolution marks the end of chapter one of our story.

The Post-War Years

While most of her ships were destroyed in the war, those few that were left and able to sail were the first to fly the flag of the new United States overseas—in England in 1783, in Quebec, and in various Spanish ports.

Gradually, Nantucket men accumulated a great familiarity with the seas. For example, they were the first to have intimate knowledge of the Gulf Stream. When Captain Timothy Folger plotted it in 1786 for Benjamin Franklin (who was postmaster general at the time), the sailing time to England was reduced by about two weeks. The British, considering themselves still the expert mariners, ignored the charts prepared by "those fishermen" and stuck to their traditional and more lengthy routes.

The end of chapter two of our story climaxes with the War of 1812. By this time Nantucket had grown to a population of about seven thousand—including almost four hundred widows and as many fatherless children. Between the British blockade and the seizure of her vessels by both the British and the French Navy (many Nantucket sailors were impressed into French service), life was indeed bleak. Over half the whaling fleet was again destroyed in this war, and the island was thrown into a severe depression which lasted for over three years.

But due to the characteristic faith and endurance of the islanders, by 1822 the island had tripled the size of its fleet and restored the whaling industry to its former level (at the same time the British whaling business was floundering).

The Greatest Whaling Center in the World

Beginning in the 1820s and building up in the two succeeding decades, the Nantucket whaling economy grew rapidly. Herman Melville was struck by the courage and strength of the whalers who set forth alone from their little elbow of sand located away offshore. "And thus have these naked Nantucketers," as he described them in *Moby Dick*, "these sea-hermits, issuing from their anthill in the sea, overrun and conquered the watery world like so many Alexanders; parcelling out among them the Atlantic, Pacific, and Indian Oceans, as the three pirate powers did Poland. Let America add Mexico to Texas, and pile Cuba upon Canada; let the English over-swarm all India, and hang out their blazing banner from the sun; two-thirds of this terraqueous globe are the Nantucketer's. For the sea is his; he owns it, as Emperors own empires; other seamen having but a right of way through it." As early as 1824 men like Captain George Chase were returning home with as much whale oil as England's entire consumption several years before. (Chase's haul was over three thousand barrels of oil after a three-year voyage.) Eight years later (1832) over thirty whaling ships set out to sea in one year alone. By 1843, Nantucket had eighty-eight whalers out sailing around the world. But by this time the voyages were long and hard. The sailors' home was their ship and most of their time was spent in the forecastle, a rather dark and gloomy area below. Food consisted of a mixture of tea, coffee, and molasses, or another dish called "scouse," consisting of hardtack, beans, and meat. Captain Benjamin Worth (*142*) spent forty-one years at sea, making thirty-four voyages in all. He is said to have sailed over a million miles, rounded the Horn sixteen times, brought in over nineteen thousand barrels of oil, and never lost a man. The total amount of time he spent at home in forty-one years was about six years.

George W. Gardner went to sea at the age of thirteen for about the same number of years as Captain Worth. He was a master for half the period. Married at twenty-nine and father of fifteen children, he spent less than five years at home in the aggregate. In 1812, he was taken by the British and lost everything. In 1820, the *Essex* was rammed and sunk by an angry whale, forcing Captain George Pollard (*39*) and a handful of survivors to spend three months in an open lifeboat. This bleak story is thought to have been the basis for *Moby Dick*.

As the photographs in this book demonstrate, whaling for those who were fortunate and determined was rewarding. Joseph Starbuck began building the "Three Bricks" for his sons in 1836 at a cost of more than $40,000—an amount that seemed scandalous at the time (*99–101*). William Hadwen built two Greek Revival houses across the street. He predicted they would make people talk, and he was right. One had an upstairs ballroom with a sprung floor and a domed roof that opened to the stars (*102–103*). Nearby, the William Crosbys gave elabo-

rate dinner parties at their One Pleasant Street home (*150*) where they introduced frozen mousse and other new dishes.

The elaborate houses that Starbuck and Hadwen were building stirred the competitive juices of Jared Coffin. His large, brick-walled estate at the edge of town was no longer suitable (*153*). He decided to build the largest and tallest house on the island in 1845, so large that its immediately succeeding owner decided to turn it into a hotel (*147*).

Lower Main Street, formerly called State Street, was originally paved with cobblestones in 1837, reaching up to Pleasant Street by 1852. Also paved with cobblestones were Broad, India, Centre, Federal, and Orange Streets. In addition, the great elm trees that line the streets were planted by the Coffins about this time.

The good years in chapter three of our story lasted only until the late 1840s. Then began the downfall, starting first with an enormous fire in 1846 which destroyed thirty-six acres of town buildings, homes, shops, and, most important, whale oil and related items stored in downtown warehouses. There was a brief period of rebuilding, but it was like the brilliant color of the maple tree before it drops its leaves and becomes dormant. Whaling became less successful. In 1846 the *Peru* returned with 966 barrels of oil, in 1847 the *Mary* with 862, and in 1848 the *Henry* with only 482—this compared with the *Sarah*'s haul of 3,492 barrels eighteen years earlier. In 1849, most of the better sailors decided prospecting for gold would be more profitable than for whale oil. A few years later, the Civil War siphoned off additional men. Beginning in the 1840s, the strip of sand known as the Nantucket Bar had blocked the harbor entrance to such an extent that whalers had difficulty crossing even with the help of "camels"—specially designed cradles with pontoons that floated the ships high in the water. In 1854, a Waltham group began to produce petroleum oil commercially, the supply of which was guaranteed in 1859 when the first petroleum well was drilled in Pennsylvania. In 1869, Nantucket's last whalers set sail, and an era had ended.

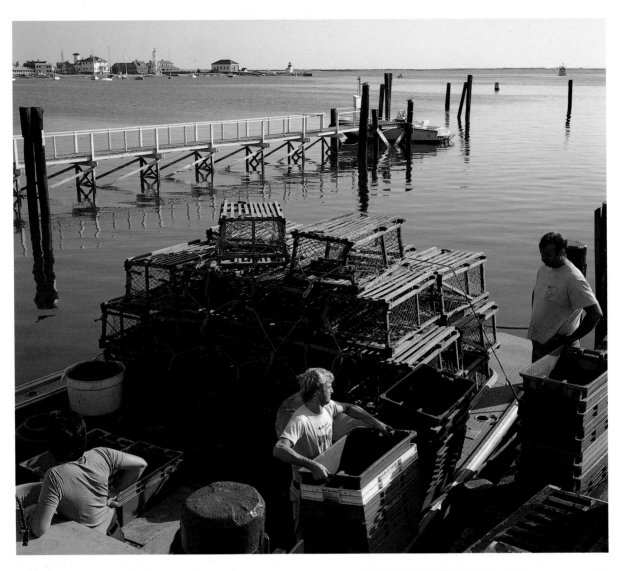

Above and *right:* Back from the sea. The *Nobadeer* is a dragger built in 1943. Its name means "good fishing grounds." The men in the photo above are handling lobster pots. Both lobster "trap" and "pot" are used interchangeably, with the latter being a more Down East term.

Privately-owned fishing boats concentrate on cod, haddock, halibut, flounder, bluefish and swordfish in the summer as well as sea scallops. Nantucket is best known for its bay scallops and off-shore bluefish which are among the most abundant in the world.

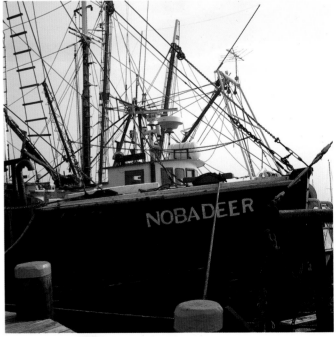

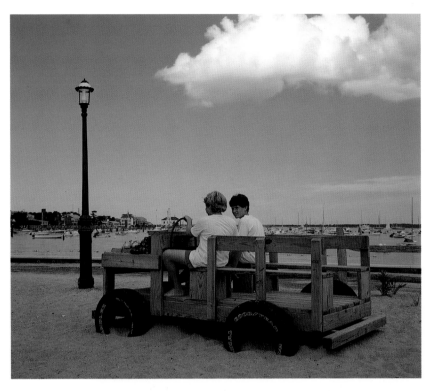

Left: "I think we're stuck in the sand." These boys are practicing for the day they will have their own convertible.

Below: A 1947 Chrysler Town and Country convertible, a beautiful blend of yacht and car.

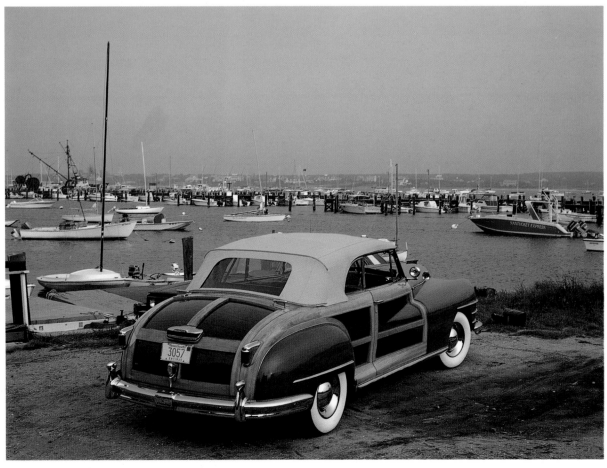

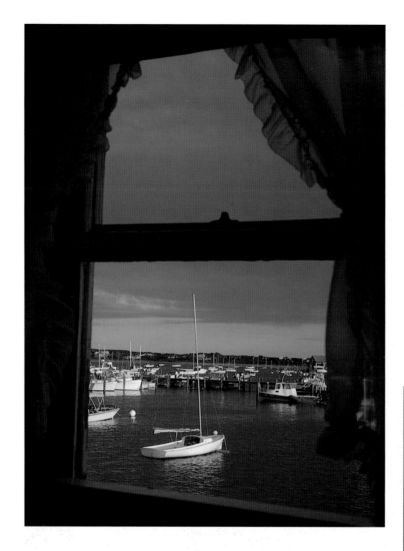

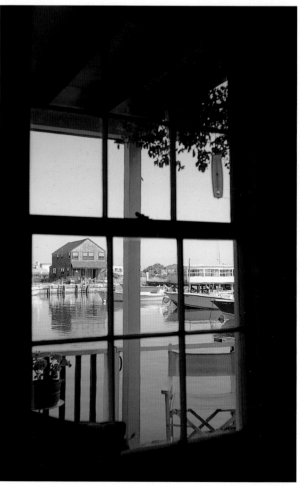

Above: Through the fluttering Priscilla curtains is an O'Day Sailor, a slightly smaller version (16' 9" versus 19') of the popular Lightning.
 Right: Peeking out from the living room of a North Wharf loft across Easy Street Basin.

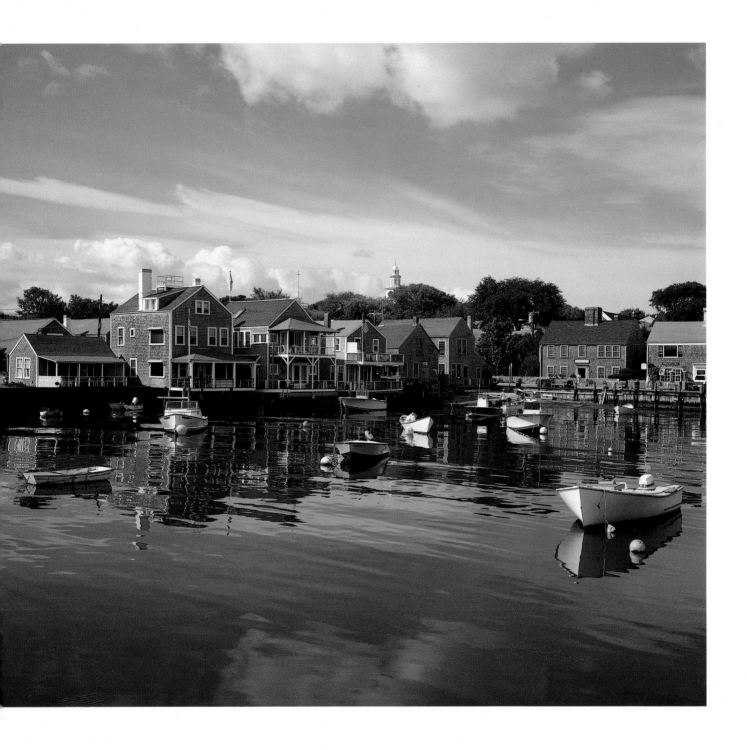

Old North Wharf and Easy Street Basin. The wharf is one of Nantucket's oldest, built in 1774. It is one of five wharves and a town pier but is the only one that is residential. It is privately owned by individual families. The familiar gold-domed steeple of the Unitarian Church or South Tower is visible in the background. This is Nantucket's oldest church, built in 1809.

Since 1820 Nantucket has had five wharves devoted first to whaling and later to various commercial operations such as lumber, coal and ice storage in the late 1880s. Steamboat Wharf (1820) was built especially for packets and was known as New North Wharf. The railroad operated from here between 1881 and 1917. Next to Old North Wharf is Straight Wharf, originally built by Richard Macy in 1723 as an extension of Main Street. Old South Wharf (1760–1762) was known for many years as Island Service Wharf. The last is Swain's Wharf, built by Zenas Coffin and Sons in 1816 and extended in 1831. It had been known as Commercial Wharf but was renamed in honor of Obed Swain who was the wharfinger when it was reconstructed in 1850.

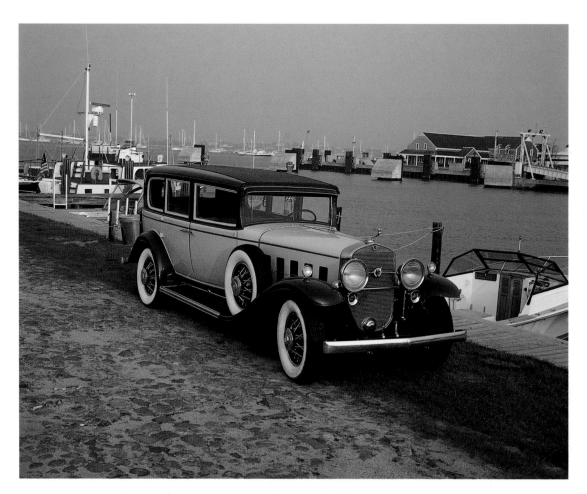

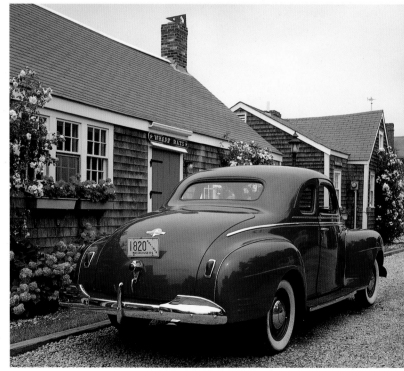

Above: A 1932 Cadillac 7 passenger sedan and *(opposite, top)* a 1932 Packard Model 901 sedan. At the height of the Depression, Detroit rolled out these unaffordable chariots with 12 cylinders. *Right:* This 1941 Plymouth businessman's coupe with only one seat was built in an era when people actually drove such goofy-looking cars with pleasure.

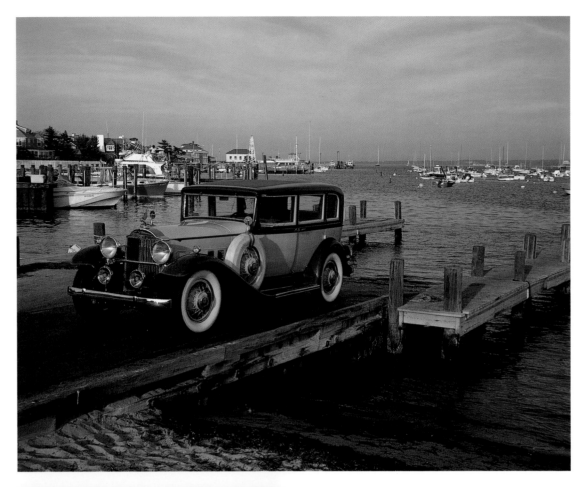

Left: Nantucket's famous Wharf Rat Club on Old North Wharf. This club was started, more or less, in 1915 in the Perry & Coffin general store, where men would sit around a potbellied stove and trade stories (or have a gam). The Wharf Rat Club has no by-laws, dues or membership hierarchy. Acceptance is based on the ability to tell good tales. Originally the club-house as well as its companions, *Lydia, Independence* and *Constitution,* were all located on the south side of the wharf.

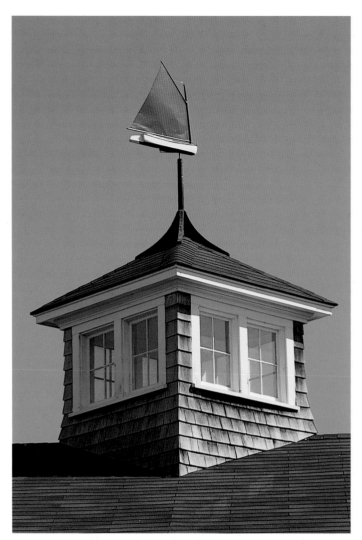

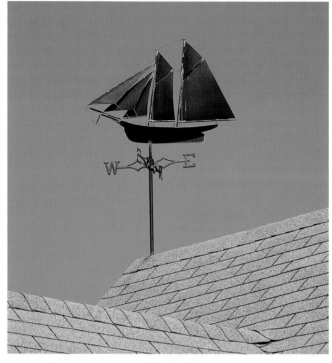

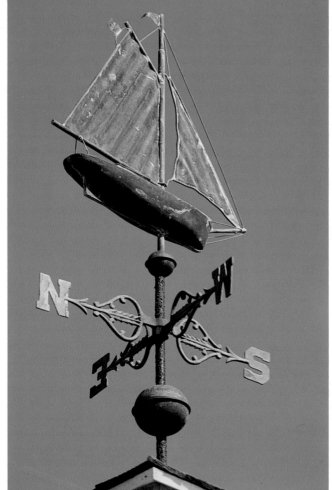

Ship weathervanes are popular on Nantucket rooftops. The bottom one says today's wind direction is news. These are the oldest meteorological devices. Before Christianity they typically displayed wind or sea deities. But beginning in the 9th century the Pope decreed every church should have a cock, after Peter's denial of Christ. Weathervanes became one of the earliest indigenous sculptures in America, beginning in the 1600s. The best known vanemaker was Shem Drowne of Kittery, Maine, whose grasshopper was mounted atop Boston's Faneuil Hall in 1749 and has survived fires, earthquakes and storms for almost 250 years.

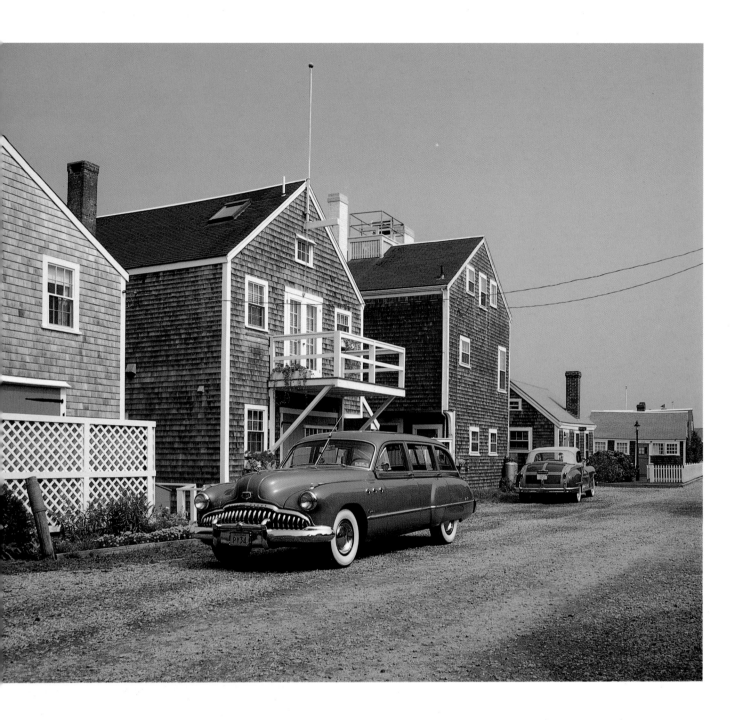

Old North Wharf. This western section of one of Nantucket's oldest wharves was once called Burdett's Wharf. The houses and lofts are a weathered blend of old and very old, an evolution of boat shops, fishing shacks, sail and sleeping lofts. Most of the structures are named after whaleships owned by Zenas Coffin (*Independence, Constitution, Lydia, Mary Slade, Zenas Coffin* and *Charles & Henry*). The latter, named for Zenas Coffin's sons, is the second loft from the left, behind the Buick. In the 1920s it was occupied by the wharfinger, Charlie Collins.

The station wagon is an unusual 1949 Buick Super Estate Wagon of which only 1,845 were made. (It weighs over four thousand pounds.) While most cars stretched their models over several years, Buick used this one only in 1949. The directions from the body manufacturer called for a waxing of the wood every three months (after a thorough washing) and every six months the wax had to be removed and two coats of Du Pont Exterior Clear Varnish applied (and another coat of wax). Not exactly maintenance-free. Buick made wood wagons from 1940 to 1953. Note the distinctive round porthole side vents on the front fender, a trademark its conservative designer preferred to utilize while Cadillac played with tail fins.

Above: Zero Main Street, headquarters of First Winthrop Corporation, and a rare 1946 Ford Deluxe Station Wagon. In 1964 the principals of Island Service Company and Sherburne Associates joined to create a company with ownership of many of the downtown properties including Straight, Island Service and Commercial Wharves. Sherburne continued to acquire, develop and renovate properties during the next twenty years, selling its holdings to First Winthrop Corporation in 1986. First Winthrop was organized in Boston in 1975 and owns, directly and through partnerships, approximately 450 properties throughout the country.

Right: A 1948 Packard Series 120 Station Sedan at the Steamship Authority Terminal. This car has a straight eight-cylinder engine and a stick shift with overdrive. Directional signals and back-up lights were new features this year.

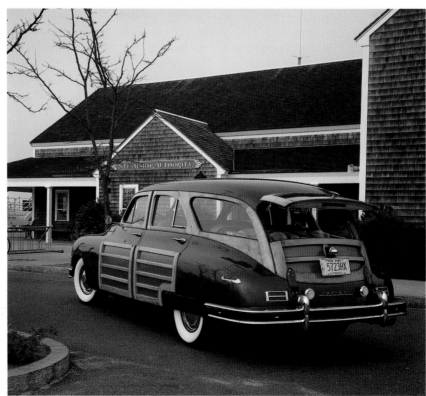

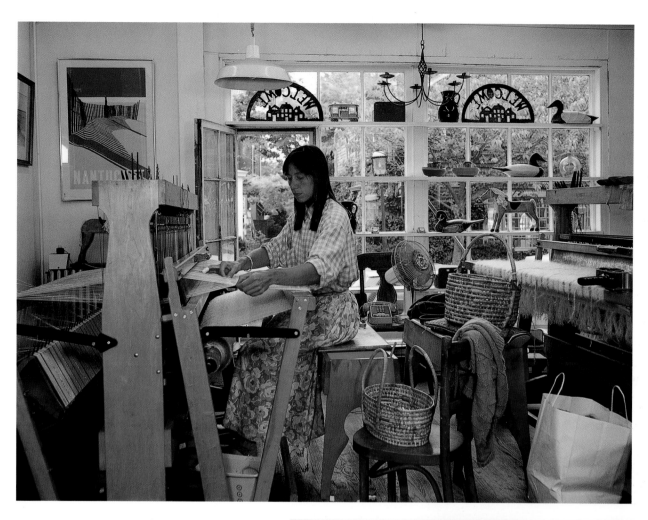

The Nantucket Looms. For many years the Cloth Company of Nantucket was located here at 16 Main Street. In 1967 Bill Euler and Andy Oates established the Nantucket Looms at the invitation of Walter Beinecke to teach Nantucketers the fine art of weaving. Their first job was for upholstery, fabrics and bedspreads for the Jared Coffin house. The Looms presently has six year-round weavers making fabrics for clothing, furniture and draperies as well as mohair throws, scarves and stoles. On the outside of the building is a large compass giving directions and mileage to Wauwinet and New Zealand (and points in between) ever since it was first painted on the side of Gardner's Gift Shop in 1922.

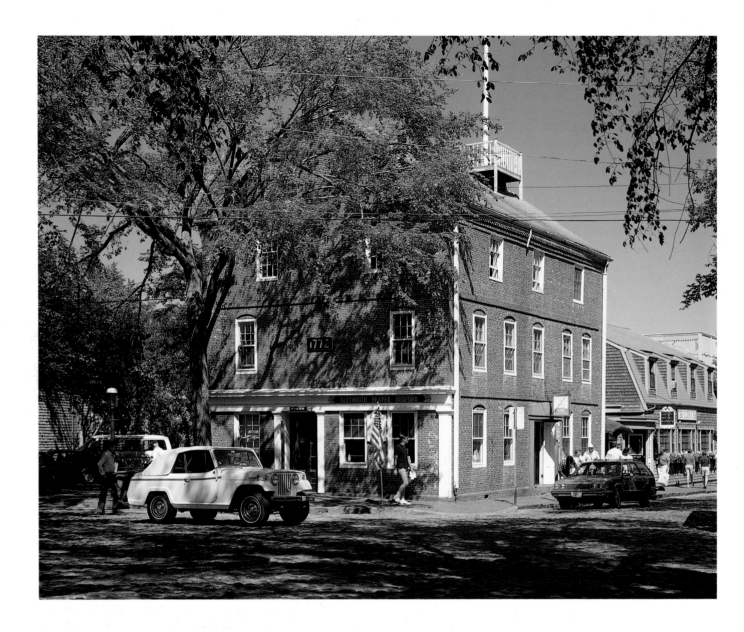

The Pacific Club, 1772, originally the counting house of William Rotch and Sons. One room became the first Customs Office in America (1783–1913). The sign on the building bears the names *Beaver, Dartmouth* and *Bedford*—all Rotch ships. The first two were involved in the Boston Tea Party, and the third was the first ship to fly the new flag of the United States in any British port. In 1791 the *Beaver* made a significant voyage, rounding Cape Horn and opening up the Pacific whaling grounds to Nantucket. Without this, the whaling industry would have diminished because of the depletion of whales in the Atlantic Ocean.

Rotch and his sons were the island's most successful merchants at the time due in part to their control of both input (oil) and output when they built the island's first candleworks in 1772. Like Henry Ford (who had his own foundry) and Isaac Singer (who had forests for his sewing machine cabinets) this was a fully integrated production line.

Since its construction, the town has occupied half of the build-ing in exchange for giving Rotch the land for it. Insurance companies occupied the other half from 1804 to 1860. The Pacific Club, initially a group of retired whaling captains, acquired the building in 1861. The structure was originally light-colored brick but was painted red in 1891.

Opposite, left: A figurehead from the 3-masted schooner *Daniel I. Tenney,* built in Newburyport in 1875. The figurehead was brought to Nantucket to adorn a Hulbert Avenue boathouse. *Opposite, right:* A Nantucket surrey for hire, outside the Peter Foulger Museum. These two-seat wagons were first introduced in the United States in 1872 from the English county for which they are named. *Opposite, bottom:* Mitchell's Book Corner, 54 Main Street. This is located in an 1847 structure that also housed the *Inquirer* and *Mirror* (on the second floor) beginning in 1887. A book store has not always been located here but there was one in 1862 when Herman Melville was perambulating the island.

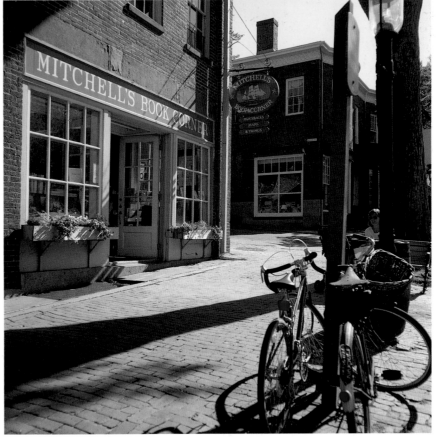

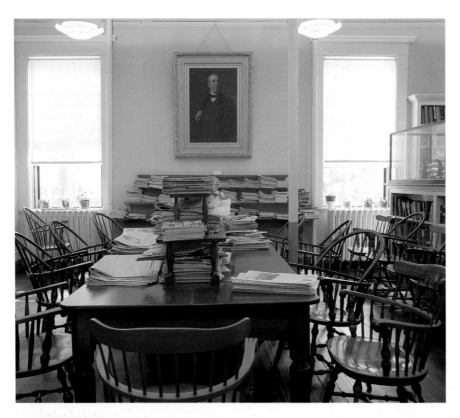

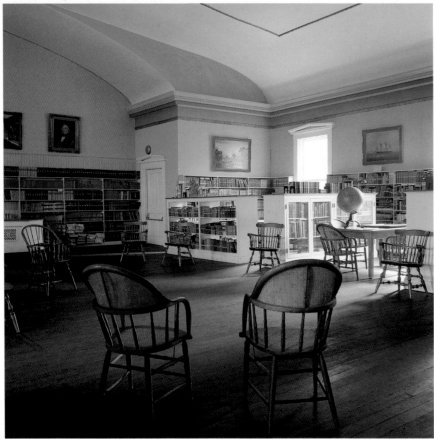

Above: Frederick Coleman Sanford (1809–1890), in a portrait by Eastman Johnson, gazes down on the Atheneum's periodicals. Sanford donated the property on which the Atheneum sits.

Left: The lecture hall of the Atheneum.

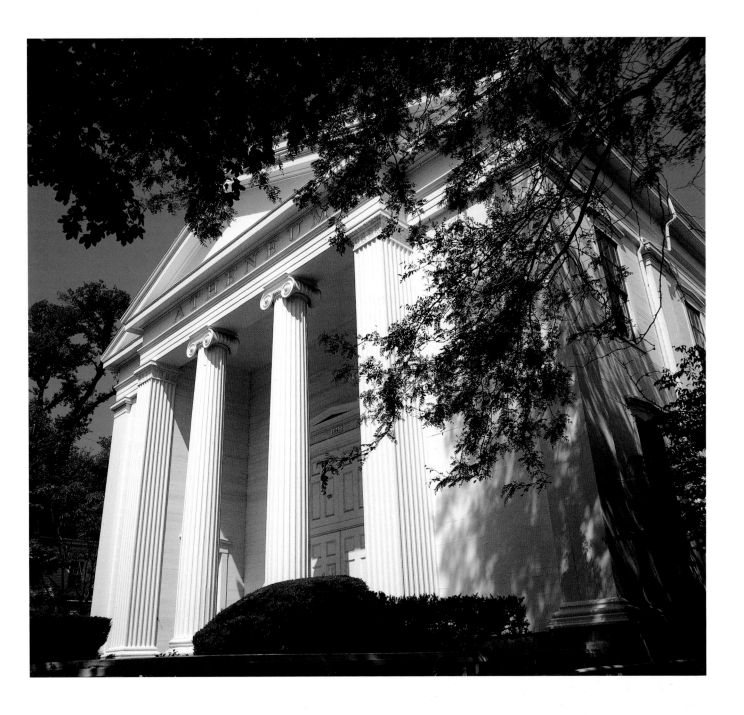

The Nantucket Atheneum, One India Street (1847). This is the island's public library and was designed by Frederick Brown Coleman who left his mark on Nantucket in the 1840s. He designed the impressive Greek Revival houses at 94 and 96 Main Street in 1840–1845, the First Baptist Church in 1841, and added the massive Ionic portico to the earlier Methodist Church in 1840. The Atheneum is Coleman's masterpiece. Its facade is impressive and monumental—windowless like a Greek temple. It has double pediments on the south, one embracing the entire portico pediment. The two Ionic columns make a statement that is both elegant and bold.

The United Library Association was formed in 1827 by merging the Nantucket Mechanics Social Library (1820) and the Columbia Library Society (1823). The name was changed to the Nantucket Atheneum in 1834 and in 1836 it moved into new quarters

designed by Charles Coffin and David Joy on a site next to the Universalist Church at Federal and Pearl (now India) Streets.

The Great Fire of 1846 destroyed its building and 3200 volumes. An appeal to the rest of the country was made and responses came in from nearly every state. A new building was opened the next year at a ceremony where Ralph Waldo Emerson gave the dedication.

Under the direction of Maria Mitchell, who had become the librarian in 1836, the Atheneum expanded, adding in 1847 the Great Hall on the second floor, where the important speakers of their time gave lectures: Horace Greeley, John James Audubon, Louis Agassiz, Daniel Webster and Henry David Thoreau. For over 50 years it was the cultural center for Nantucket.

The Great Hall has since become a reading room adorned with the library's collection of Chinese paintings and ship pictures.

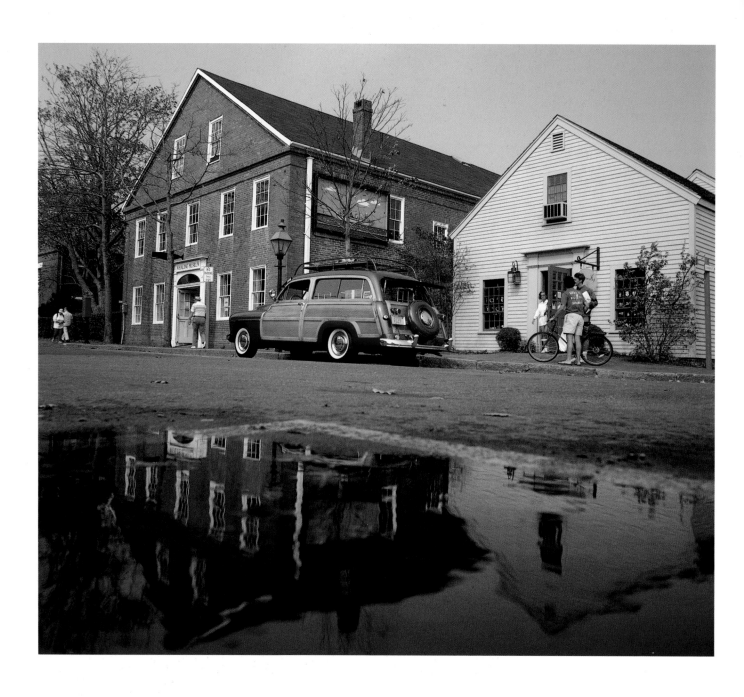

The Whaling Museum on Broad Street was built in 1847 by William Hadwen and his partner, Nathaniel Barney, as a candle factory. Everything on Broad Street was destroyed in the Great Fire of 1846 except for Jared Coffin's house. Broad Street was originally laid out in 1678 and, like its sister Main Street, it was widened after the fire. Also like its sister, Broad Street has cobblestones, now quietly napping under a blanket of macadam. The car is a 1949 Mercury Eight station wagon.

Opposite, top: The Navigation Room of the Whaling Museum, showing the original Fresnel lens used in Sankaty lighthouse (one of the first such lenses made) and other navigational memorabilia.

Opposite, bottom: A whaleboat shop at the Museum showing a fine collection of antique tools and, in the background, an old steam-driven lathe.

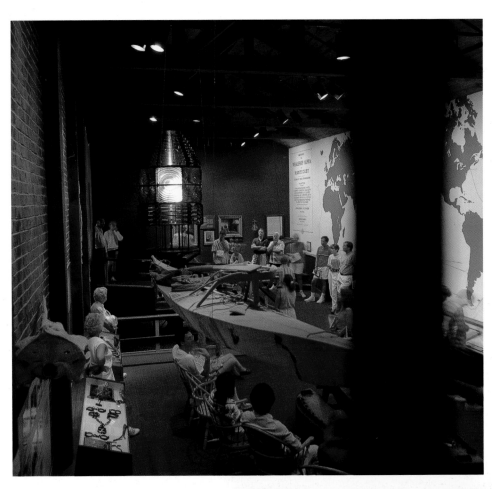

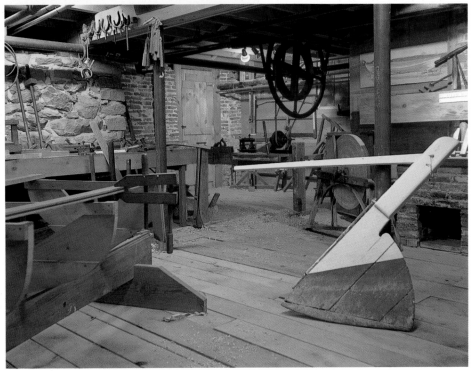

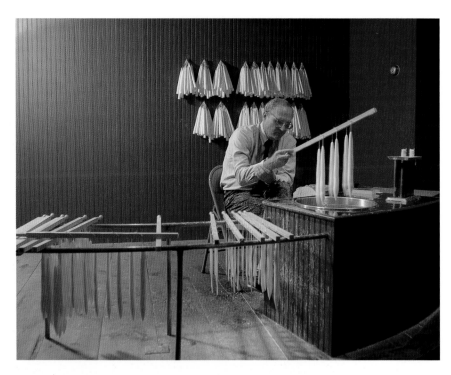

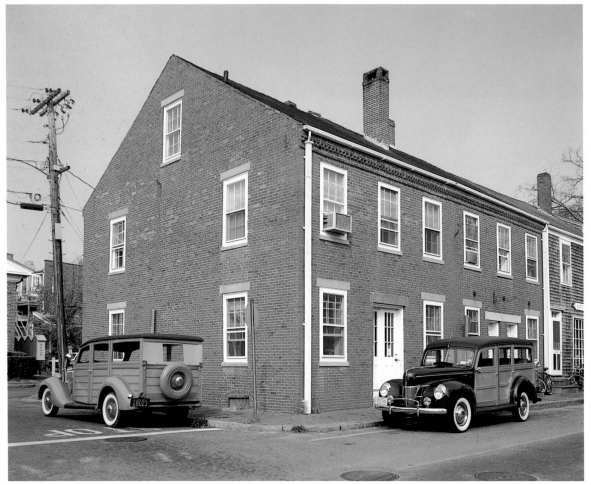

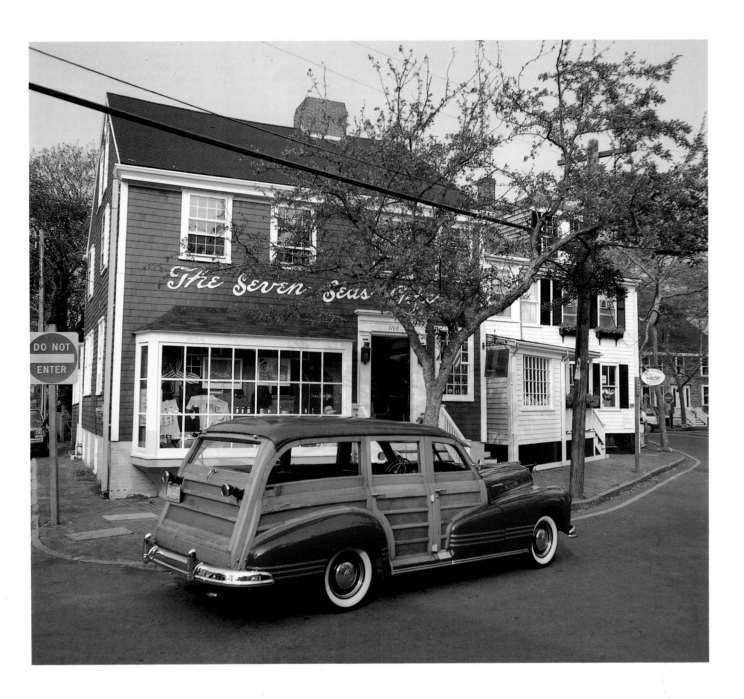

Above: A giftshop at 46 Centre Street. This was originally a house built in 1760 for Capt. William Brock. It was also the home of Capt. George Pollard whose *Essex* was rammed by an angry whale in 1820, causing him and a few survivors to spend three months in an open lifeboat. Herman Melville is thought to have based *Moby Dick* on this incident. The car in the foreground is a 1946 Pontiac Streamliner Six station wagon with a body by Iona.

Opposite, top: Candlemaking at the Thomas Macy Warehouse (1846) on Straight Wharf. Candles are made from stearic acid, a crystalline animal fat which resembles spermaceti, the waxy substance found in the large cavity of the sperm whale's head. Candlemaking required separating the oil from the spermaceti

through an elaborate process developed in Newport in 1751.

Opposite, bottom: The Old Town Building, 5 Washington Street (*ca.* 1830) built by Thomas Coffin and James Athearn. In 1836 the town purchased the southern half of the building and in 1884 the other half. These quarters included the police station and jail cells, with the Old Gaol on Vestel Street serving as a backup. In 1968 the Nantucket Historical Association, incorporated July 9, 1894, acquired the building, which has now been designated an historic landmark by the Department of the Interior.

Union Street was laid down in 1726 to become most of the harbor-side boundary of the West Monomoy Lots. In the foreground are 1935 and 1940 Ford station wagons.

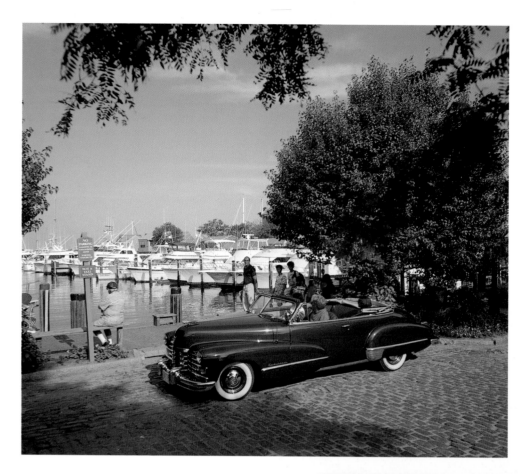

Above: The Boat Basin at the edge of town. Where Main Street and Whale Street cross is a merger of town and harbor—a place where artists and others can simply sit and "watch the world pass." This is an area bustling with activity, now as before, shoppers and tourists having replaced the deckhands and merchants of the 1800s.

The car is a 1947 Cadillac Fleetwood—no tail fins yet but a grille that is unlike any other—a sculpture in silver.

Right: A familiar scene at the hairdresser: "What happened, Grandma?"

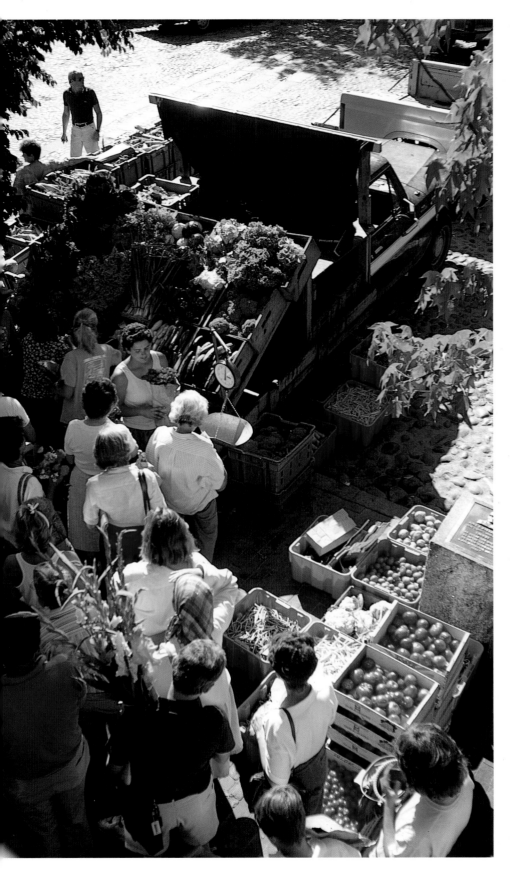

The Bartlett Farm stand on Main Street has been offering freshly picked vegetables and flowers at this location for almost 50 years. The cart is a treasured reminder of the era when vegetables were not wrapped in cellophane and then thrown into an air-cooled bin at the Finast, an era when shopping included a grain of news and gossip with friends.

The Bartlett Farm is Nantucket's largest, with over 100 acres under cultivation. It has been in the family for seven generations. Originally a dairy farm, Bartlett's has expanded into vegetables, flowers and even wine. Its principal business is vegetable growing and it raises, among others, twenty different varieties of lettuce producing approximately 6,000 heads every two weeks. Vegetables are supplied to the island's main grocery stores as well as restaurants and hotels.

Federal Street was originally the water's edge. But in 1743 the dunes along here were leveled to create the Bocochico Share Lots. The street was widened after the Great Fire of 1846 and provides a more suitable site for the Atheneum. Newer structures, such as the Post Office and 23-21 Federal, fit well into the environment, thanks to the regulations of the Historic Districts Commission. Restoration work began downtown in the 1920s and received further impetus from a 1940 survey by Everett Crosby, who recommended the general policy that the old was to be preserved, the garish avoided, and commercialism disguised. Edouard Stackpole returned from directorship of the Mystic Seaport and published stories of Nantucket history in the Historical Association bulletins. Walter Beinecke began to develop the waterfront and marina in 1964 through Sherburne Associates, whose successor, First Winthrop Corporation, is housed at Zero Main Street.

Above: The Dreamland Theatre. This land-mark is Nantucket's oldest and largest theatre, the only structure on South Water Street that predates the 1846 fire. The building was originally constructed in 1829 at the corner of Main Street and Ray's Court. It has been a straw hat factory, a Friends' meet-inghouse, and a rollerskating rink, and in 1883 was moved to Brant Point to become the centerpiece of the Nantucket, the island's grandest hotel. In 1906 it was floated back to its present location and became a theatre.

Left: A 1941 Plymouth on Still Dock. This is only a two-door compact but it means busi-ness. The nautical hood ornament is appro-priate for Nantucket. Still Dock is a waterway between Old North and Straight Wharves that was filled in around 1830.

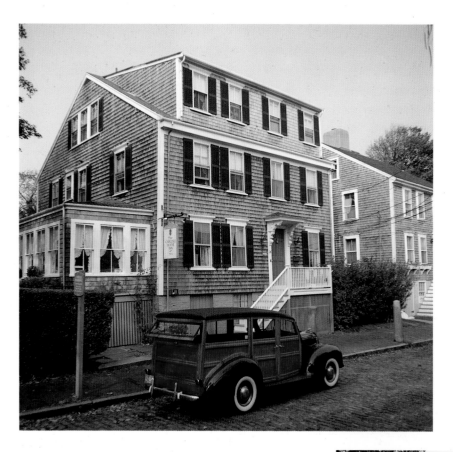

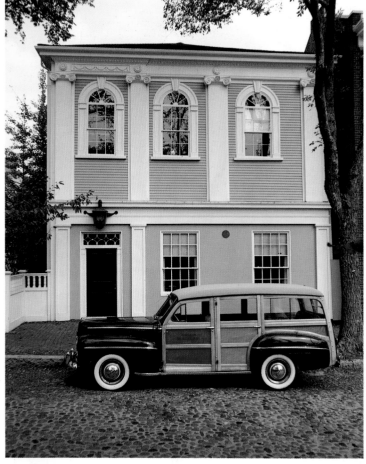

Above: A guest house at 26 North Water Street built *ca.* 1765 for Richard Swain. The car is a 1938 Ford wagon, the first one to offer glass side windows, not just curtains.

Right: Masonic Hall, 63 Main Street (1802). This was built by the Freemasons, one of the earliest fraternal orders in the country. The lodge halls, derived from the medieval craft guilds, were popular in the second half of the 19th century. They provided fellowship as well as types of insurance, credit and social security that were unavailable to the average worker.

This Federal-style building originally had five bays but the two on the left were lost in 1872 to a new house which has since been taken down. Over the years Masonic Hall has housed many businesses, including the Western Union Telegraph Co. It was abandoned in the early 1960s but saved from demolition by the Nantucket Historic Districts Commission. It now houses the Pacific National Bank's Trust Department. The car is a 1948 Ford Deluxe.

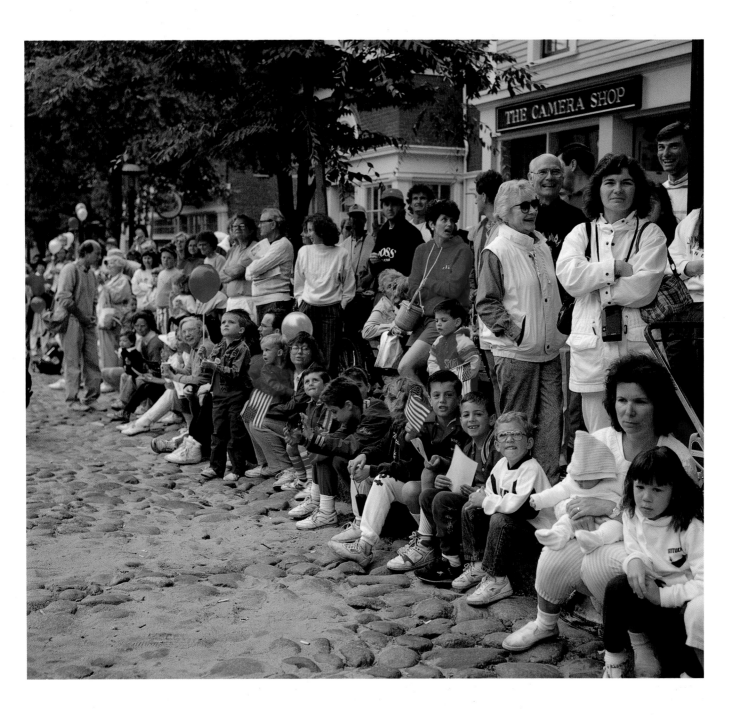

Gathering for the July 4th activities on Main Street. For many years, youngsters of all ages have enjoyed the Independence Day festivities which often include a water fight between two fire-fighting apparati.

Main Street was laid out by the Proprietors around 1697. Its name was changed to State Street in the early 1800s and then shifted back to Main by 1833. This section is referred to as Main Street Square and was somewhat enlarged in 1847 when the rows of stores on the north side were pushed back about twenty feet. Thus Main (and Broad) Streets give the arriving visitor a wide introduction to the town.

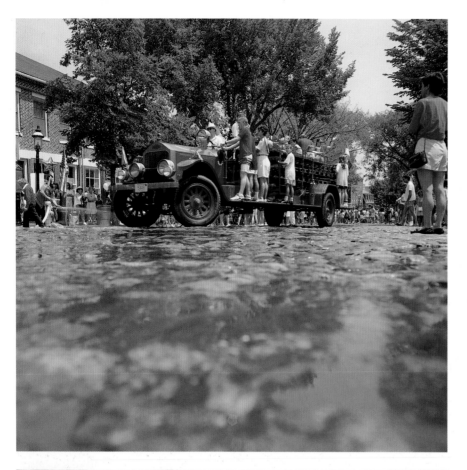

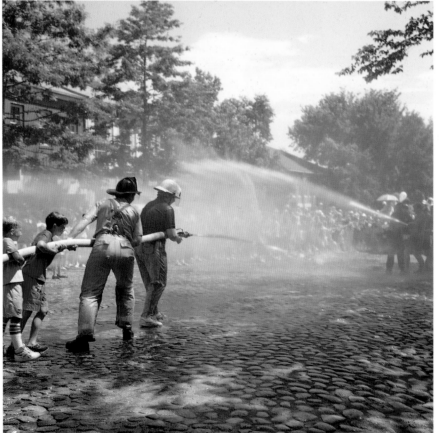

Above: This 1927 American LaFrance quadruple combination City Service Ladder Truck was purchased by the town when new for $12,500. It served the Fire Department faithfully until 1960 and continues today in cameo appearances.

Left: A hose fight between two fire engine companies: a hand pumper versus the above ladder truck.

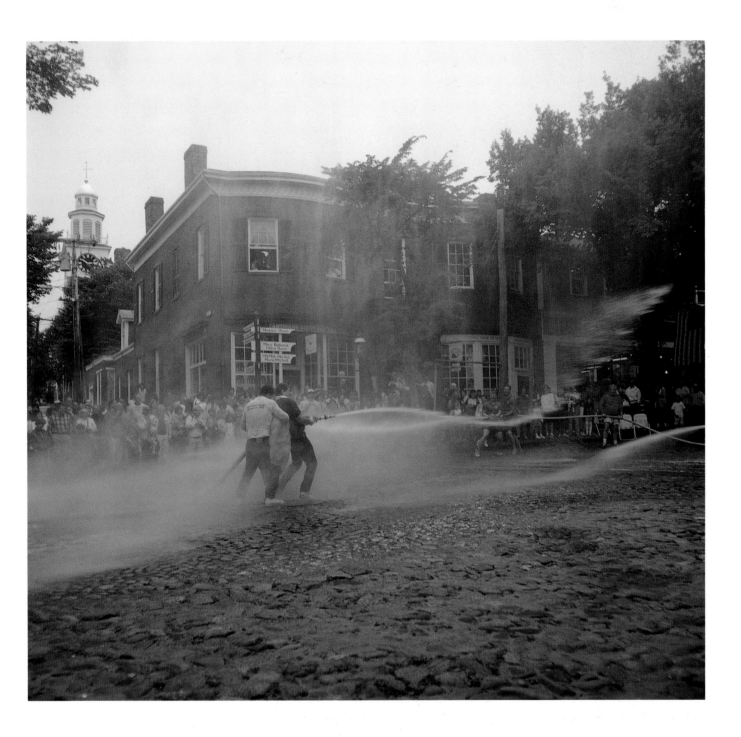

July 4th activities. The annual water fight gives the fire brigade a chance to show its new equipment to the delight of all. This site is where the Great Fire of 1846 occurred, starting on lower Main Street and proceeding up as far as the Pacific National Bank before turning north to the Jared Coffin house. Buildings were dynamited in an effort to check the blaze. Only the major brick buildings contained it, and after it finally subsided, the town had lost thirty-six acres of its most valuable property—the stores, warehouses and factories of its whaling business.

The water fight today begins with an 1840 Cataract Hand Pumper, actually used in the 1846 fire and now owned by the Nantucket Historical Association. It is superseded by the 1927 American LaFrance which, in turn, is overcome by the 1974 Mack pumper.

The LaFrance truck was retired from service in 1960 because the brakes no longer passed inspection. It was bought by Flint Ranney who sent it off-island for overhaul and repairs. He drove it back with his new bride on their honeymoon. All was fine until the renovated brakes locked while crossing the Bourne Bridge. Everything eventually worked out.

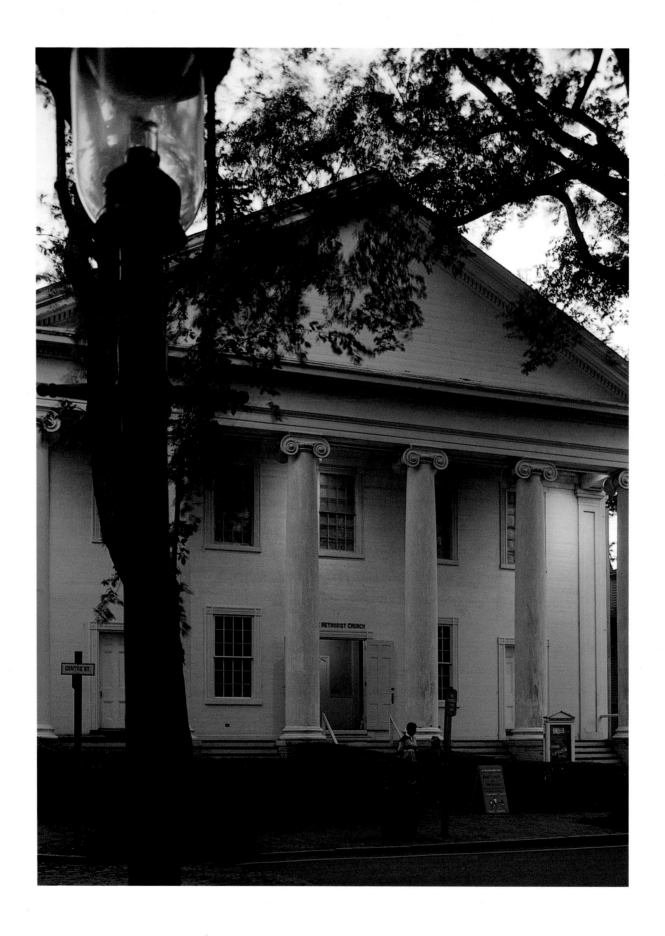

Opposite: The Methodist Church on Centre Street (1823). The pediment with its handsome dentil molding and six plain Ionic columns is believed to have been added by Frederick Coleman in 1840. The building is not much taller than its neighbors yet the oversized columns give it a massive feeling, making the church seem larger than it actually is. Shortly after the church was built its cellar was used to store whale oil. The Methodist Society in Nantucket dates from 1799.

Above: The Philip Folger house, 58-60 Main Street (1831), now used commercially. Originally it was one of the handsomest residences, a combination of Federal and Greek Revival with curved fronts inspired by Asher Benjamin's work on Beacon Hill, Boston. After Jared Coffin's "Moor's End" this is the second all-brick house to be built. The oldest house with exposed brick ends is the Silas Jones house, built in 1770 around the corner at 5 Orange Street. After the 1846 fire this house was converted to storefronts whose floors were lowered to street level. H. M. Macy & Co., a dry goods store, occupied one of these.

Right: The Pacific National Bank, 61 Main Street (1818). This is the finest example of pure Federal-style architecture on Nantucket. It is built of Flemish brickwork (alternating long and short bricks) on granite foundations. The Pacific National Bank name was adopted in 1865 and two bays were added along Main Street in 1894. The bank and the church are stately structures which have stood side by side, like Grant Wood's "American Gothic," for 170 years.

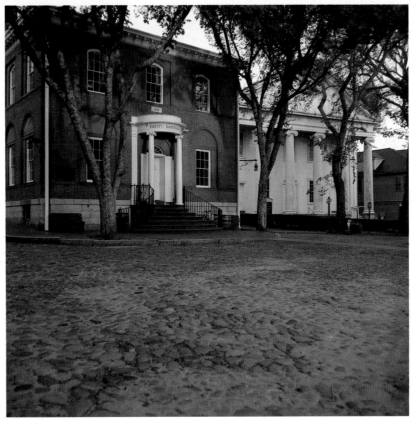

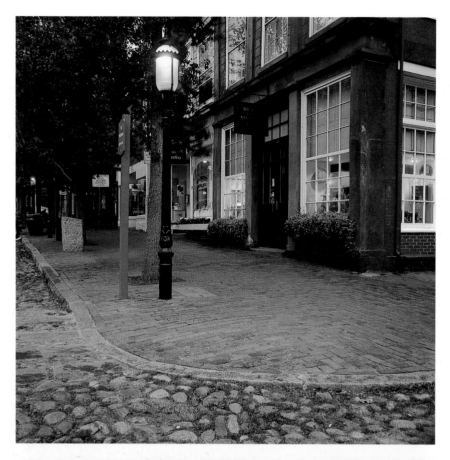

Above and *left:* Main Street shops. This structure was built in 1847 by Kelley and Gorham. The corner shop has served many businesses, from hardware to health foods, but is now the island's premier antique and gift shop.

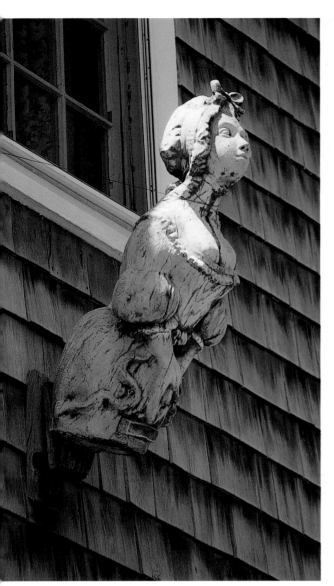

Figureheads around Nantucket remind us of its nautical past. Since the Egyptians first decorated the prows of their ships with eyes to help them find their way safely, sculptural bows have always been symbols of good luck. The Romans used animals (boars, swans), a theme which was continued by the Vikings and Danes (who favored dragons). During the 16th century the carvings turned to saints and eventually the person for whom the vessel was named. While the majority stayed with simply a carved figurehead, a galleon built in 1637 and appropriately called *Sovereign of the Seas* spent almost 20% of its total cost on carving and gilding.

Right: A camera shop and an antique store on Main Street. This handsome brick structure was built in 1892 and modified in 1912.

Below: Also dating from 1892 was this building, replaced in 1910 and substantially modified into a restaurant, fondly remembered as simply the Sweet Shop and now the Espresso Cafe.

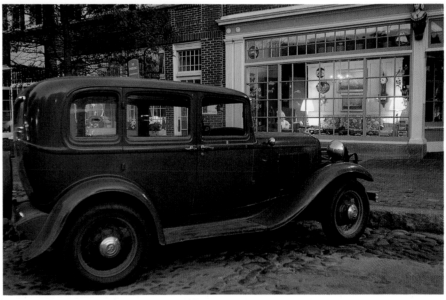

The lower section of Main Street is called Main Street Square and many of the brick buildings were built for several tenants grouped into a block. The store at the top is the Union Block, built in 1847 by George Folger. James Easton, the jeweller, occupied the store presently owned by Coffins' Gifts, one of the island's oldest gift-shops.

The 1932 Ford Model 18 is parked in front of a handsome Greek Revival building, built after the 1846 fire and one of the first to incorporate a steel structure. Note the V-8 on the Ford's hub-caps. This was the first year of Ford's V-8 engine.

The timelessness of Nantucket is uniquely reassuring. The town displays its history in a quiet, fulfilling way—reminding the visitor of the people and events that preceded us and at the same time assuring us of a continuity tomorrow.

The Methodist church and the store in the photograph *(above)* are the only two structures on Centre Street to have survived the 1846 fire. Firemen worked valiantly to save the church. The Lord gave the store as a dividend. The store *(right)* is in Sherburne Hall (1847), one of six shops with a large meeting hall above used by the Independent Order of Odd Fellows.

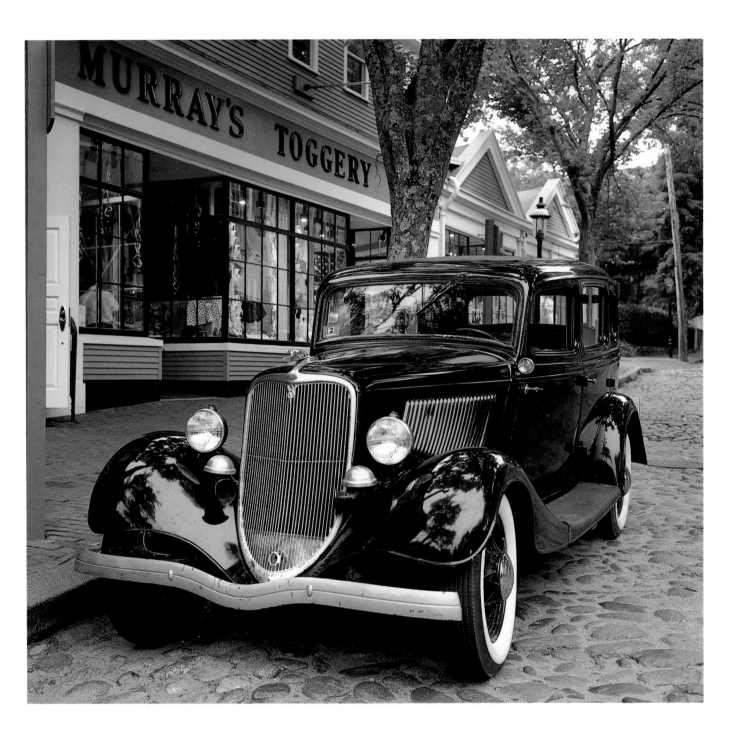

The upper edge of Main Street Square is where the Great Fire reached before heading north along Centre and Federal Streets.

The car is a 1933 Ford, one of the first with a V-8 engine. It is a deluxe model because it has two taillights (but only one windshield wiper). It was owned by Mrs. Underwood and stored in the winter at Brant Point. The family was one of the early promoters of "Beach Side," now known as Hulbert Avenue. Ford made cars with this stylish "V-Front" design until 1940 when it switched to a flat front. Their first V-8 engine was fitted into the 1932 Model 18, probably more engine than the car needed. Neither Chevrolet nor Plymouth offered a V-8 until 1955, 24 years later.

Opposite: Centre Street from Main to India (or Pearl) was known as Petticoat Row due to the many female proprietors who worked there while their spouses were at sea. The nickname began in 1848 when Andrew Macy sailed off to join the California Gold Rush, leaving his bookstore to be run by his sister, Harriet.

The English maples, Chinese elms and ginko trees were planted along Centre Street in the early 1850s by N.A. Sprague about the same time the elms were planted by Charles and Henry Coffin along Main Street.

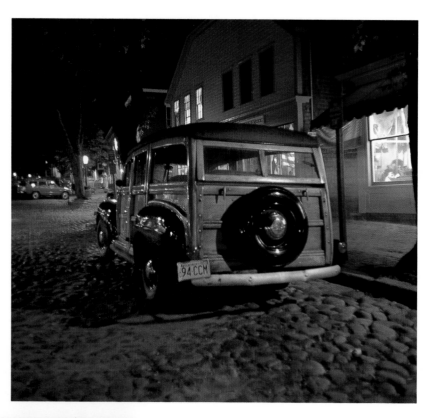

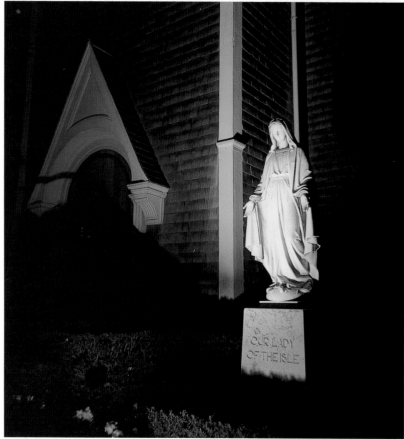

Above and opposite: Main Street shops at the horse fountain. After the fire, Main Street was widened but the stores where the Nobby Shop is are the only ones built on their original sites. They were commissioned by Philip Folger whose handsome brick residence at 58 Main Street helped stop the westward thrust of the fire. In the new 1847 building were a variety of businesses —including Ray & Barrett's Hardware, and James Bunker's law practice.

The building next to the Nobby Shop was occupied by the Union News Room and, upstairs, the *Inquirer* and *Mirror* until the latter moved across the street to a location above Mitchell's Book Corner store in 1887. The *Inquirer* started in 1821 and is one of the oldest continuously published newspapers in the country. The *Mirror* was organized in 1845 and merged with the *Inquirer* in 1865. When I was growing up it still had a large blanket format and required long arms to hold it open.

Left: Our Lady of the Isle stands in front of St. Mary's Church (1896) on Federal Street, lending a sense of peace to the bustling downtown scene.

Erica Wilson's Needleworks Shop on Main Street. The building where this and adjacent shops are located was completed in 1847 and is known as the Hussey Block. Miss Wilson first came to Nantucket in 1962 to teach needlework across the street where the Nantucket Looms are located today. She was born in Scotland, did her first piece of embroidery at the age of five and spent her childhood moving along the English coast because her father was an aircraft spotter during the war. She attended the prestigious Royal School of Needlework in London which was established to teach ladies to make church vestments. In 1954 she sailed to New York on the HMS *Queen Mary* and started a class in Millbrook, New York. She began the course with difficult gold church embroidery, a technique so difficult that for the next class everyone mysteriously had become ill and did not show up. She subsequently switched over to crewel work—a light stitch that does not cover the whole area—which became most popular. Soon people began to write for instructions and before long she and her husband were making mail-order kits. Requests came in at the rate of over 100 per month. The dining room table became their workshop as samples were printed and assembled with yarns into kits—soon the country was launched into a large needlepoint bee. Many of the island's homes have Erica Wilson-designed pillows and chair covers. A remarkable collection of 32 chair cushions may be seen at St. Paul's Church—Nantucket scenes worked by the ladies of the congregation during 1970. A similar task is presently underway for the Union Chapel in Siasconset.

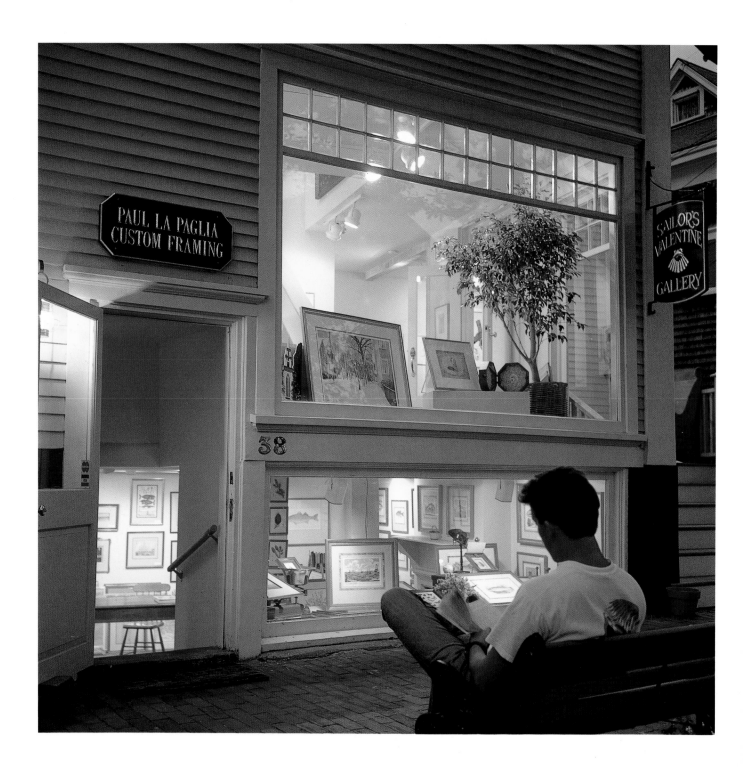

Above: Centre Street is filled with galleries and shops from Main Street to Broad. It used to have cobblestones, and the section from Main to India was referred to as Petticoat Row beginning in 1848 in deference to the large number of female proprietors. Most of the structures were built after the 1846 fire. Centre Street was originally laid out as part of the Wescoe Acres Lots in 1678 and is thus, together with Broad Street, one of the oldest streets on the island.

Opposite, top: At the foot of Main Street are the bandstand and old chowder houses. The 1949 Buick Super Estate Wagon quietly attests to another era—not of whaling ships but of motoring adventures in graceful cruisers on country roads. Despite its transgressions of the 1970s and 1980s, Buick is still known for building big handsome vehicles.

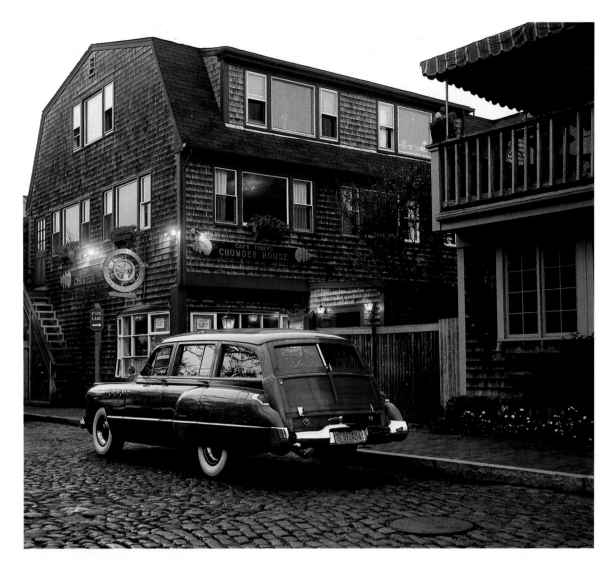

A restaurant and antique shop on India Street. The car is a 1930 Ford Model A phaeton. The phaeton model is named for the graceful open carriages of the last century, which in turn are named for the son of Helios, who drove his father's sun chariot too high in the sky and was struck down by Zeus' thunderbolt.
 Prospective diners contemplate the night's specialties.

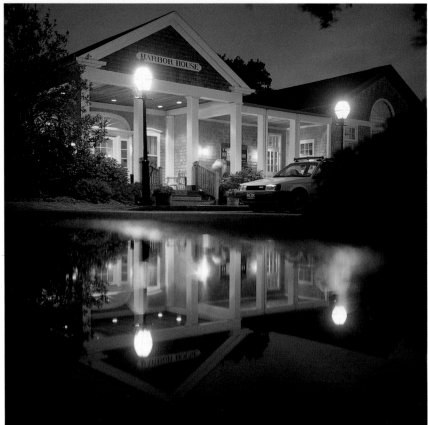

Right: The Harbor House. This is part of the Springfield House, a large rambling structure built at the corner of North Water and Easton Streets in 1883 and a successor to the original Springfield House built at 21 North Water Street in 1864. It was relocated in 1917 and had three stories with a veranda extending across the front to the dining hall next door. In 1979 the Harbor House built individual townhouses on the lawn sweeping down to South Beach Street, and it added the Meetinghouse.

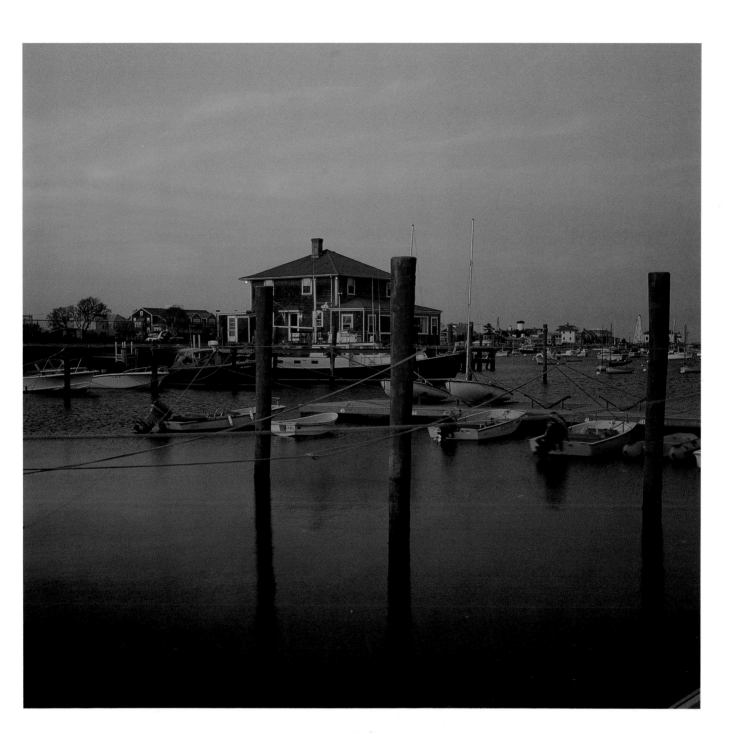

Above and *opposite, top:* The Nantucket Yacht Club. This was organized in 1890 as the Nantucket Athletic Club. A large clubhouse was built in 1904 containing facilities for all activities popular at the time: bowling, billiards and cards. Recreation was different then. There were no golf courses, tennis or sailing clubs on Nantucket. There were not even sports clothes; everything was conducted in business suits (for the men) and floor-length dresses (for the women). Sailing was for commerce, not sport, although catboats could be hired for a picnic excursion. Most of the vacation time was spent reading, writing letters, playing cards or rocking on wide verandas of the new hotels. Nantucketers had not yet really learned to play.

In 1908 the Athletic Club added a gymnasium which was occupied by the Naval Reserve during World War I. The facilities were subsequently acquired by the Nantucket Yacht Club, organized in 1920 by a group of Hulbert Avenue residents.

The Yacht Club owns a large number of moorings as well as the Boat House in the photograph above.

Old South Wharf (1760–62, 1770), originally built during the rise in whaling activities. When the historian Hector St. John de Crèvecour visited the island in the 1772 he was struck by the industriousness of the whalers who had built four wharves into the harbor, capable of handling 300 vessels, surrounded by count-ing houses, tryworks, boat building and blockmaking shops. When the fleets were successful, he observed that the tempo of business would make one imagine Nantucket to be the capital of a very large and opulent province and not, as he first thought, merely a large sand dune fertilized by whale oil.

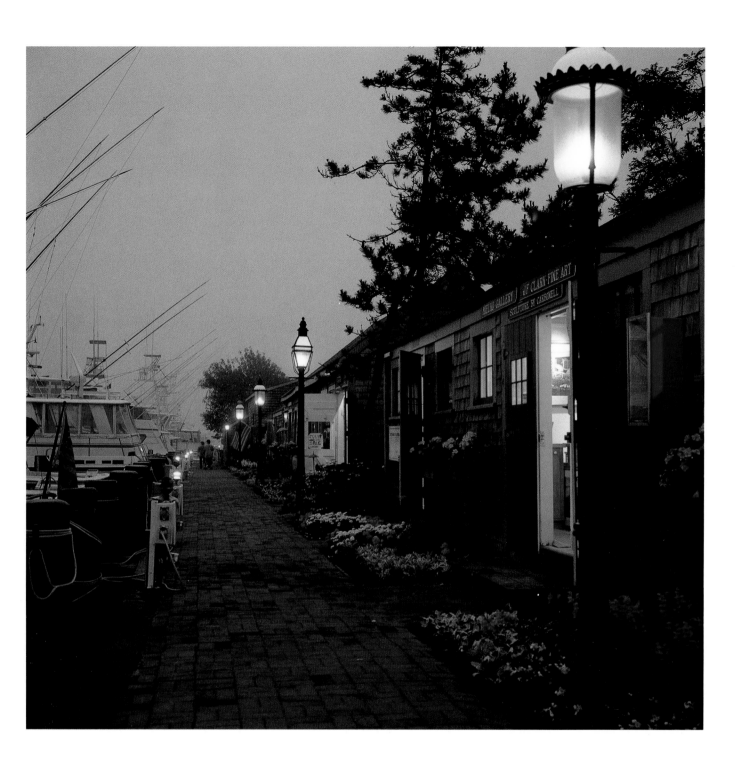

In the early 1900s Old South Wharf was known as Island Service Wharf and its owner, Henry Lang, turned it over to the government during World War I. Most of the artists' studios on the north side (pictured here) were fishing shacks and boat houses that date from the 19th century. When the wharf was refurbished in 1967 as part of the marina project, they were scheduled to be torn down. But Walter Beinecke decided to move them onto the parking lot of the new A&P during construction and sent them back with a new old look. Visitors along South Wharf have difficulty distinguishing the new structures from their elderly cousins.

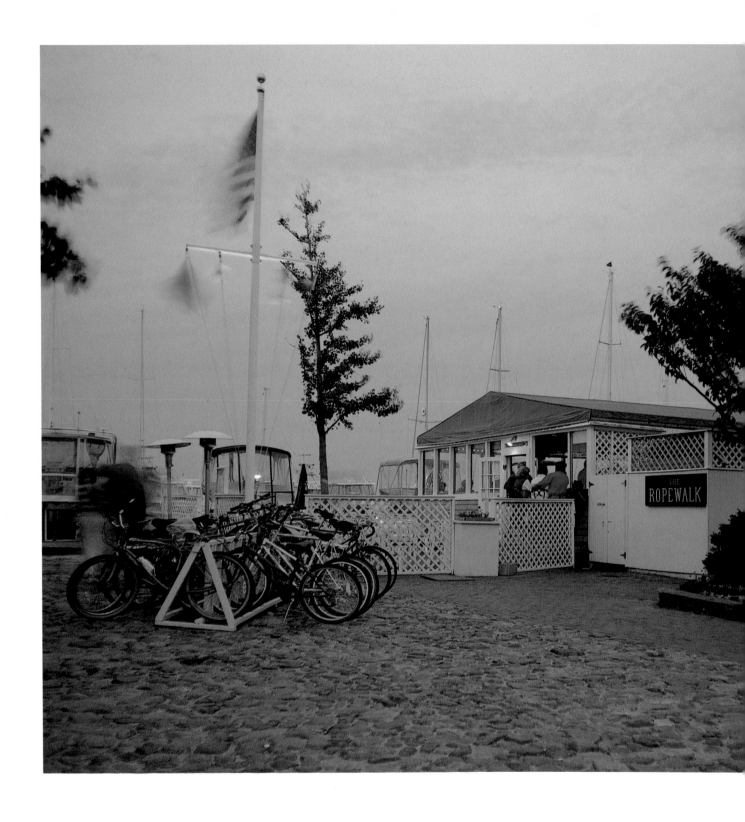

At the end of Straight Wharf. Many of the commercial buildings on the wharves have been greatly altered over the years or torn down. A grain elevator and fishing shacks have been saved and restored on Old South Wharf as part of the marina project. Two brick commercial buildings along Main Street/Straight Wharf were preserved—the Rotch Market (1772) and the Thomas Macy Warehouse (1846). Most of the other commercial structures of the 18th and 19th centuries have been replaced. The restaurant

above occupies a former livery garage. It is called The Ropewalk and is one of a succession of recent entertainment spots using this name. In the early 1800s Nantucket had 10 ropewalks in operation at one time, so important were hemp rope and lines to the rigging of the whaleships. Ropewalks were long covered sheds where the fibers were laid—varying from four-strand howsers to whale lines. They were not measured in feet or yards but in fathoms, a unit equal to six feet.

The galleries on Old South Wharf are arranged asymmetrically along an open courtyard. Some push forward, others recede, all ringed with colorful flower beds and dotted with summer artists and their easels.

Robert Perrin was one of the first artists to locate on what was then called Island Service Wharf. Sybil Goldsmith had a studio and many others have since followed including Greg Hill, Donn Russell, Barbara Cocker, Tom Meilko, Kerry Hallam and David Hostetler.

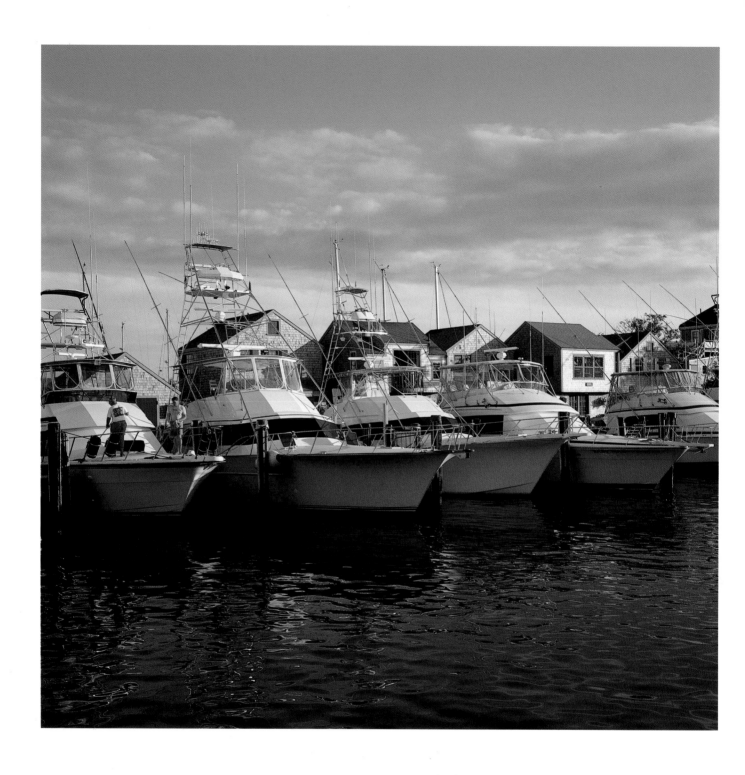

Pleasure craft at the Boat Basin. The origins of sailing for pleasure are unknown. In the mid-1600s, Charles II introduced yachting to England, incorporating the Dutch word *yaght.* The Dutch, a leading maritime power in this era, had developed the small and fast *yaght* for a variety of purposes, including sailing simply for pleasure. Adrian Block's *Onrust* may be considered the first *yaght schip* built in America (1614) in order to take the Dutch explorer back to Holland (by way of Block Island). In England the first yacht club was organized in 1775 and in the U.S. (the New York Yacht Club) in 1844. The Nantucket Yacht Club traces its origins to 1890. Commodore John Stevens of the New York Yacht Club, together with his brother Robert, fostered the design of yachts using new mathematical and scientific principles and were instrumental in developing yachts as we know them today—not just downsized schooners but sleek-hulled sailing craft known for both speed and grace.

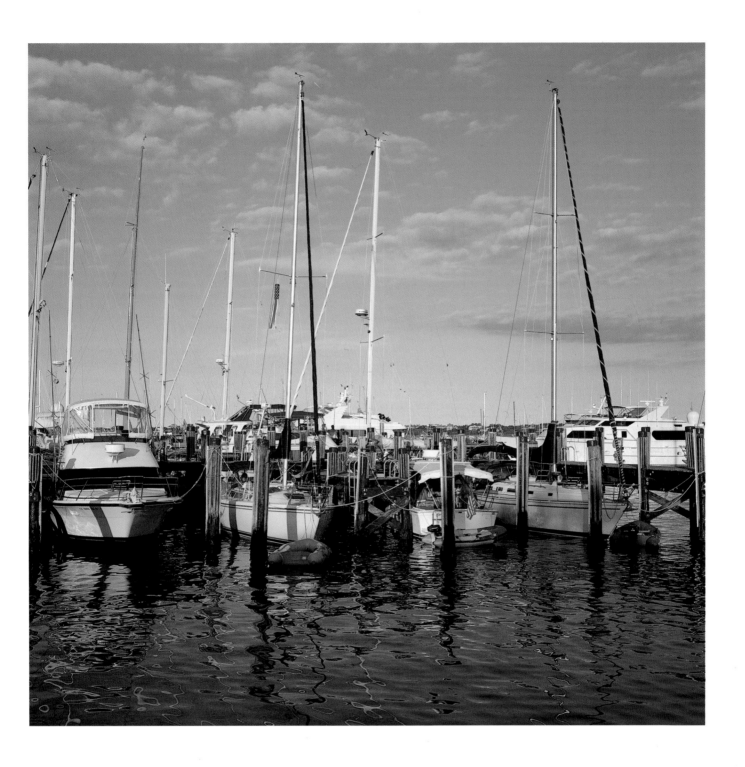

The past 100 years have seen commercial schooners and sloops being altered, as fishing vessels have given way to racing and day sailing. The motor yacht, however, is a more recent invention. Ole Evinrude developed a detachable rowboat motor in 1909 but the more affluent were drawn to the large steam yachts. The Vanderbilts were among the most prominent yachting dynasties, where comfort, style and unlimited wealth produced extraordinary showpieces, reaching lengths of over 400 feet by 1930. Since World War II, however, power boating has become a truly democratic pastime. The evolution of more sophisticated engines, starters, navigation equipment and materials has caused the number of Americans involved in boating to increase from about 5 million in 1950 to over 60 million today.

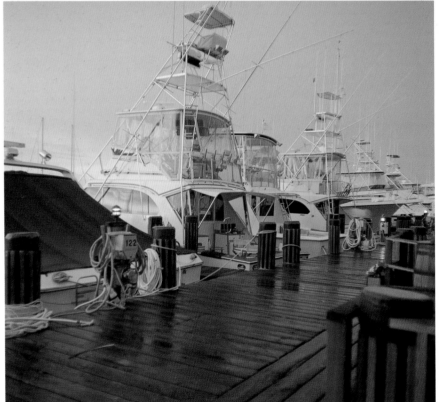

From the quietly purring Chris-Crafts, their mahogany sides shimmering in Adirondack waters, and the floating salons of the 1920s with their wind-up Victrolas, the motor yacht has come a long way. Today's towering entertainment centers tackle the most arduous waters and yet, in keeping with yachting tradition, make the day's catch incidental to reaching the night's next port of call.

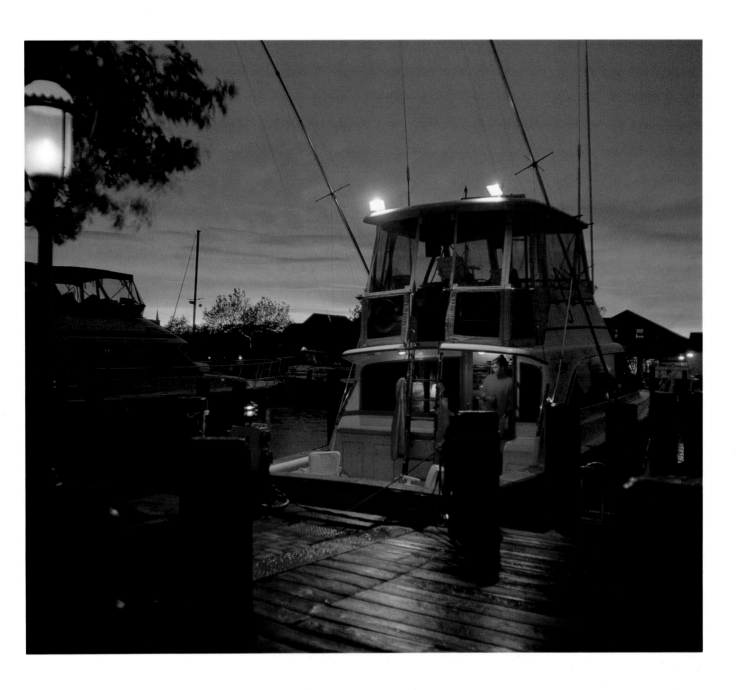

The Nantucket Boat Basin was constructed between 1967 and 1969. Presently it has 243 slips accommodating yachts from 19' to 210', the average size being 42'. The Boat Basin is considered one of the premier ports of call for the "mega yachts," boasting more of this class than any other marina on the East Coast. On a typical summer night there are over two dozen yachts exceeding 65' and at least ten over 110' in length. Most of the visitors are from New York and Connecticut as well as Maryland. The average stay is two to four nights. During the off-season the marina is occupied by local fishing or scalloping boats. Two events in August attract large sailing vessels—the Opera House Cup Race, open only to wooden-hulled sailboats, and the Broward Rendezvous. The latter craft range from 72' to 130' and, since their introduction in 1956,

have become the finest mega yachts built in the United States today. The largest one, the *Pegasus,* has three decks and a flying bridge. Broward manufactures approximately eight yachts each year.

Many of the sport fishing motor yachts (such as the one shown here) calling on Nantucket today are in the 48'–61' range. They are used both for serious fishing (blue marlin and swordfish as well as bluefish off Great Point), and also for travel and living aboard as a summer residence. During the winter their owners tie up in Florida and don coats and ties for afternoon cocktails on each others' brigs. But during the summer it is a different story: shorts, golf shirts and flip flops are the marina dress—until it is time to go out to dinner, that is.

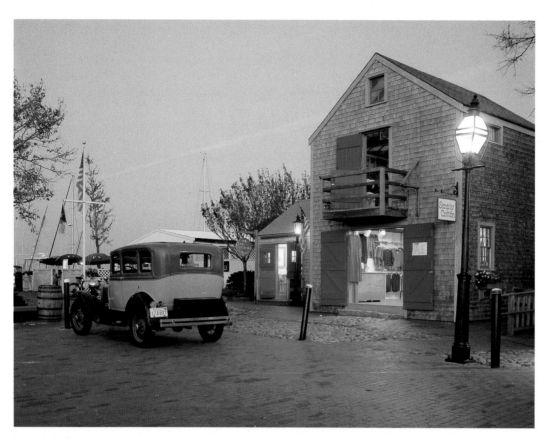

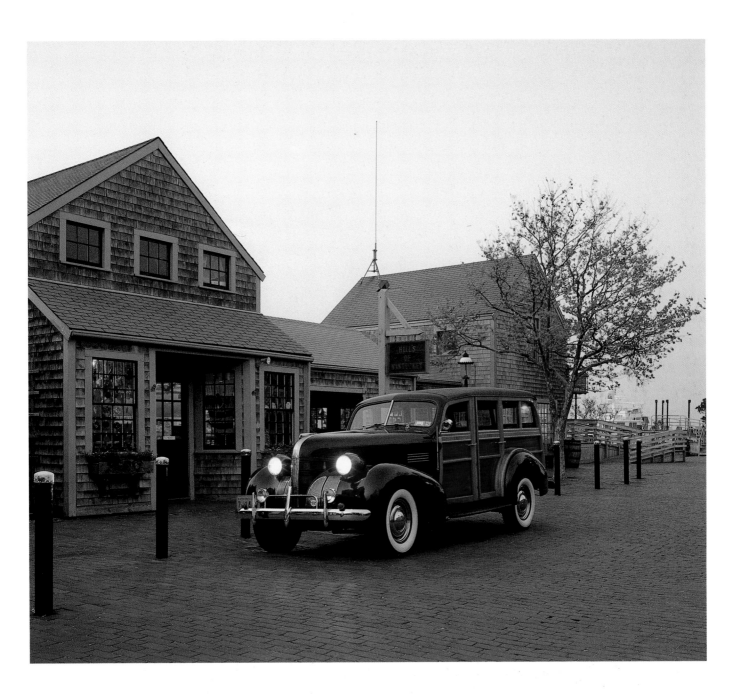

Opposite, top: A 1931 Ford Model A Town Sedan on Straight Wharf. This car was somewhat daring for Mr. Ford: it was no longer offered only in black but could also be obtained in gray.

Opposite, bottom: Slightly more out-of-reach is this 1932 Packard Model 901 sedan.

Above: A 1939 Pontiac Quality Six station wagon. The body was made by Hercules and of the 800 wagons made, only four are still running. Pontiac's famous Indian head ornament is here, serving as the hood latch. The car is named for the chief of the Ottawa tribe, an important leader in the Great Lakes area, and also for a Michigan city known as a manufacturing center for wagons and buggies. The Pontiac marque was introduced in 1926 as a less expensive version of its Oakland. Cadillac, named for a French colonist who first settled in Detroit in 1701, brought out a down-scaled car called the La Salle in 1927, after the Frenchman who had grabbed Louisiana in 1682. Buick had the Marquette and Oldsmobile the Viking. Of all these companion cars, only Pontiac has survived, and of course it replaced the Oakland.

73

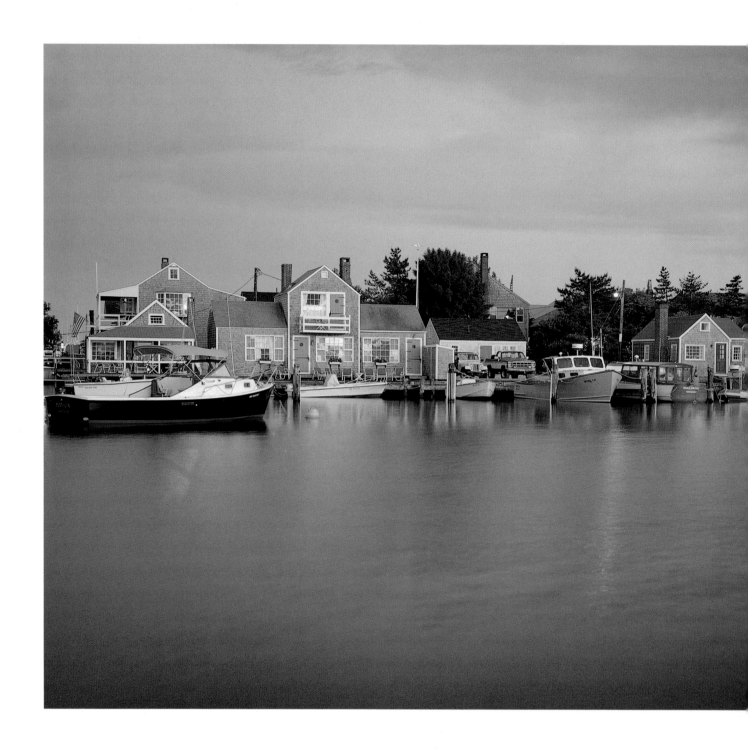

The best way to approach Nantucket is by sea. Rounding Brant Point, the entire town displays itself all at once, in a broad panorama of wharves, buildings and sailboats. The harbor is alive with the activity of sails and flags during the day. At evening the lights of the wharf cottages and ships take over. In the background are the two belfries of South Tower and Old North Church, sentinels to this extraordinary scene for over 150 years.

Nantucket's appeal to summer vacationers came only at the end of the 19th century as the country became more aware of leisure time. Prior to the Civil War the United States was largely an agrarian economy and families could not afford vacations. Wage earners frequently worked both Saturdays and Sundays. Only the wealthy had country estates. But in the 1870s a period of prosperity and expansion began. The combination of rail transportation, industrial production and mechanized farming created a new middle class of white-collar workers who had both the time and resources to vacation.

Nantucketers recognized this trend and invested precious capi-

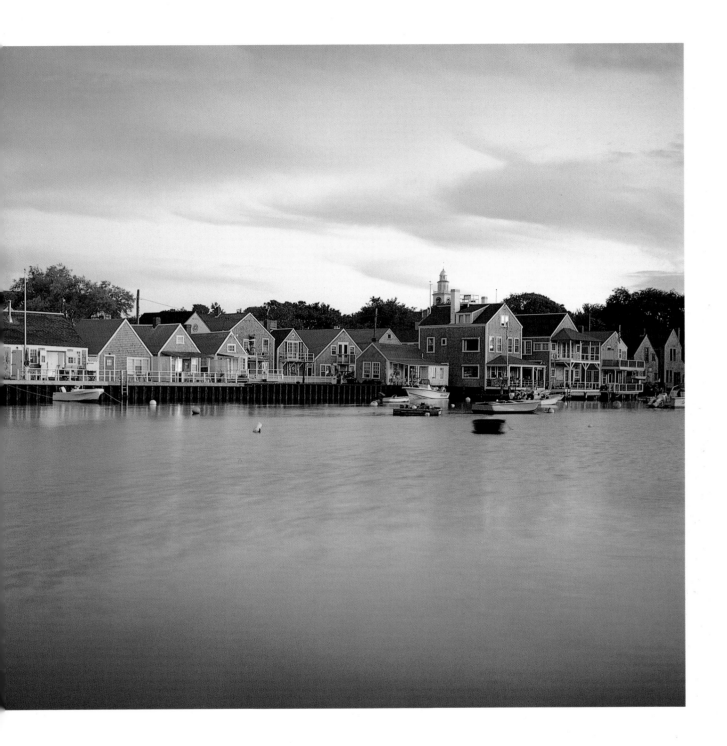

tal in refurbishing or building new hotels. These had large dining rooms that could provide a wide choice of entrees, wines and liquors, as well as capacious public rooms for dancing, parties and meetings. Thus began the island's summer business.

Sailing for pleasure came more slowly. Before World War I the harbor had few recreation facilities. All sailing was commercial. Large catboats such as the *Lilian*, which would run daily excursions to the Wauwinet House, tied up in the area previously occupied by the Skipper Restaurant called Catboat Basin. Even the rail-

road line from Steamboat Wharf went around this important fishing enclave. Bathing at Children's Beach was considered foolish and the Nantucket Athletic Club offered no outside activities at all. But with its reorganization as the Yacht Club in 1920 and the increasing popularity of tennis and swimming, all of this began to change. And Nantucket's commercial business of fishing and agriculture became subsidiary operations.

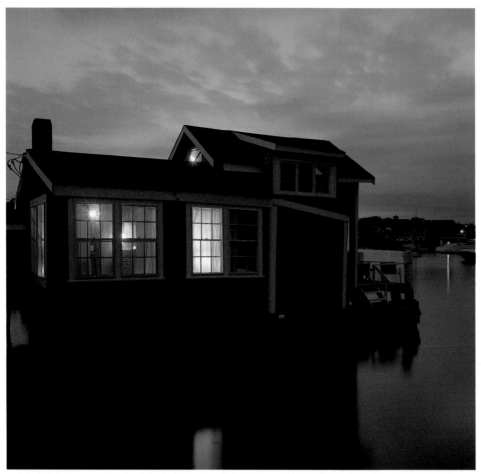

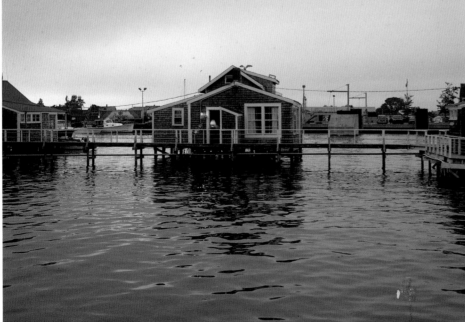

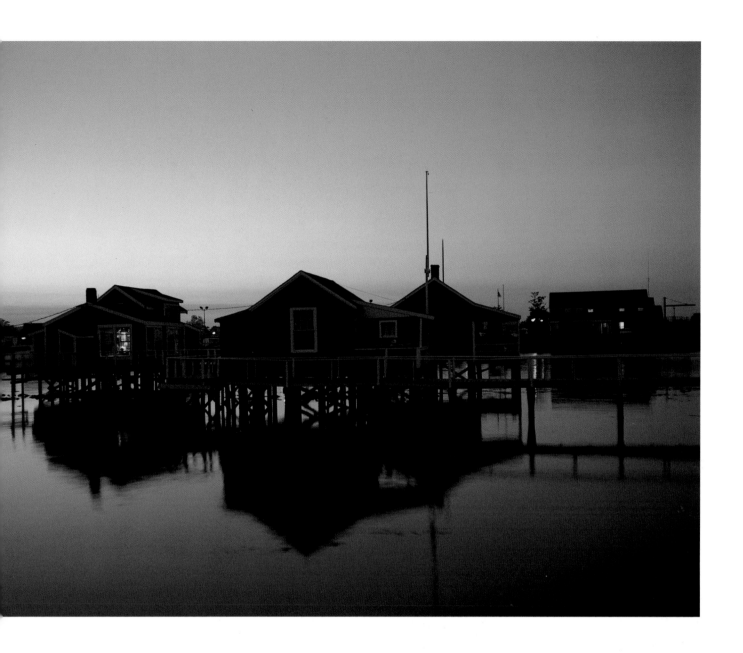

North Wharf. Here in the harbor the architecture of the houses merges with the boats; the cottages reach out to the water's edge and over it. There are no street boundaries. The cottages shown in the photograph above are, from the left, "Omega," "Zenas Coffin," "Peru," "Seaquin," and "Edward Cary." The "Seaquin" was originally used by its owners as a teahouse while the "Peru" was the ticket office and landing stage for the *Lilian* which made daily excursions up the harbor. Many of the structures have been rebuilt after the violent "no-named" storm of October 30, 1991.

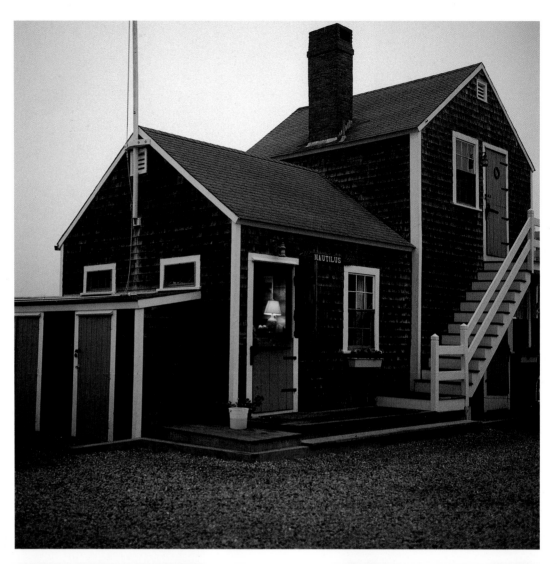

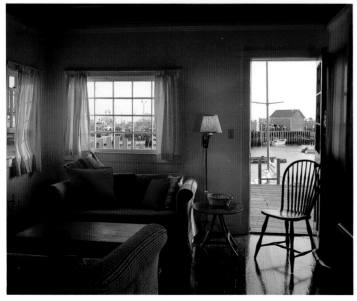

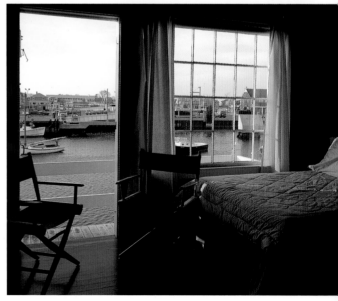

Above: "The Barnacle" on Swain's Wharf (*ca.* 1870). This is one of the few remaining private homes on Swain's Wharf. Obed Swain was the wharfinger when it was reconstructed in 1850. The wharf was originally built by Zenas Coffin and Sons in 1816 and extended in 1831. It has a solid foundation of granite blocks brought from Connecticut, the only Nantucket wharf so constructed. Charles and Henry Coffin had a brick warehouse at the foot of the wharf which more recently has served as the American Legion headquarters. During the reconstruction of the wharves (1967–1969) work continued along Swain's Wharf to Washington Street. Telephone lines were buried and cobblestones re-laid but unfortunately gas tanks still cohabit with artists' galleries.

The car is a 1940 Chevrolet Special Deluxe.

Opposite, top: One of the larger cottages on Old North Wharf is "The Nautilus," named by the Sanford brothers after the spiral mollusk as well as Jules Verne's sightseeing vessel.

Opposite, bottom: The upstairs chamber of "The Nautilus" (*right*) offers harbor views at the edge of the bed. The living room of "The Fish House" (*left*) opens up to Easy Street Basin and the former docking area of the Skipper Restaurant which was originally based on the old sloop *Andrew Gurney*. The main mast of this ship was taken down to serve as the tail at the Old Mill in 1921. When radio transmission first came to Nantucket, Capt. Whitman ("Whitty") Riddell operated a radio shack here, running a long receiving aerial from the top of the cottage across the water to the Skipper.

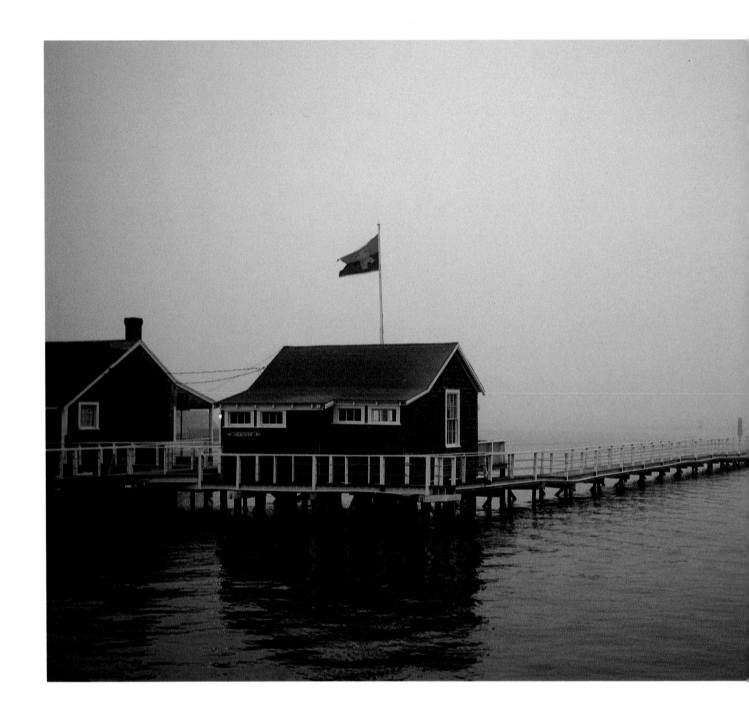

The arms of North Wharf (*left*) and Straight Wharf reach out to welcome the evening arrival of the Hy-Line's new *Great Point*, seen in the mist. This view is taken from what would have been the end of Still Dock, a waterway between North and Straight Wharves that was filled in around 1834 and has a narrow road servicing shops and residences on the two wharves.

The activity is quieter now than during the whaling years. The latter business was labor-intensive in a variety of ways, with the wharf fronts taken over by outfitting the ships as well as handling their return cargo. In the late 18th century Nantucket sent increasing numbers of ships and men to sea as the demand for

headmatter grew. (Headmatter was the common name for the waxy substance, spermaceti, found in the large cavity of the sperm whale's head, used for candles and whale oil lamps.) From 25 ships in 1730 the fleet doubled by 1748 and was over 200 by the 1760s. At the time of the Revolutionary War over 150 ships were setting out to sea each year, employing over 2000 seamen, approximately the same as the year-round adult male population today.

The city of London ordered the installation of street lamps throughout the city, for the safety of its citizens, and by the mid-1740s it was considered the best lit city in the world. Birmingham

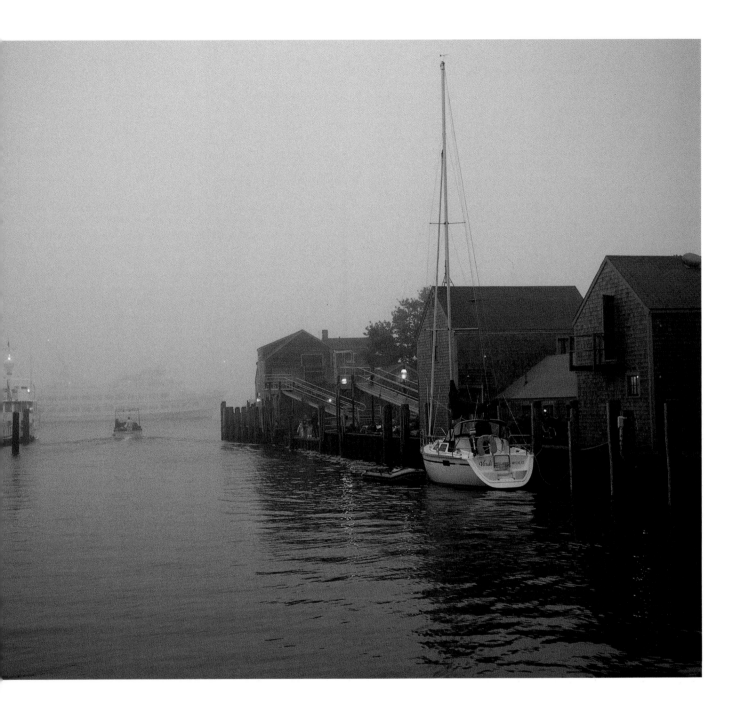

and other cities installed lamps on the main streets and around the docks, warehouses and mills. Whale oil was also sought by industry. The expanding textile industry, for example, employed large quantities of oil in cleaning wool prior to spinning.

At the same time, New England's appetite for Nantucket whale oil grew due to the development of the candle industry. Although sperm whales had been pursued since the early 1700s, the establishment of a spermaceti candle manufacturing industry increased their value.

In 1751 a Newport resident, Jacob Rivera, developed a technique of using headmatter in candlemaking, separating the oil from the spermaceti through an elaborate pressing process. The results were significant because the candles gave a brighter light. Other candle factories were established in Rhode Island and Massachusetts, totalling 12 by 1763. And yet only 3 or 4 could process all the precious headmatter caught in a typical year. It was thus a seller's market which Nantucketers were able to recognize. Both William Rotch and shortly thereafter Joseph Starbuck realized that candlemaking was an integral part of the whaling process and provided them with successful vertical integration.

Above: Summer dusk at the Boat Basin shows a range of modern fishing craft as well as a touring yacht at the end.
Right: The small "Seaquin" is decorated for the July 4th festivities.

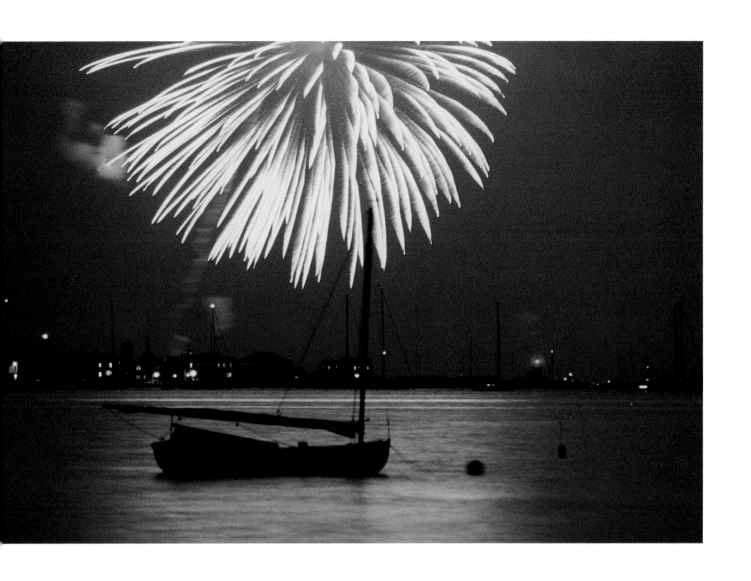

Fireworks at the Jetties Beach light up the July 4th sky. This popular event has not been without its share of challenges from both the weatherman and the purse keeper.

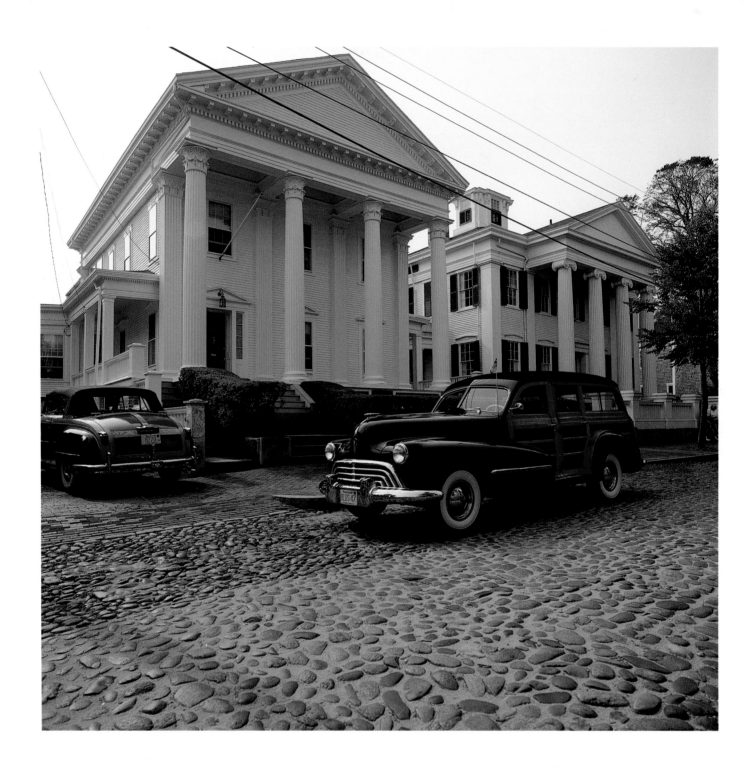

The William Hadwen houses, 94 and 96 Main Street (1840–1845). These Greek Revival houses, built by a wealthy silversmith and merchant, are the most dramatic of the Main Street homes. Note the unusual Corinthian capitals of No. 94 which, together with those at the Westmoor Inn, are believed to be the only such capitals on the island. The entablature above has bold dentils and modillions. The style of No. 96 with its simpler Ionic moldings is a bit quieter. Hadwen lived at No. 96 and his niece, Mary Swain, at No. 94.

Parked in the front is a 1947 Oldsmobile 66 station wagon, one of three running out of a production of 968 units. The car has Hydra-Matic Drive which Oldsmobile pioneered in 1940.

Nantucket Architecture

Nantucket is a unique architectural treasure. Its houses sit side by side, each a bit different from the next, none clamoring for attention, and all strung together with fences and sidewalks. They were all built on an island thirty miles at sea without native trees large enough for structural timbers or flooring. Everything was imported, and great care was taken to get it right the first time. They were carefully maintained and occasionally picked up and moved. Houses would burn but were rarely torn down. The island is one of the largest and finest historic districts in America.

Several distinctions may be made about these homes. First, many have a unique glass transom over the interior doors, probably to detect fires. And since the fire was the chief source of light and warmth, it was a constant presence and threat. Second is the rooftop walk, which was used either to spot incoming whaleships or to enable a busy seaman's wife to pour a bucket of sand down a burning chimney. And third is the absence of the overhang, which was popular elsewhere on early New England homes, and the absence of the popular Cape Cod cottage, which sprang up throughout the Northeast.

A stroll along upper Main Street offers an architectural experience unparalleled anywhere else in New England. All of the homes on this street were built with whale oil. Most of the wealth was accumulated by the whale merchants and investors rather than the captains themselves. Zenas Coffin and Joseph Starbuck were two such men, and between them they account for thirteen of the most prominent Main Street residences. Zenas Coffin was one of the wealthiest men in America at the turn of the nineteenth century. His sons lived at Nos. 75 and 78 Main Street, while his daughters occupied Nos. 90, 91, and 99 and his granddaughters Nos. 86 and 98. Joseph Starbuck built three matching brick houses for his sons, Nos. 93, 95, and 97, while his daughters lived across the street at Nos. 92, 96, and 100.

The Macys were not to be outdone by such display. Francis, George, Silvanus, Thomas, and Zaccheus all lived along the street (Nos. 77, 86, 99, and 107, respectively), although it should be noted that Thomas married a Zenas Coffin girl and George a Zenas Coffin granddaughter.

The original Nantucket settlement was at Sherburne, between Capaum Pond and Hummock Pond. Capaum was open to the north shore at the time and afforded a protected harbor. When a storm closed it off in the latter part of the eighteenth century, the inhabitants

gradually moved to a new site called Wescoe, which is approximately where Nantucket is today. Because of the tremendous scarcity of wood, many houses were simply picked up and relocated; it was cheaper to move than to build. (In fact, Herman Melville observed in *Moby Dick* that Nantucketers carried their wood around as if it were pieces of the true cross.)

The Elihu Coleman house, built in 1722 (*129*), is the only homestead remaining on its original site in Sherburne. The Christian house of 1720 on Liberty Street was moved into town in its entirety in 1741 by its owner Thomas Macy who then gave it to his son Nathaniel. Similarly, the eastern section of the Christopher Starbuck house (*110*) is thought to have been built in Sherburne in 1690. The western half dates from around 1715. Sections of the Zaccheus Macy house (*113*) and the Josiah Coffin house (*131*) were also brought over from Sherburne.

As the community moved eastward and began to settle at Wescoe, the houses were located closer together and right on the street, in the English style. This is in contrast to other New England towns where houses often were set back behind lawns or gardens. As a result, Nantucket developed quickly into a city as opposed to a village. Even at the peak of whaling prosperity, Nantucketers preferred to build their stately homes right next to one another as they might have done in New York or Philadelphia.

Proceeding up Main Street from the Pacific Bank, one notices two prominent homes, both of which were occupied by presidents of the bank. No. 72 Main Street (*88*) was built by John Wendell Barret in 1820. This dignified house barely survived the Great Fire of 1846, not because the flames were about to engulf it but because the fire wardens intended to blow it up to check the fire's spread. Mrs. Barrett simply refused to leave and fortunately the direction of the fire changed, sparing the house. Frederick Mitchell built the house opposite, at 69 Main Street, in 1834 (*89–91*). He was a whaling merchant and also was president of the bank.

Henry and Charles Coffin, sons of Zenas Coffin, built the identical houses at 78 and 75 Main Street between 1831 and 1833 (*94–95*). Charles was a Quaker and preferred the conservative brownstone trim, whereas Henry had white trim and a cupola instead of an exposed roof walk. The two brothers were quite philanthropic, planting elm trees on Main Street in 1851 and bringing a wide variety of wildlife to the island at about the same time (including over forty thousand English pine trees).

The rooftop walk, like the one on the Sidney Chase house at 82 Main Street (*92*), was an essential part of Nantucket architecture, enabling the women to watch for the return of their sailing husbands. They have often been called "widows' walks" which is a mistake because clearly if a woman were indeed a widow she would have no need to be up there. George Macy lived at 86 Main Street (*92*), which was built in 1829. Note the similarity between this and Thomas Macy II's house at 99 Main Street, built two years before in 1827 (*108*). Both Crosby and Macy married Zenas Coffin girls. Captain Job Coleman lived at 88 Main Street (*92*), a home which dates from about 1830. He was one of the first to sail for California in 1849 at the beginning of the famous rush for gold.

The three identical houses located at Nos. 93, 95, and 97 Main Street (*99–101*) are commonly referred to as the "Three Bricks." They were built between 1836 and 1838 by Joseph

Starbuck for his three sons, William, Matthew, and George. Matthew's house, the "Middle Brick," still remains in the family. Joseph Starbuck's daughters lived directly opposite the "Three Bricks" at Nos. 92, 96, and 100. The first of these houses was built in 1838 by William Swain. The second, along with its companion next door, No. 94, was constructed between 1840 and 1845 by William Hadwen, a silversmith, whale oil merchant, and a candle maker (*102–107*). The refined Greek style of these houses, which were designed by Frederick Brown Coleman, represents the zenith of whaling prosperity. No. 94 has a second-floor ballroom with a specially sprung dance floor and a rooftop dome that can be opened to the stars.

While Orange Street (*162*) boasted the reputation of being home to 126 whaling captains, it was Pleasant Street that rivaled Main Street for expression of whaling wealth. John Coleman designed the two graceful homes at Nos. 7 and 9 during the early 1820s (*151–152*). His brother, Frederick, designed the Greek Revival mansions on Main Street about twenty years later, as well as the Baptist and Methodist Churches and the Atheneum, the last being probably his greatest achievement (*204–205; 48; 34–35*). Both architects were noted for their excellent taste, proportionate designs, and their carving and finishing skills. They were two of the most influential men to shape the face of Nantucket. William Crosby and his wife lived at One Pleasant Street (*150*), a home which was completed in 1837. It became known as Nantucket's "social center," with the Crosbys entertaining regularly. The house was decorated with marble mantlepieces, French doors, and silver doorknobs.

"Moor's End" was built between 1829 and 1834 by Jared Coffin (*153–155*), who had accumulated a fortune through partnerships in three successful whaleships. Mrs. Coffin felt it was too far out of town and convinced him to build another home in town in 1845 (*146–147*). A year later they packed up and moved to Boston, again most likely at her request. "Moor's End" was sold and resold many times. Finally in 1873 it was put up for auction and Jared Gardner bought it for $2,350. (He also bought the Old Mill in 1822 for twenty dollars and was going to use it for firewood, but later changed his mind when he saw how difficult it would be to take apart.) "Moor's End" is probably the island's most beautiful home, and it was practically given away—an indication of the extreme poverty that had befallen the island at that time. While the values of this and other fine homes were unusually depressed in the 1870s, it is interesting to note how inflated they have become 125 years later.

This brief commentary and accompanying photographs focus on a few of the more interesting and important Nantucket residences from the whaling era. There are many more that, unfortunately, have had to be omitted but they are all still here for the visitor to see.

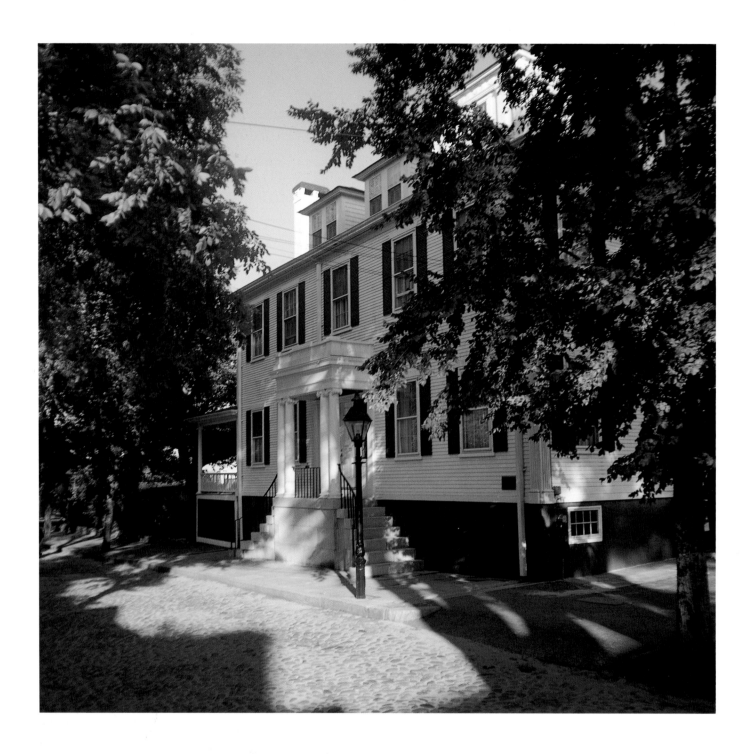

The John Wendell Barrett house, 72 Main Street (1820). The early Greek Revival style of this house shows in the pair of slender Ionic columns on the raised portico and in a pilastered observatory (not just a cupola) on the roof. The fine conservative design of this house both outside and inside helped set the pattern for later Main Street residences, a rich architectural pageant that unfolds upon walking up the street. John Barrett was a successful whaling merchant who later became president of the Pacific Bank.

During the Great Fire the town officials planned to dynamite the house in order to stop the fire's spread. Mrs. Barrett believed the fire would stop, partly because of the presence of the brick bank diagonally across the street, and she refused to leave the house! Soon the wind shifted and the fire veered to the north along Centre Street. Instead of collapsing after this trying evening, Mrs. Barrett organized supplies of coffee and food for the firefighters.

The Frederick Mitchell house, 69 Main Street (1834). Frederick Mitchell, like John Barrett, was a whaling merchant and later became president of the Pacific Bank. In 1889 Caroline French lived here. Her father owned a brick warehouse with Benjamin Coffin on Washington Street now known as American Legion Hall. Miss French was a principal benefactor of St. Paul's Church, and for a while the house served as its rectory and later as a "church haven" for the clergy from 1914 to 1955.

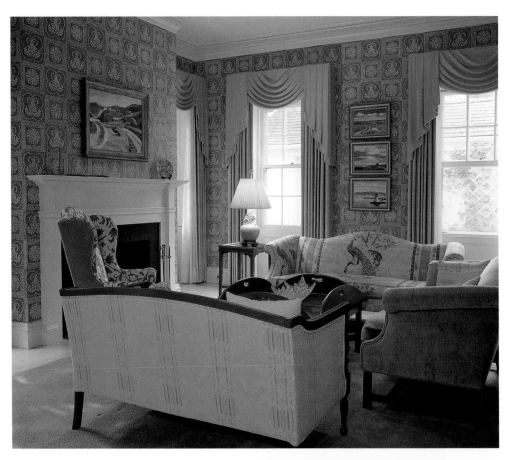

The Frederick Mitchell house is of English Georgian inspiration with parlors on either side of the central hall. Paintings by the owner are hung here.

The rear parlor is used as a library, and the dining room is now an adjoining wing.

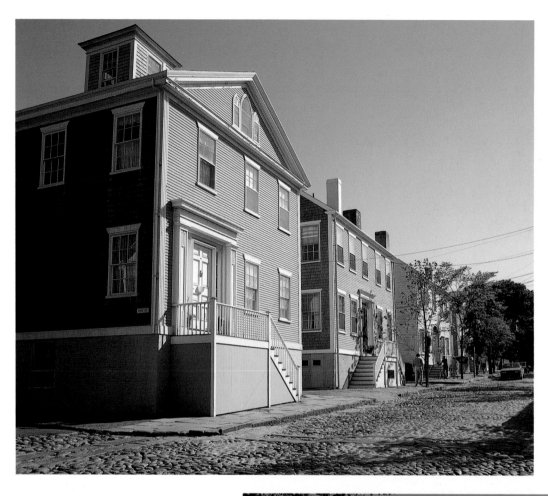

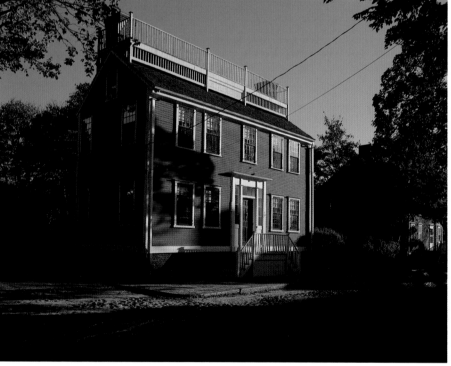

Above: The George Macy house, 86 Main Street (remodelled *ca.* 1834 for Ann Coffin Crosby), the Job Coleman house, 88 Main Street (*ca.* 1830), and the Matthew Crosby house, 90 Main Street (1829). By the early 1830s cupolas had become popular, as may be seen on the George Macy house above, probably influenced by Henry Coffin's house built across the street the year before.

Right: The Sidney Chase house, 82 Main Street (1820), with a simple yet elegant roof walk running the entire length of the house, chimney to chimney.

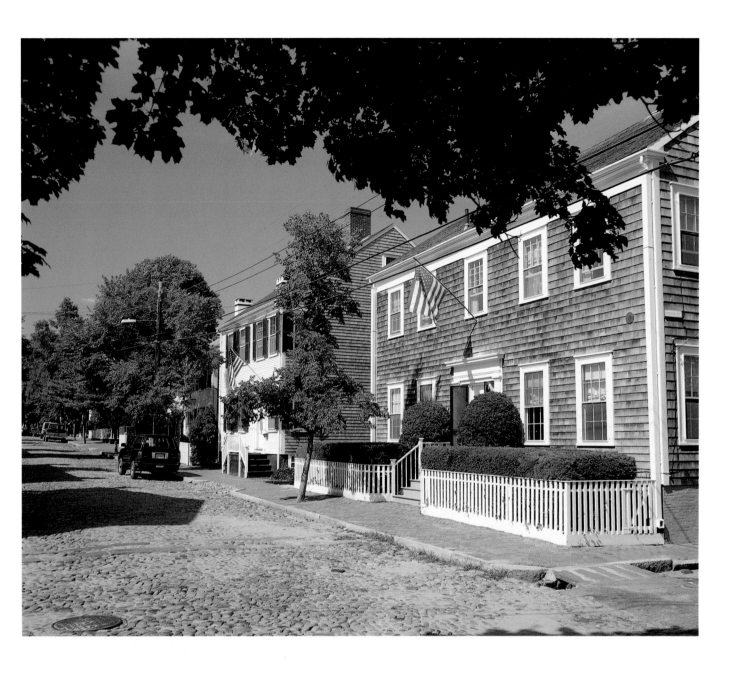

The Jabez Bunker house, 85 Main Street (*ca.* 1725, 1795), the Charles Clark house, 87 Main Street (1830), and the Silvanus Macy house, 89 Main Street (1740, 1875). The beauty of the town is its architecture—street after street of sturdy, self-reliant structures, some simple, some grand, all trim and organized, standing side by side for over 150 years. Main Street is as handsome a thoroughfare as anywhere, but it is not the only one. Pleasant, Orange, Liberty, Union—all offer a rich architectural vocabulary but speak a common language.

Main Street is the same as a century ago except for the cars—moving at a snail's pace in deference to the cobblestones that nearly shake the tan off drivers. Cobblestones were first laid in 1831 on Lower Main Street as well as Broad, Centre and Orange Streets in order to enable the carts to move up to the shops from Straight Wharf more easily. By 1852 they had reached Pleasant Street. Cobble is an Old English word for loaf or lump. The stones are warm to the eye but hard on the feet and bicycle. They slow cars to a proper, leisurely pace.

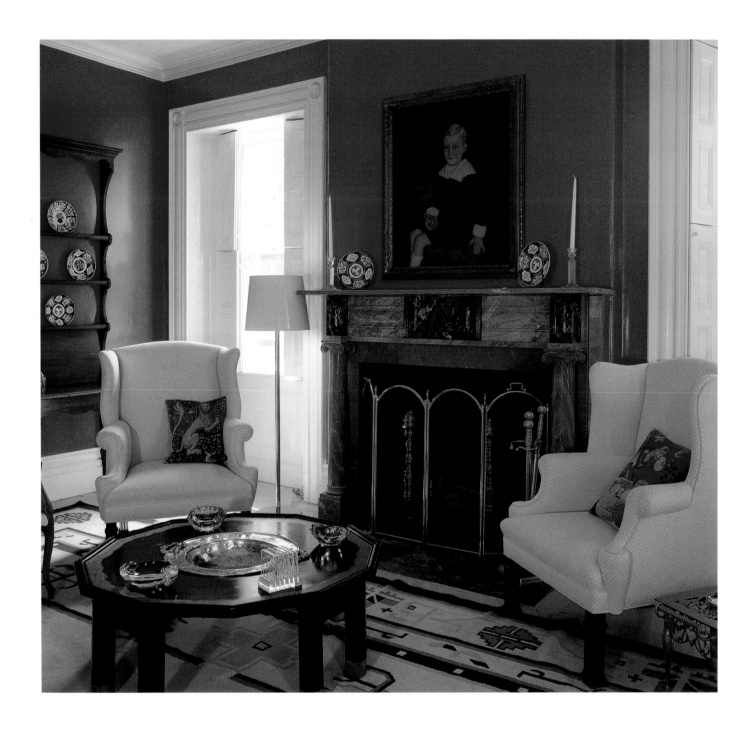

The Charles Coffin house, 78 Main Street (1831). This was the first Main Street house built entirely of brick. Henry Coffin built a residence across the street at No. 75. Both were sons of Zenas Coffin, one of the wealthiest men in America in the early 1800s. They carried on his business and were the last whaling merchants to close their books. Charles, a Quaker, selected a house with brown trim, set back behind a "sheath of wheat" fence, whereas Henry had white trim and a cupola instead of an exposed roof walk. The car is a 1939 Pontiac Quality Six station wagon.

Herman Melville served as a crew member on board the Coffins' *Charles and Henry* during 1842–1843. In 1842, their *Constitution* was the first to use "camels" successfully in exiting the harbor after a prior attempt had resulted in broken chains and damage to the ship that took a year to repair. The Coffins recognized the importance of the new technique of using camels to float ships over the sandbar at the mouth of the harbor. They worked closely with designer Peter Ewer to correct the problems. Charles and Henry were also public-spirited men, Charles founding the Atheneum library and Henry planting many of the elm trees around town.

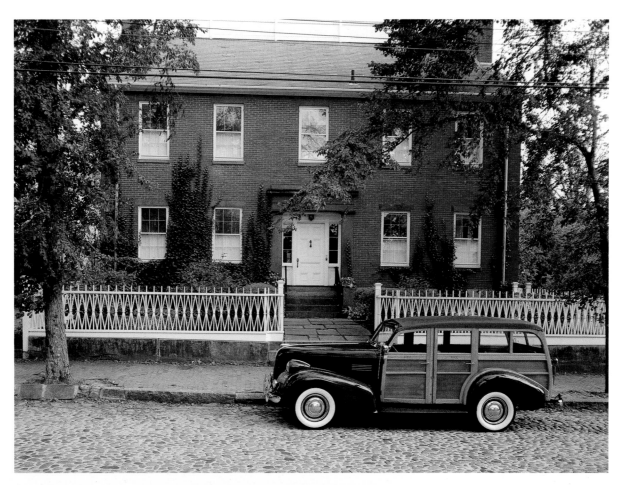

The Matthew Crosby house, 90 Main Street (1828). This house is very similar to the Thomas Macy II house at 99 Main Street (1770, 1830). Both gentlemen had married Zenas Coffin's daughters and were thus brothers-in-law of Charles and Henry Coffin.

Upper Main Street from Pine to Pleasant was known as "Court End" in the mid-1800s. Most of the houses were built in the Greek Revival or Georgian style. The Starbucks, Coffins, Macys, Crosbys, Hadwens, Barneys, Swifts and Swains had such a close family relationship that it was a neighborhood of in-laws. This house is an excellent example of the Federal style which prevailed until the early 1830s. Doorways became more elaborate with recessed porticos. The roof pitch was more gradual, emulating the flat roofs of the Italian palazzos. Also copied from the Italians were balustrades, cupolas, louvered shutters (which were designed to block out the hot southern European sun and were used in Nantucket and throughout New England without discrimination). The sideboard and dining table in the photograph are Sheraton pieces acquired on Nantucket many years ago. The pictures are of Admiral Perry's Great White Fleet.

The William Swain house, 92 Main Street (1838). Mary Swain was the granddaughter of Joseph Starbuck who built houses for her uncles across the street. These views show Nantucket interiors of the 1880s. The portrait of the young woman in the ornate frame (*above*) is believed to be by Thomas Sully, the 19th-century Philadelphian portrait painter, while Grandmother Halsey looks down on the piano keyboard in the front parlor (*right*).

The gardens of 99 Main Street (*above*) and 96 Main Street (*left*), both Nantucket Historical Association properties. The Nantucket Garden Club maintains the gardens behind No. 96 in the style of the period. Included are golden yarrow, dittany, thistle, coral bells, bee balm, phlox and candytuft.

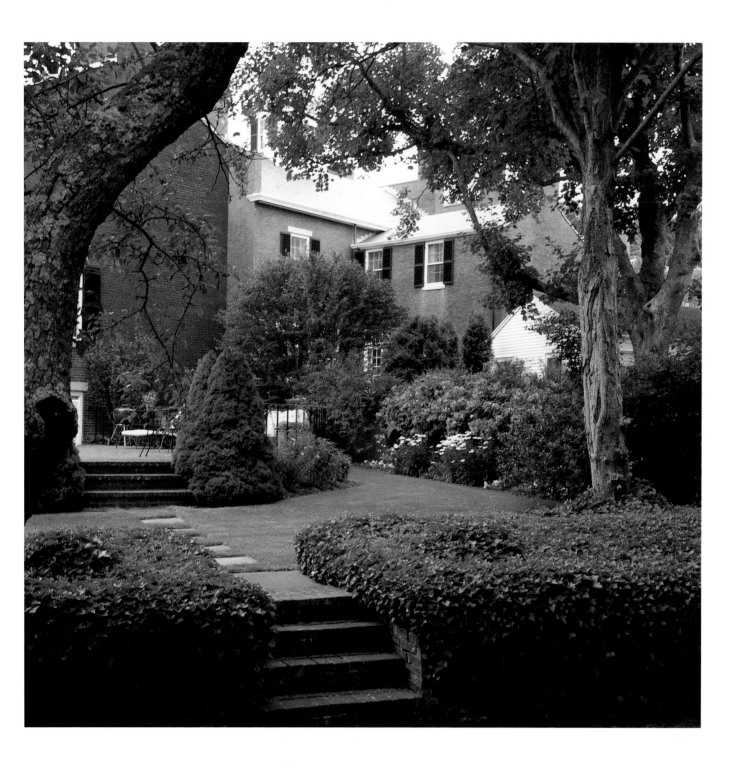

Behind the "Middle Brick," 95 Main Street (1838). This garden is rich with the foliage of andromedas, holly, rhododendrons and azaleas. The home was built by Joseph Starbuck for his son Matthew, who was twenty-two at the time. He became the true successor to his father's business and his house is one of the few on the island still in the family.

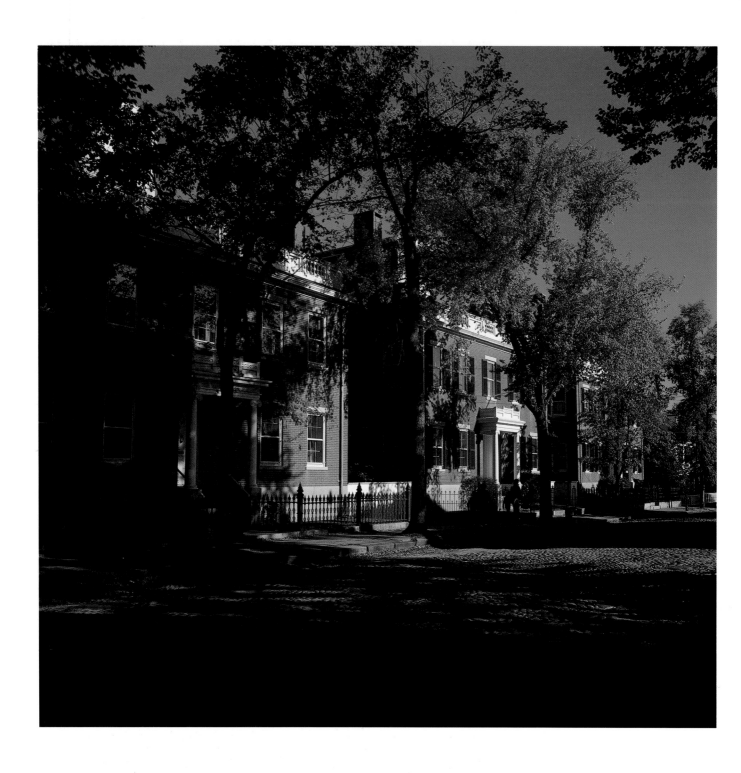

The "Three Bricks" at 93, 95 and 97 Main Street (1836–1838). These identical homes were built by Joseph Starbuck, the most successful whaling merchant of his time, for his three sons William ("East Brick"), Matthew ("Middle Brick"), and George ("West Brick"). With the launching of a new ship, the *Three Brothers*, in 1833 the family had seven successful, consecutive voyages from 1833 to 1865. All three houses are built in the Federal-Greek Revival style, with four end chimneys, granite steps, Ionic porticos, recessed doorways and square cupolas. While Charles and Henry Coffin had similar but not identical brick houses farther down Main Street, these were all the same. They sit squarely on the street and make a bold statement. Since Starbuck was a Quaker, their style was conservative. Jared Coffin copied the style six years later, incorporating a third full story.

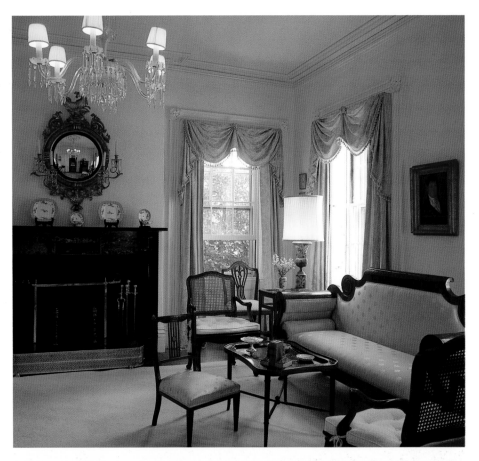

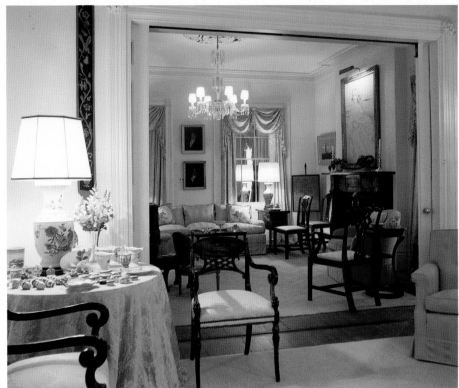

The front and rear parlors of the "East Brick" have been tastefully decorated with a soft palette of grays, greens, and beige, accented with coral and yellow. The Empire settee (*above*) is believed to have been in the house from the beginning (1837) since there is no door large enough to accommodate it.

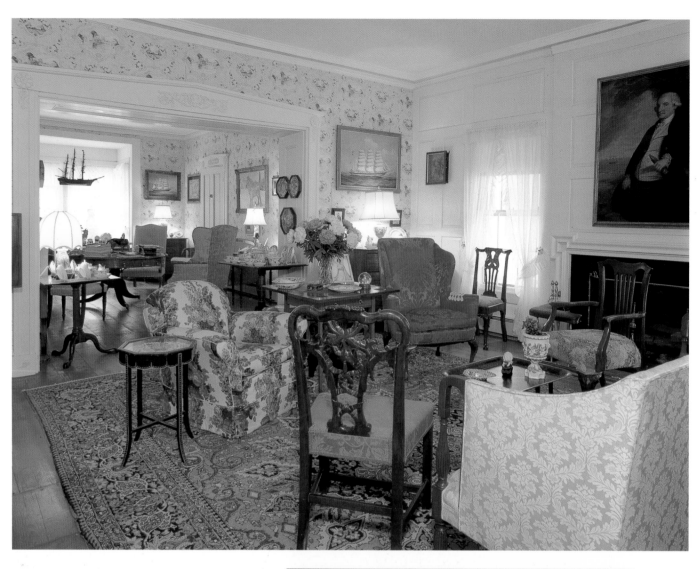

The front parlor of 94 Main Street (*above*) and the famous ballroom ceiling (*right*). The center of the dome could be removed so that dancers could see real stars on a clear evening in addition to the plaster stars or snowflakes on the dome itself. The dance floor was built with barrel-like staves which flexed under the weight of the dancers.

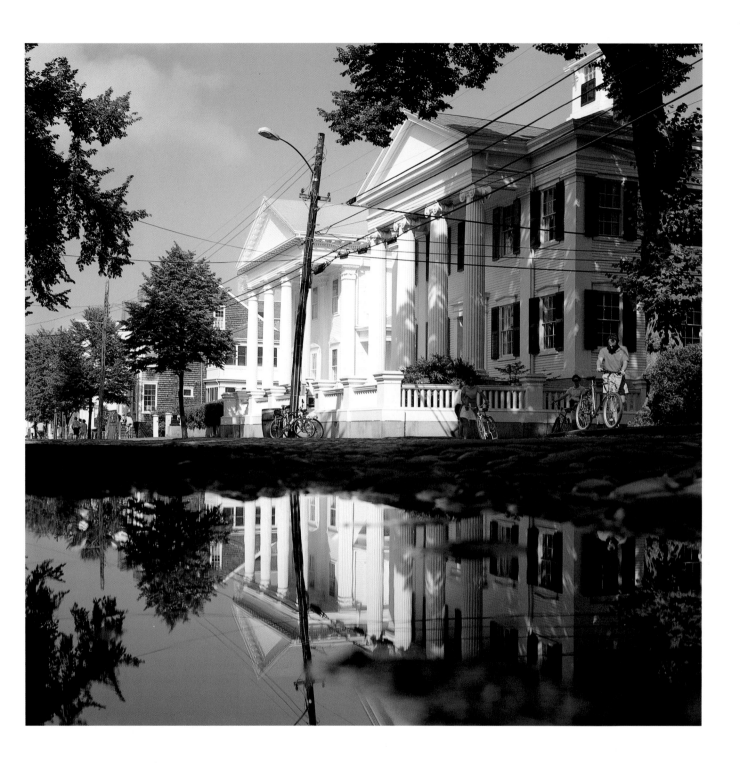

The William Hadwen houses, 96 Main Street (foreground) and 94 Main Street (1840-1845). Hadwen's silversmith and Newport backgrounds are reflected in the refined and bold designs by Frederick Brown Coleman. These represent the culmination of the Greek Revival period—a period of island prosperity reflected in sophisticated architectural design. Soaring columns, recessed porticos, and high foundations were new elements. Frederick Brown Coleman and his brother, John, greatly influenced the evolution of Nantucket architecture during the peak whaling years. These are the last major houses Coleman built (1845), although the Atheneum was built two years later.

Above: A dolls' tea party in the children's room. Joseph Barney, whose father was Hadwen's first partner in the Hadwen Barney Candleworks (now the Whaling Museum), was the second resident of the house (1864–1923). He moved into the house with four children as represented by this period display.

Right: The front parlor of the Hadwen House, 96 Main Street, showing the portrait *Elisa McArthur Coffin and Children* by James Hathaway, 1844. Below is a neoclassical sofa made *ca*. 1840.

The Satler breakfast room in the Nantucket Historical Association's Hadwen House. The third and last owners of the house were the Satlers, who owned it from 1923 to 1963. This room remains decorated as the Satlers had it. Note the unusual knife boxes on the bow front sideboard on the left. The room looks out onto a garden maintained in the style of the 1850s.

William Hadwen was born in Newport and entered the jewelry business in 1812 in Providence with Jabez Gorham. The business lasted until 1818, with Gorham continuing on his own and

Hadwen moving to Nantucket. He started his own jewelry store in 1820 and married Eunice, daughter of Joseph Starbuck, in 1822. He entered the whale oil and candle manufacturing business in 1829 with his brother-in-law Nathaniel Barney, and became quite successful. He built 96 Main Street for himself and his wife and 94 Main Street for his niece, Mary Starbuck Swain, and her husband, George Wright. Mary's parents, Mary and William Swain, lived at 92 Main Street.

Above: The rear room of the Hadwen House's double parlor, used by the Hadwens as their family dining room. Originally a dumbwaiter connected this room with the kitchen in the basement. In the background, behind the pocket doors, is the Satlers' breakfast room.

Right: Eunice Hadwen's bedroom upstairs showing a whalebone and ivory swift with initials "EH", a knitting basket and the painting *Little Nantucket Girl* by James Hathaway.

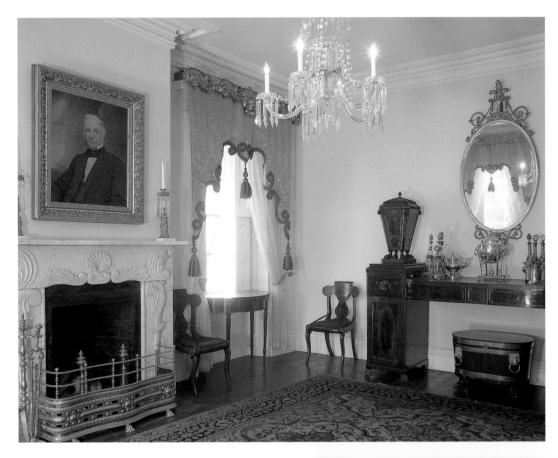

Above: The formal parlor. Over the mantle is a portrait of William Hadwen and against the back wall is a Regency sideboard with a standing knife box *ca.* 1840. On top of the sideboard is a Barney silver service.

Right: William Hadwen's bedroom. Next to the bed is a candle stand with a whale oil lamp on top. The patchwork quilt is an "autograph" quilt made on Nantucket with each square patch signed by the woman who worked on it.

Right: The Benjamin Coffin house, 98 Main Street (1834). Benjamin was a son of Jared Coffin and built this dignified white house with a front sidewalk of bluestone. It was the site of the original Friends' Meetinghouse. In front of the house, at the intersection of Pleasant Street, is a sunken cistern, one of several installed many years ago and fed by rainwater to insure an adequate supply of water in case of another fire.

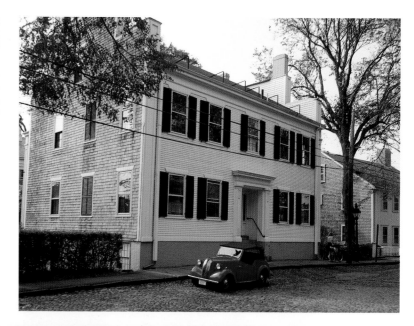

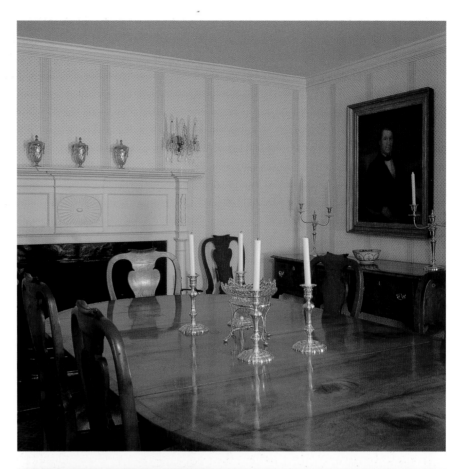

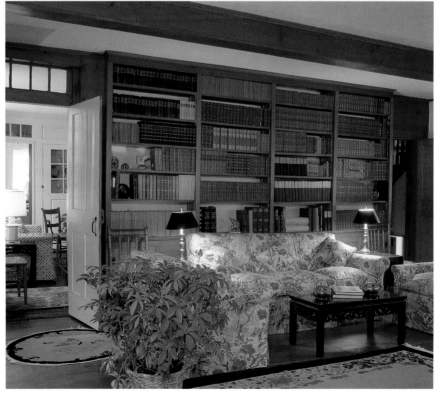

Opposite, bottom: The Thomas Macy II house, 99 Main Street (1770, 1830). This house was originally built in 1770 by Valentine Swain. Thomas Macy, son of Obed Macy, the historian, and uncle of R. H. Macy, added the front section in 1830. The five-bayed facade with an elliptical fanlight and sidelights is one of the most handsome on the island. The fan is blind because the ceiling of the original house behind it was not high enough for a glass window to be installed. The railing that curves out, down the steps, and along the sidewalk has a gentle rounded top. A plain picket fence would not have been acceptable to Macy.

Above: The dining room at 99 Main Street. Against the back wall are a Federal mantle and coal stove (*ca.* 1835) and a portrait of Thomas Macy.

Right: The library of the Thomas Macy house, decorated with the furniture of the last owners, Sally Harris Tupancy and Oswald Tupancy. The house is now owned by the Nantucket Historical Association as is the Hadwen House.

Above: The Joseph Mitchell house, 100 Main Street (*ca.* 1800, 1840). Just before he moved into No. 96 Main Street, William Hadwen lived in this two-family house with his partner, Nathaniel Barney. Capt. Joseph Mitchell later occupied the house. Mitchell went to sea at age 14, became a captain at 28, and was particularly successful in the California Gold Rush as a commander of ships rather than a miner of gold. But his whaling voyages were long, arduous and lonely. He spent the best years of his life on board whaleships, separated from his wife and family.

Right: The Christopher Starbuck house, 105 Main Street (1690, 1753). The oldest part of this house was originally located near Capaum, which means "enclosed harbor."

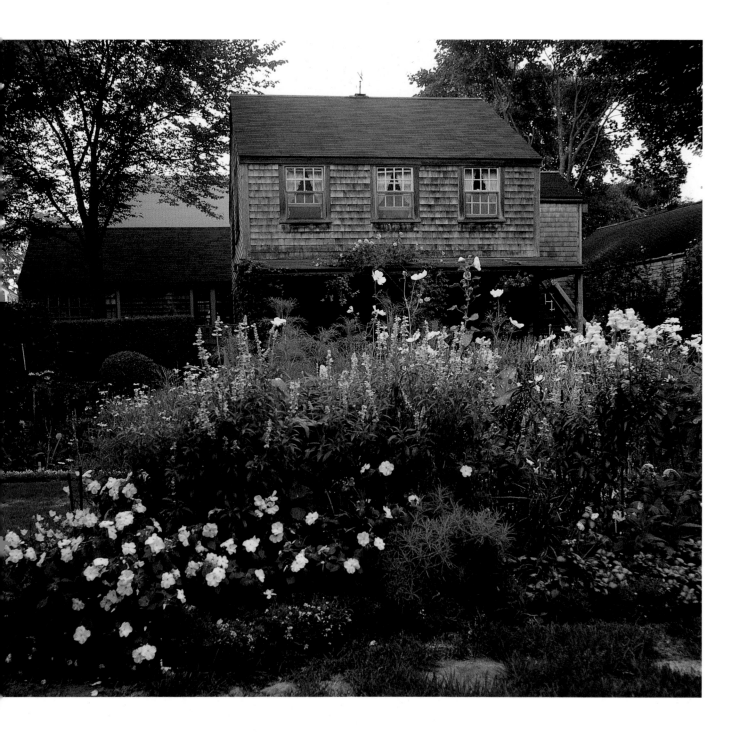

The garden of 105 Main Street is planted with white flowers so that in the evening their aroma and glow can be enjoyed while sitting on the terrace.

This house was relocated from Sherburne because most of the timber for Nantucket homes came from the mainland, and it was far cheaper to move than to build from the beginning. There were two Sherburnes, the original being near Capaum and the new one being the Nantucket town we know today. The Nantucket name was adopted in 1795.

While living in this house, Christopher Starbuck formed a trading company in 1767 with Nathaniel Macy and Joseph Swain. They had twelve whaling ships, trading headmatter with mainland companies for dry goods and other items. Four years later Starbuck and his partners were selling a wide variety of items such as Russian duck cloth, anchors, sail needles and English silk. But the Revolutionary War ended the business and they had to embark on a slow rebuilding afterwards.

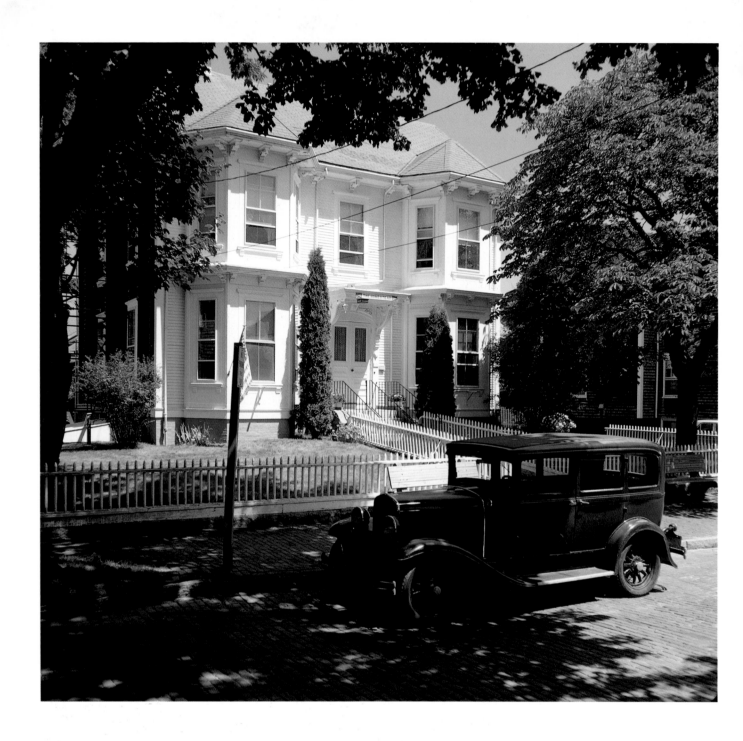

The Edward Perry House, 115 Main Street (*ca.* 1890). This is presently known as "The Homestead," a residence for older men and women. The Old People's Home Association was founded in 1919 for the purpose of providing "a comfortable home during the closing years for elderly people." It had four guests when it moved into these quarters in 1930.

The 1930 Chrysler 66 is one of only 500 made. It has wooden spokes but no heater or radio. It was purchased new by the owner's parents from Hardy's Garage on Washington Street after they had moved out to Monomoy and found commuting to town by boat inconvenient.

Left: The Civil War Monument at the top of Main Street was erected in 1874 to honor Nantucket natives killed in the war. The island sent 339 men, 56 more than her quota. The base is the millstone of the Round-Top Mill which was the last of the five windmills to be built (1802) and hopefully the last to be taken down (1873). Behind the monument is a small structure that was once an A&P and more recently the Dry Shoal Cleaners.

Below: The Zaccheus Macy house, 107 Main Street (1748). Macy was a boat builder, and his avocation was that of a physician caring for broken bones. He treated about 2000 cases, and, being a Quaker, never charged for his services. The house was later occupied by Reuben Joy.

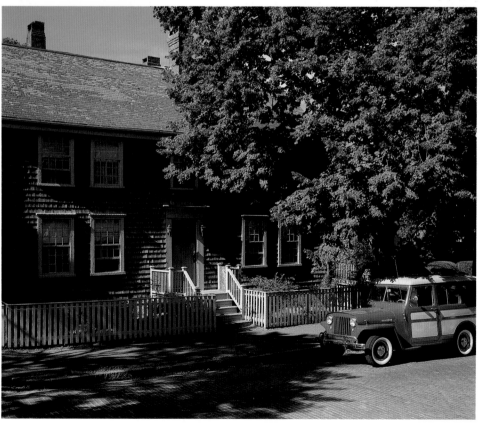

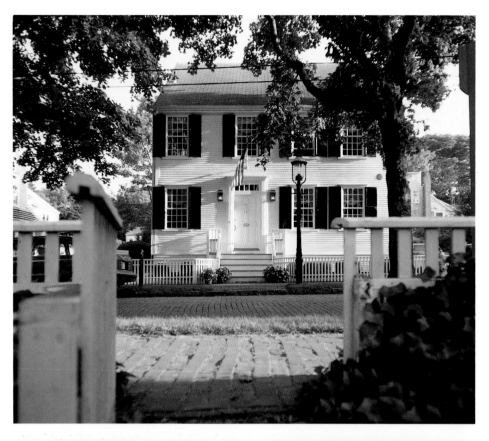

The Thomas Paddack house, 120 Main Street (1807). Paddack married Elizabeth Gardner and was captain of the *Perseveranda* when he was captured by the British on Tuckernuck Shoal in 1811.

The vitrified brick on this section of Main Street was laid in 1903 as a smoother alternative to cobblestones. The roses surrounding the terrace are "Betty Pryor."

Above: The living room of the Paddack house contains a tasteful collection of 18th- and 19th-century antiques including a portrait of a brother and sister by Joseph Whiting Stack (1815–1855), painted in 1840, an American pictorial hooked rug (*ca.* 1850), a mahogany Chippendale serving table (*ca.* 1770), a Queen Anne wing chair, also from Massachusetts (*ca.* 1740), and an early 19th-century daybed.

Left: The rear parlor is now a cozy library with a collection of Martha Washington plates over the mantlepiece and a pair of cast iron owl andirons (late 19th century). The bold use of striped wallpaper on the ceiling, dark stained moldings and corner posts, plus a colorful and eclectic collection of furnishings give this home a distinctive and most welcoming feeling. The designer was Robert Denning who worked with the owners in creating these rooms.

On the following page are the dining room and kitchen of this house. On the left of the dining room is a portrait of James Schevenhoven (by Ammi Phillips) and other portraits from the mid-19th century. Also from the period are a handsome group of Windsor comb back side chairs, oversized hurricane chimneys on the table, and English tea services. Note the handsome rag rugs with deep padding. Additional early American portraits fill up the kitchen, whose warm wainscoted walls and ceiling make this more of a yacht than a kitchen.

Above: The Richard Gardner II house, 139 Main Street (*ca.* 1686), built at the same time as the "Oldest House" with a similar layout, lean-to design and windows imported from England. Originally this house had only one large room per floor.

The car is a 1938 Ford, purchased by the owner's father new for $1,100. The unusual teardrop headlights were used from 1937 to 1940. This car's only option was a radio, which then weighed 40 pounds and, despite inflation, still does.

Right: A portrait of Gladys Wood hangs next to her famous hat with its orange scarf (which is also seen in the painting). Miss Wood owned this house from 1927 until 1971.

Opposite: The dining room and kitchen of the Thomas Paddack house.

The dining room of the Richard Gardner II house. Shown here are massive summer beams or lintels running parallel to the fireplace, an English dining table (*ca.* 1750) with a long medial stretcher and large turned legs, and a set of double spindle back English side chairs (also *ca.* 1750). These furnishings plus the small diamond pane windows visible on the opposite page give the house an English look. Under Miss Wood's watercolor portrait, which was painted by Elinor Barnard in 1926, are a large English pewter charger (*ca.* 1740), and a Dutch pewter chocolate pot (*ca.* 1800). Note the brass school bell at the edge of the fireplace which probably came from the Nantucket High School.

The house had been owned by Gardners for almost 150 years until 1926 when it passed out of the family. One of the owners was George C. Gardner who purchased it in 1840 and raised turnips for seed which he sold to Breck's in Boston. The large second-floor bedroom of the house was his seed storeroom. He was a true gardener.

In the living room (*opposite*) are numerous antiques including the step-down Windsor arm chair on rockers, with a comb back design (Massachusetts *ca.* 1825) and a child's ladder back chair of similar origins. The jigsaw puzzle is newer but indicative of the timelessness of many rainy day Nantucket activities.

For almost 50 years this house has been affectionately known as the Gladys Wood house. After graduating from Smith College and serving with the YMCA and the 8th Airborne Division in World War I, Gladys Wood came to Nantucket and started the Skipper Restaurant in 1921 with a colleague. This was an outdoor canopied affair on the deck of an old wooden-hulled schooner anchored in the Easy Street boat basin. The decks sloped appropriately and the bowsprit thrust itself majestically toward Old North Church. My oldest brother got his first summer job here, doing pots and pans. After graduating from this institution he went to Exeter.

Upon selling the Skipper, Miss Wood went into real estate and built up a very loyal clientele of summer renters. There was only one house she had trouble with—the old and cavernous Nantucket Golf Clubhouse on Cliff Road, where the Conservation Foundation is today. If prospective renters (or buyers) were showing up on a foggy afternoon, Miss Wood turned it into an event—with cookies in the oven, a fire blazing in the living room and a gathering of her colleagues for tea. With so much activity no one minded the 60' living/dining room that was open to drafty rafters.

A section of the wall has been left open in the Richard Gardner house living room to show its early construction of wood lathes and clam shell mortar. Clay was also filled in as an insulating material. The Chippendale-style desk is from Connecticut (*ca.* 1780) as is the side chair. The pine blanket chest is unusual with its cut-out end feet and dates from about 1720. Above it is an equally rare and early landscape painting by Reggie Levine, proprietor of the Main Street Gallery. The framed silhouette is of one of the Gardners (*ca.* 1840), and the mahogany Chippendale-style mirror, also American, is of a similar era.

Many of the furniture styles popular in America were of English influence, but the woods were different (cherry and maple rather than walnut, yew, mahogany and lots of veneer) and the designs were often a bit simpler. The most popular item was the Windsor chair, introduced to this country around 1725 and being made on Nantucket as early as 1760. The chairs evolved into a variety of styles but all basically followed a pattern of turned upright spindles for the back and a hard, curved wooden seat. One of the most successful chairs ever designed was the elegant yet simple continuous arm Windsor, the arc of whose back flows down into its outstretched arms. Windsor chairs and the plain Nantucket-style tables became the vernacular furniture of the Quakers on the island until the middle of the 19th century. We are fortunate that so many of these simply made examples survive today.

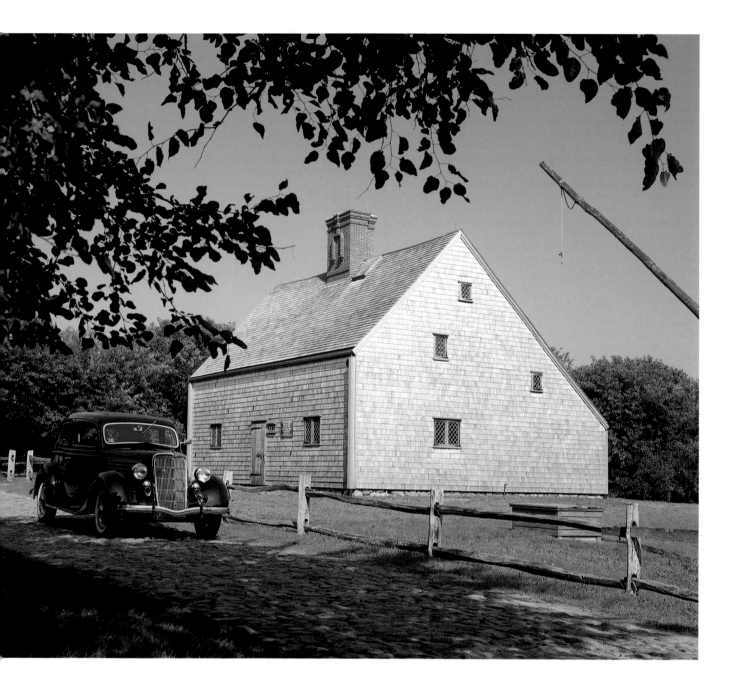

The Jethro Coffin house on Sunset Hill (*ca.* 1686) also known as "The Oldest House." Up from the main thoroughfare of West Chester Street, it has withstood the changes to Nantucket plus storms, fires and even lightning in 1987. It was built as a wedding present for Jethro Coffin (age 23) and his bride Mary Gardner (age 16). Jethro was a grandson of Tristram Coffin, one of the first settlers. John Gardner, Mary's father, was a later participant invited by the original group to become "halfshare men." John Gardner believed that everyone should have equal votes—no distinction between the percentage of his shares. Eventually he got his way. The Gardner family supplied the land and the Coffins the lumber. The wedding was delayed because Tristram wanted

to see the property deed which John Gardner had neglected to transfer to his soon-to-be son-in-law. When the paperwork was completed, the ceremony proceeded, uniting two strong and independent families.

The car is a 1935 Ford Tudor sedan with wire-spoked wheels. Wire wheels were phased out in 1936 and the separate headlights slipped into the fenders in 1937.

The main staircase of the Richard Gardner III house, 32 West Chester Street (1723). This is one of the earliest houses to belong to a whaling captain and has two full stories. Straight Wharf was built in the same year. The center of town was shifting from Sherburne to the Great Harbor as sheep raising was giving way to fishing and whaling.

On the hall chair is a Nantucket lightship basket. Baskets were originally made by the Indians, and by the 1830s began to have wooden bottoms rather than woven ones. Nantucketers started to use rattan from the Philippines and China, which they imported directly. A third characteristic was also added at this time: the use of molds to make perfectly round nests of baskets. Beginning in 1856 baskets were made on the *South Shoal* lightship by sailors who, during their long periods of isolation, created some fine examples. One of the most prolific makers was Capt. Charles Ray, who had completed 200 by 1866. His grandson Mitchell carried on the tradition, and after signing the bottom of the basket added the following verse: "*I was made on Nantucket, I'm strong and I'm stout. Don't lose me or burn me and I'll never wear out.*" José Formoso Reyes came to Nantucket from the Philippines in 1945 and, unable to obtain a teaching position, took up basket-making. He was a skilled craftsman, adding the lid to the baskets and the ivory carving. By 1952 the present-day basket, a familiar badge recognized by fellow Nantucketers around the world, had evolved.

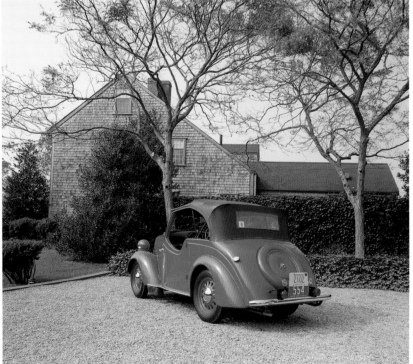

Left: Calling on the Richard Gardner III house is a 1936 Standard Flying Eight. Standard Motors merged with Triumph after World War II and for many years produced the popular English roadster, Standard-Triumph.

Above: The whalebone swift was made at sea and is used for winding wool. The early-eighteenth-century wall clock is known as a "wag-on-the-wall." The wing chair is covered in a copy of the flame stitch pattern, and the unusually large and handsome library is filled mostly with Quaker study books which belonged to the Brock family from 1822 to 1902. Both Priam Brock and the original owner, Richard Gardner III, were lost at sea. Richard's turn came first, two years after he moved in. Priam did not have many more years, having been carried down by a whale in 1832 when he was captain of the *Franklin* at the age of 22.

Right: The massive dining room fireplace was discovered behind a smaller one. The large oak summer beam is unusual as is the collection of early pewter. A "summer" is not only a season but also a lintel.

Below: The rear sitting room of the house (the keeping room) contains fine examples of early-nineteenth-century furnishings. A hidden door to the left of the fireplace leads to the second floor, and on the right of the fireplace is a unique Nantucket lightship knitting basket made by José Reyes. The Hudson River Queen Anne chairs are eighteenth century. A cobbler's bench now serves as a coffee table.

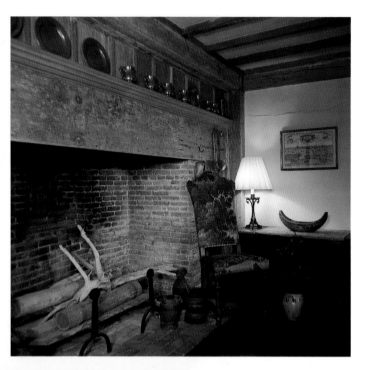

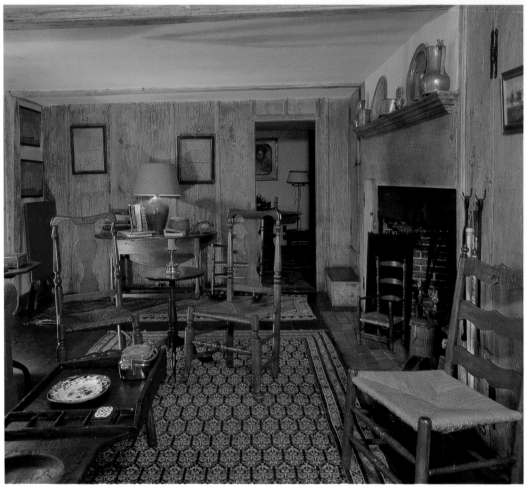

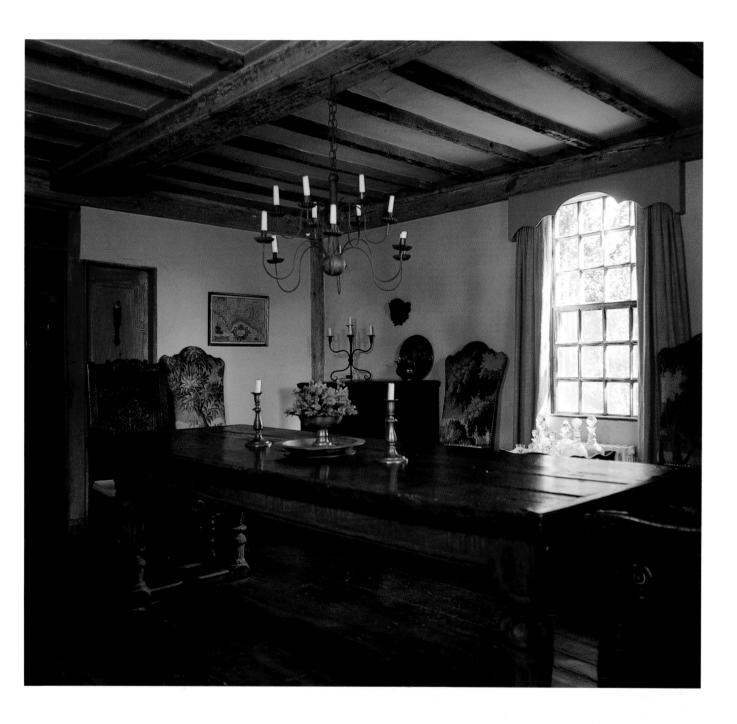

The dining table and chairs are early seventeenth century. The table is an English oak refectory table and the chairs are covered in a Verdure-design Gobelin tapestry, original to the period. The pewter compote and candlesticks are American (*ca.* 1800).

The original design of the Nantucket houses comes from the English cottages of the same period (1680–1740). Traditionally they face south with no roof overhang in order that the winter sun be allowed full penetration.

Richard Gardner, an Englishman, lived on Sunset Hill near his niece Mary Gardner and her husband Jethro Coffin. His son, Richard II, built the house at 139 Main Street and Richard III built this one. In 1667 Richard the First was granted an area called "Crooked Record"—an irregular plot on the map roughly bound by the present-day streets of Gardner, Liberty and Lily on the East, Main on the South, New Lane on the West, and West Chester and Centre on the North.

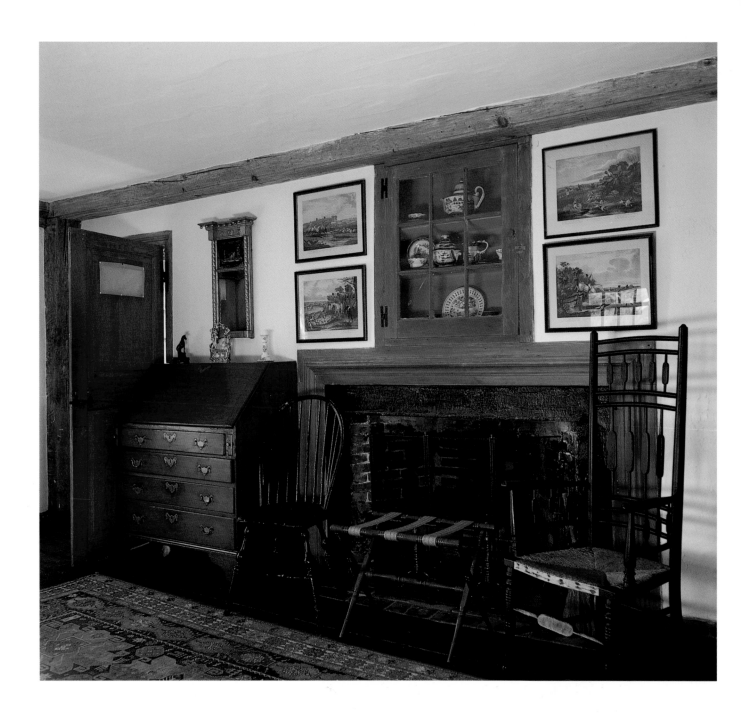

Above: The master bedroom contains a slant-top maple desk from New York (*ca.* 1730) and, on the right, a whimsical Arts & Crafts chair acquired from the Sea Cliff Inn when it was razed. Over the mantlepiece is a parson's cupboard (common in Rhode Island but unusual on Nantucket) containing a Canton teapot and Staffordshire cups.

Opposite, top: In the west parlor are a banister back heart and crown chair, a style made only in Connecticut (*ca.* 1750) on the right of the fireplace and another banister back armchair of the same period. The green painted Windsor armchair on the left is believed to be originally from Nantucket.

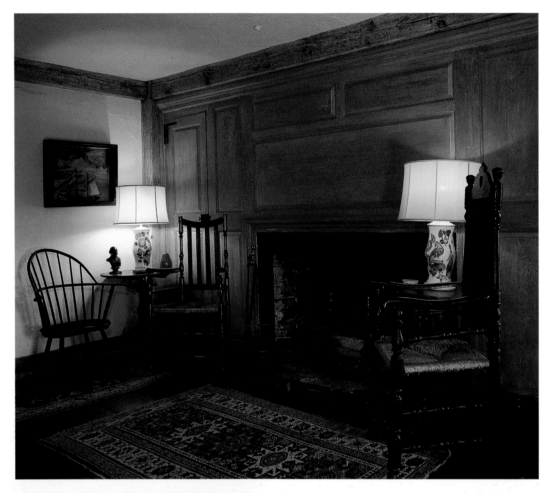

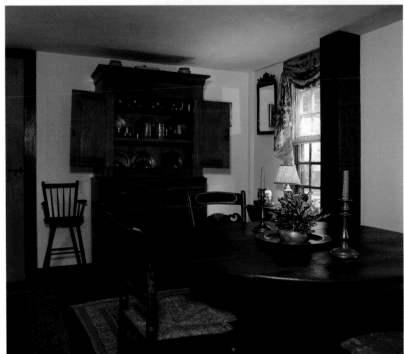

Left: The breakfast room of the Gardner house contains an eighteenth-century New York state linen press and table. The chairs are Sheraton fancy chairs (*ca.* 1820) with original painted decoration. The Windsor high chair has been in the house for many decades. This room was known as the buttery and was used for the storage of food and utensils. The borning room was at the other end of the rear sitting room, a room where children were born and cared for when ill.

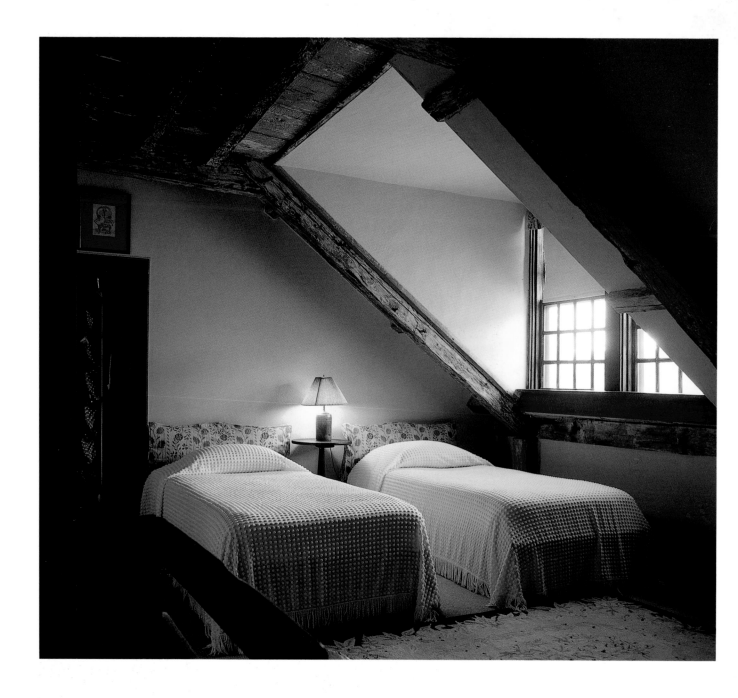

Above: An upstairs sleeping chamber at the Richard Gardner III house.

Opposite, below: The Elihu Coleman house, in the original Nantucket settlement of Sherburne (1722). This is the only house remaining in the settlement and contains one of the largest fireplaces on the island—ten feet across and virtually a small room in itself.

From 1700–1760 the predominant house style was the lean-to which evolved when the English enlarged the rear of their homes, extending the north roof so that it came closer to the ground. This was the style of the Puritans.

The Quaker faith fostered a continuation of this simple design with no ornamentation and no unnecessary display of opulence, such as a house with a full second story all around. By the 1750s the majority of Nantucketers were Quakers by faith or at least in spirit because they accepted the Society's views on all aspects of daily life—in dress, architecture, education, family life, economic and social values.

However, the disruptions caused by the Revolutionary War and ensuing for a decade afterwards precipitated a weakening of the Quakers' hold on Nantucket. The Friends no longer set the standards of behavior. Other views became acceptable including an increased willingness to display one's successful whaling achievements with more elaborate dress and architecture.

The Barnabas Gardner house, 153 Main Street at Caton Circle (*ca.* 1725). This is one of the oldest houses on Nantucket. Its simple design with a steep shed roof has never been altered with dormers, and no porch or elaborate entrance was ever added to its face. The circle is named for Clara and Cosimo Caton, a schoolteacher and a civic worker during the 1940s–1960s.

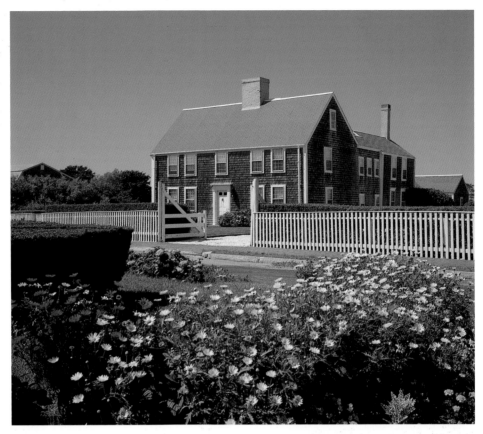

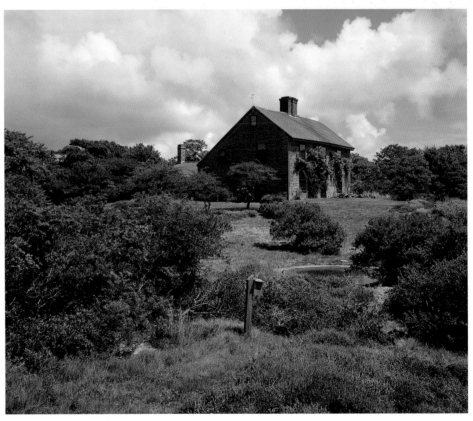

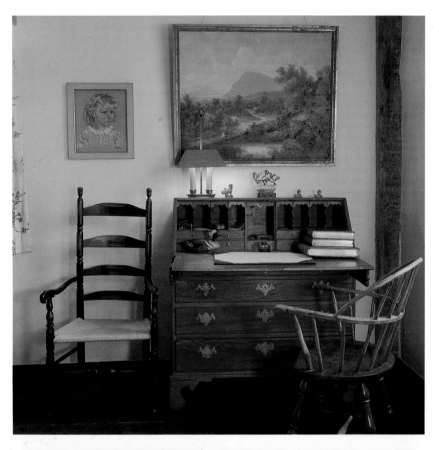

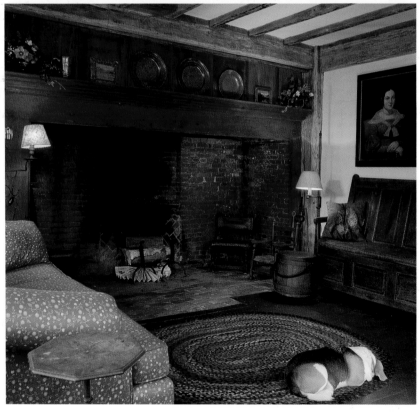

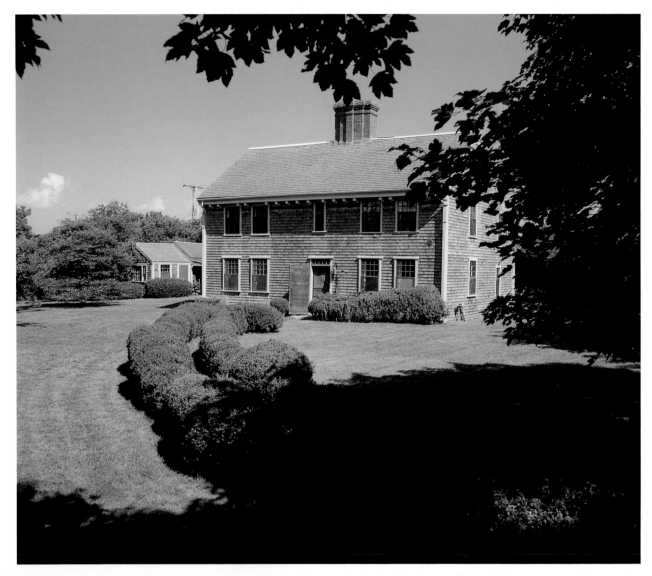

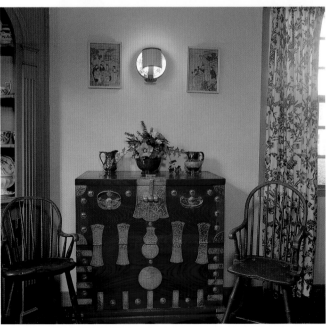

The Josiah Coffin house, 60 Cliff Road (1724). This was built by a son of Jethro and Mary Coffin ("The Oldest House") for his own son. Like his father's and Elihu Coleman's house, this is of the lean-to style and faces south. The Josiah Coffin house has a more elaborate front facade and chimney stack than Coleman's. It has more windows on the front and heavy brackets under the main cornice—nice features for the period. Nantucketers used a compass to position their houses, often with extraordinary accuracy. In the late 1880s, Professor Henry Mitchell (Maria's father) decided to test the accuracy of this house and calculated the sides would have pointed to magnetic north in 1723. The house was indeed laid out that year.

Opposite, top: A portrait of the owner's daughter by Mary Sarg and an early Hudson River School landscape hang above a Connecticut slant-front desk and Windsor chair, both *ca.* 1790.

Opposite, bottom: Danny snoozes in front of the massive fireplace—one large enough to sit (or nap) in on a chilly night.

Left: This chest was acquired by a member of the family when travelling in China.

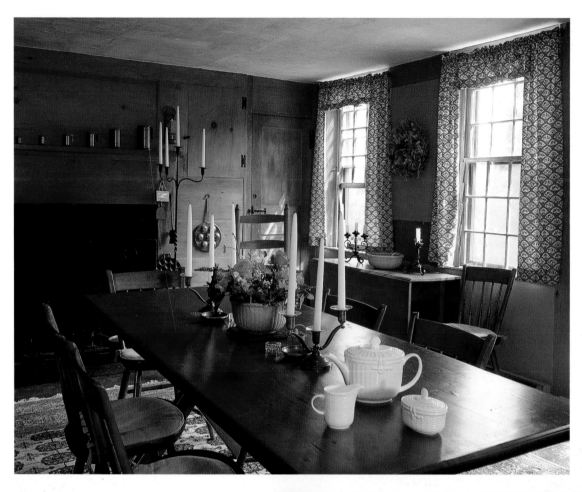

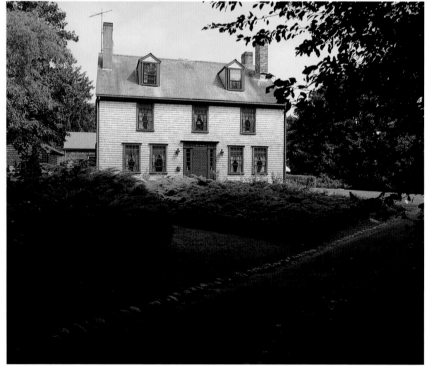

Right: The Thomas Gardner house on Gull Island Lane (1739). This is believed to be the first house on Nantucket built with the north and south roofs of the same height—the roomier Georgian style that was becoming popular on the mainland and came to Nantucket in the 1730s. Gardner was severely criticized by the Quakers for such display.
Above: The dining room of the Thomas Gardner house. The ceramic tea service on the dining room table was designed by George Davis in a Nantucket lightship basket pattern as was the ceramic flower container.

An upstairs bedroom of the Thomas Gardner house with a typical country Sheraton bed. The 7-inch lightship basket was made by the owner's younger daughter.

Originally the site of the house was called Gardner's Island, later changed to Gull Island. Around it was Lily Pond through which flowed a creek that emptied into the harbor near the present-day Children's Beach. Barzillai Coffin widened the creek in an attempt to operate a fulling mill. The mill was unsuccessful and Lily Pond is now mostly grass and shrubs. Richard Gardner III's house originally overlooked the north side of the pond from West Chester Street.

For the past hundred years this house has alternated between being an inn and a private residence, finally returning to the latter category in 1951.

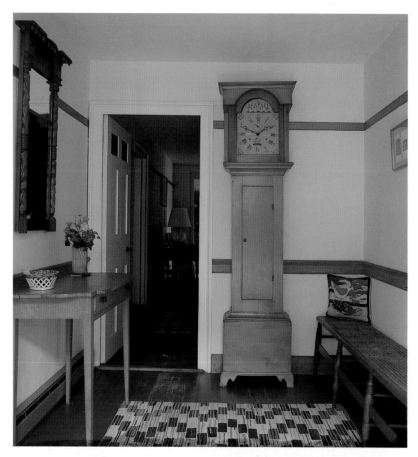

Left: The tall clock in the Thomas Gardner house was made by R. Whiting Winchester, the Hepplewhite table dates from *ca.* 1790 and the bench from *ca.* 1820. The needlepoint pillow was made by the owner's eldest daughter. *Below:* The living room features a wonderful mixture of early American and Empire furniture. Note the glass lights in the top of the hallway door. Later homes feature glass transoms above the door as may be seen on page 137.

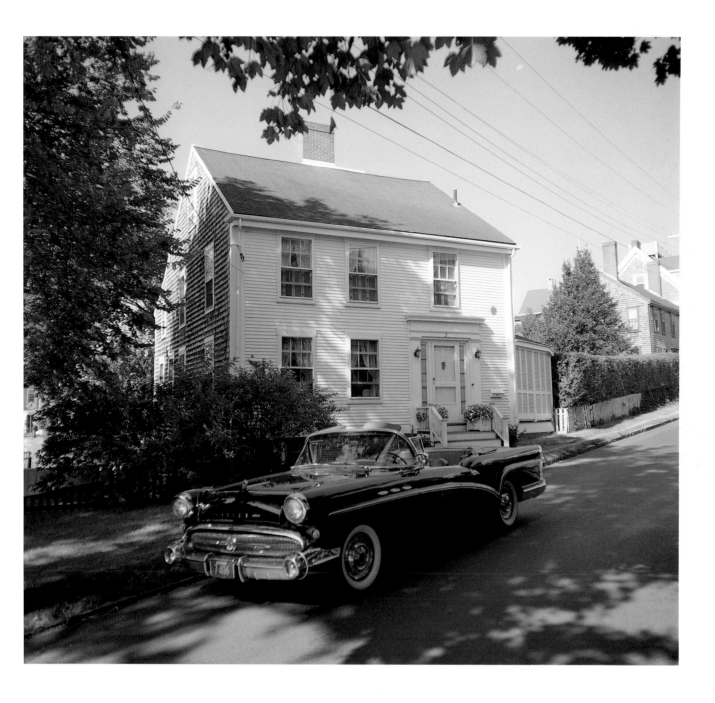

The Laban Swain house, 2 Cliff Road (*ca.* 1795). This charming house shows New England frugality with a clapboard front and shingled sides. Given its location at the beginning of Cliff Road (originally North Street), one of the main routes, it has served in various capacities as a house, shop and boardinghouse. In 1877 it was called Nickerson's—a private boardinghouse operated during the season for the accommodation of "steady, transient or table boarders" offering reasonable terms and a pleasant location.

The car is a 1957 Buick Century convertible. At the height of its popularity, Buick offered four different convertibles, one for each series (Special, Century, Super and Roadmaster)—more than any other manufacturer. The cars were available in a variety of colors, each with a color-coordinated canvas top. Buick had noted the success of Nantucket's Rainbow Fleet.

This Buick has four stylized vents on the side of the hood. On my father's 1940 Buick the first vent was actually the hood latch. On the 1949 model the vents were round portholes (page 29). The latter car offered Dynaflow transmission, a different version of the successful Hydra-Matic Drive introduced by Oldsmobile and Cadillac in 1940. Chrysler tried Fluid Drive, but by 1955 all had switched to Hydra-Matic, including Packard, Studebaker, Hudson and Nash, although most chose to call it a different name such as Ford-O-Matic or Merc-O-Matic.

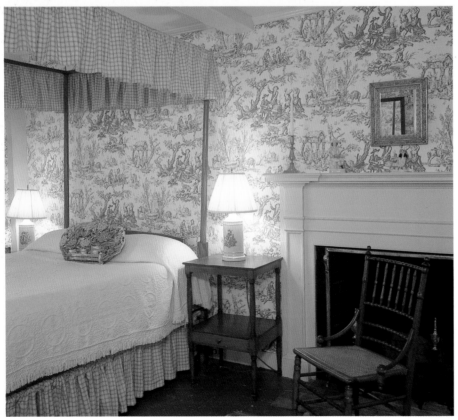

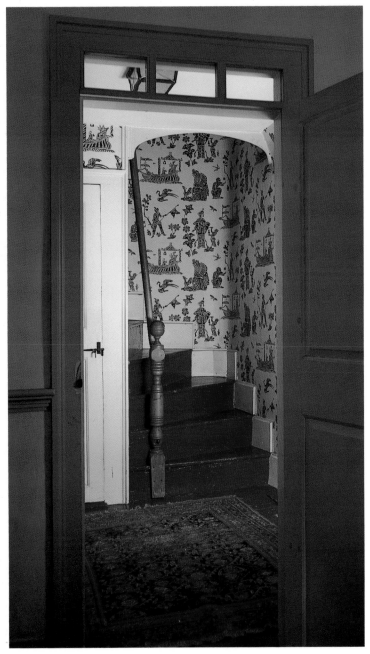

Opposite: The living room and master bedroom of the Laban Swain house show a special Nantucket charm as do the dining room (*above*) and front hall (*right*). The hurricane lamps on the table throw off a warm glow in the evenings. Note the hall banister which is almost completely vertical. Above the dining room door is a glass transom, typical of and unique to Nantucket and thought to provide a quick check for a possible fire in an adjacent room.

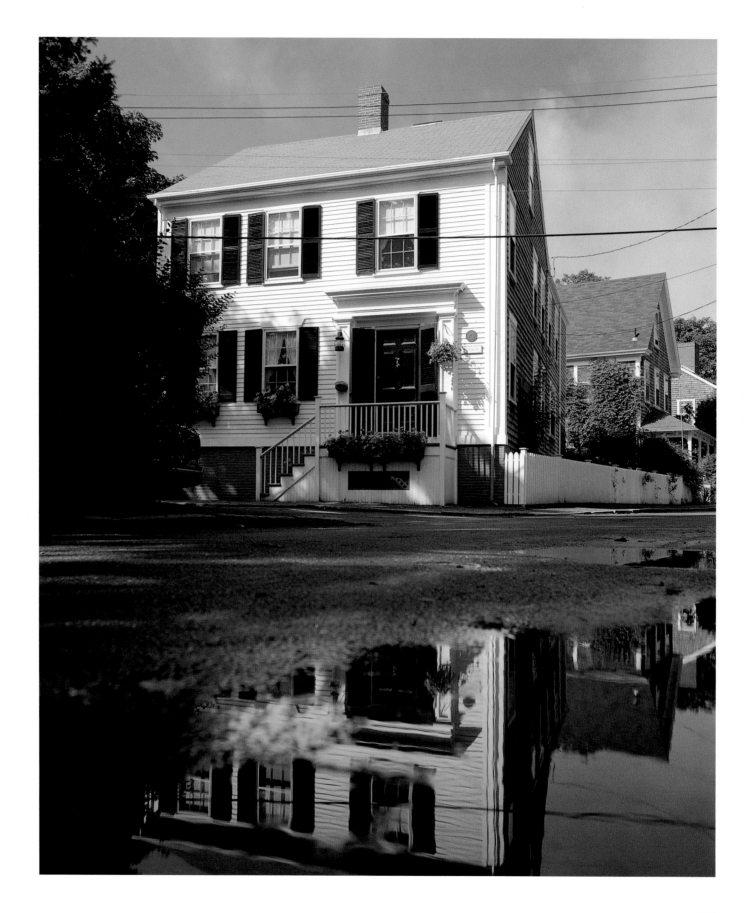

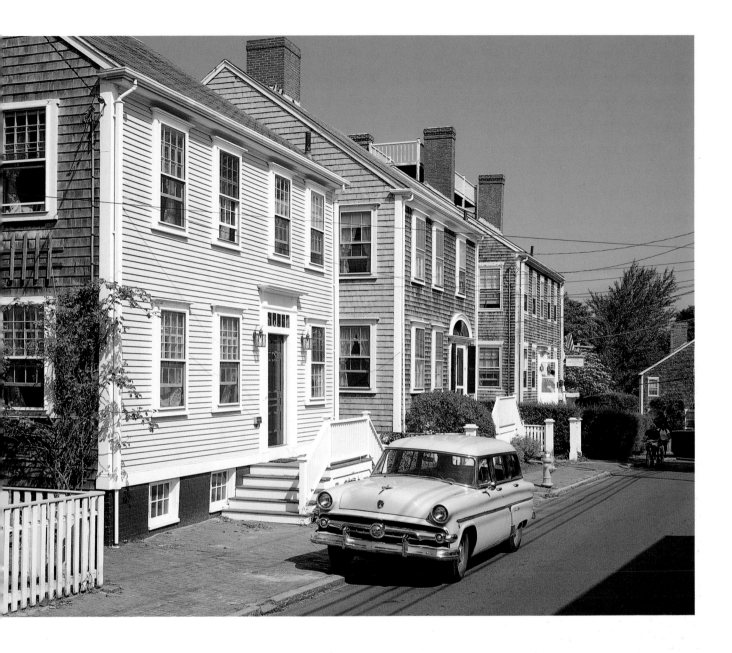

Left: The Hezekiah Gardner House, 8 Winter Street (*ca.* 1785). In 1678 the settlers laid out a 20-acre site in the area called Wescoe. It was divided into narrow lots, bounded by Liberty, Lily, Broad and Federal Streets. The area became popular as the town shifted toward the Great Harbor. Originating as footpaths, the streets were widened for carts and, for the first time, none of the houses faced south; they all faced the street. Federal Street was at the water's edge. The area in front of Federal was called Bocochico, a word of Spanish origin meaning "little river" after a stream that ran east of Federal to what is now Easy Street Basin. This area was filled in and divided into commercial lots in 1746.

Above: Looking down Gardner Street at Nos. 14, 16 and 18, typical mid-19th-century 2½-story houses. This street was laid out in 1763 by Ebenezer Gardner, whose descendants became prominent whalers by the turn of the next century. One of them, Capt. George W. Gardner, started sailing in 1822 at the age of 13 on

board a ship captained by his father. He was 29 months at sea on his first voyage and 35 on the next. Because of his youth he had to live in steerage and subsist on salt junk and hard bread. After five years of sailing with his father he was still never permitted to eat a meal with him. By the age of 36 he had spent 23 years at sea and a total of 30 months at home between voyages.

The streets of Nantucket are seldom straight. They angle and merge in an unpredictable manner, medieval in their lack of plan as they flow every which way—short, crooked and fascinating, with courts and lanes branching off everywhere. Their houses are strung along in similar variety with greenery in between and a band of white fences or brick sidewalk holding the entire collection together.

The car is a 1953 Ford Country Sedan. Its fancier cousin, the Country Squire, had simulated wood sides. Ford ceased production of real woodies in 1951 and Buick, the last to stop, in 1953.

Above: Erica Wilson's house on Liberty Street with her 1922 Side-Door Model T Ford. Since 1964 Miss Wilson has been teaching needlework to island children and their parents, and every summer she hosts a seminar on embroidery, drawing women from all over the world. *Right:* The author's handiwork may be seen in the crewel work pillows on the living room sofa, behind an English coffee table brought from her overseas family home. The dreadnought ship model and banjo clock both date from about 1860.

Left: The cozy library features many of the family's interests including a half-model of their Indian sailboat *Korduda* over the mantlepiece and other items of knitting and nautical nature. *Below:* An 18th-century dining table is surrounded by rush-bottom Hitchcock chairs. The house is located on one of the town's oldest thoroughfares (1678) which twists and turns in a medieval fashion.

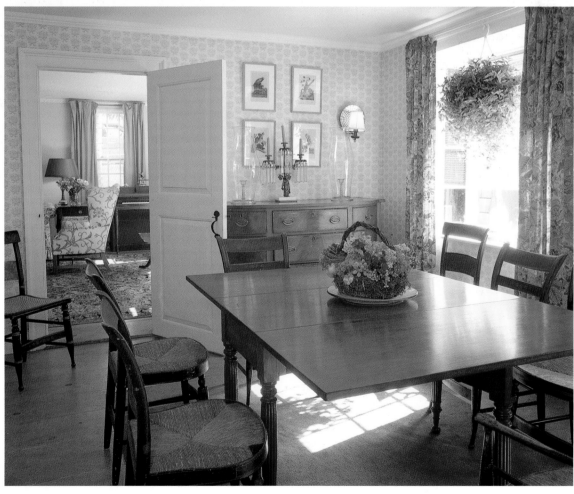

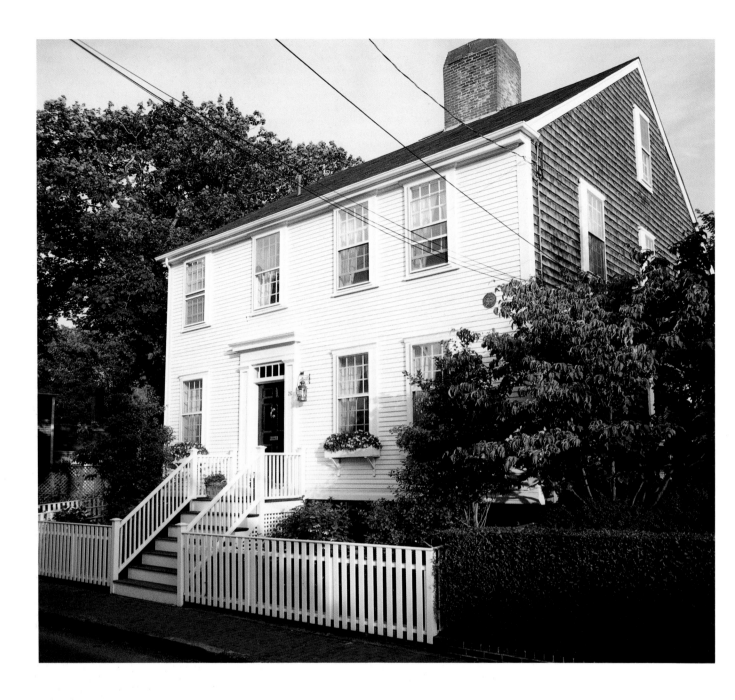

The Benjamin Worth house, 26 Liberty Street (1814). The house was built by Solomon Swain but it is named after a famous later occupant, Benjamin Worth, a captain who held the record for whaling voyages—almost a million miles, rounding Cape Horn 16 times and the entire globe twice. He spent a total of 41 years at sea, bringing in over 19,000 barrels of whale oil and never losing a man. The aggregate amount of time at home between voyages was about six years.

Liberty Street was laid out in 1678. Due to a lack of lighting at this end of the town the area became known as Egypt because, after sunset, it was as dark as The street is one of Nantucket's most confusing because of its perambulatory nature. It parallels Main Street (more or less) from Centre to Gardner. Then it turns right and becomes the continuation of Gardner, bends to the left, forks and instead of ending at Lily Street, meanders over to West

Chester and eventually The Cliff under the name North Liberty.

Nantucket's streetscapes offer a subtle tonic in an era of rapid change. A stroll through a garden is refreshing as one observes the new growth of spring that by fall will be wilting away. But a stroll down a street is more timeless. One is surrounded by houses that have survived world wars, the Civil War—maybe even the Revolution. There is no escape from the reminder that the streets have been trodden by everyday people for many years. And so will be the case for years ahead.

Opposite, top: A ladder back elbow chair (*ca.* 1780) and contemporary wallpaper give a cheerful look to the entrance foyer. *Opposite, bottom:* The dining room features an English walnut gate-leg table (*ca.* 1670) and a handsome set of spindle back chairs (*ca.* 1780). The house presents a pleasing mixture of old and new styles for comfortable living.

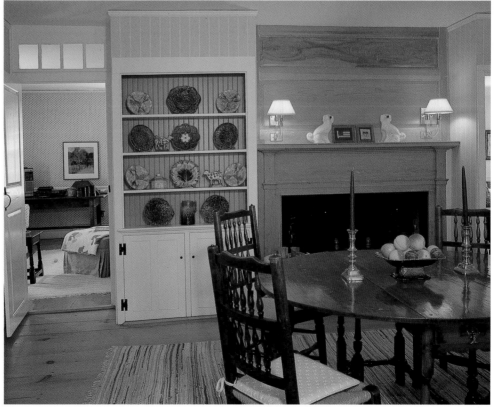

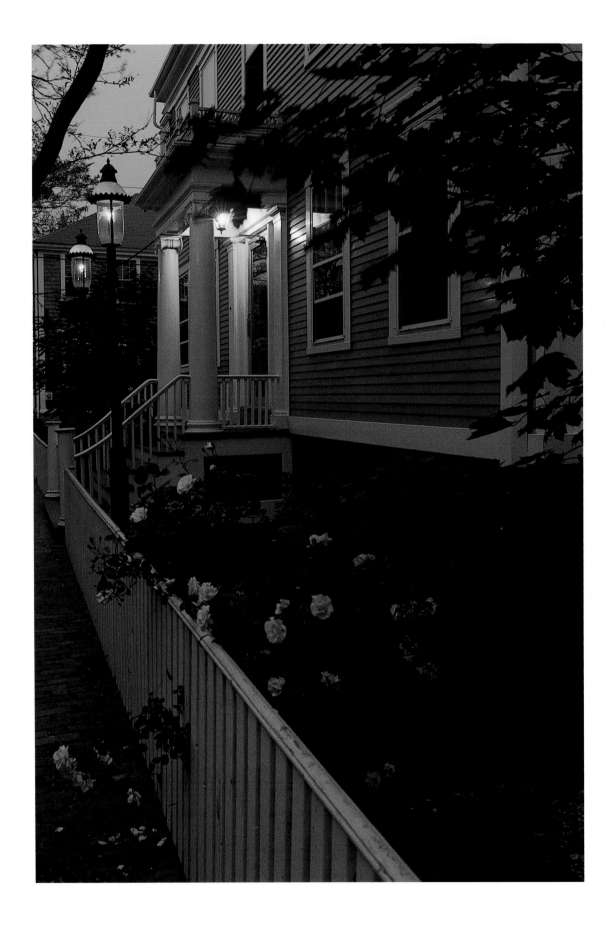

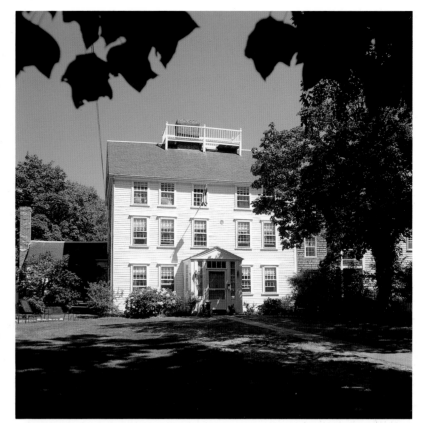

Opposite: The Harrison Gray Otis Dunham house, 56 Centre Street (1842). This house, now part of the Jared Coffin House group, was built for the owner of the whaleship *Nantucket.* The house survived the 1846 fire because of the protection offered by the brick Jared Coffin House.

Above: The Peter Folger II house, 51 Centre Street (1750). This house was occupied by a Folger for almost 200 years. Peter I was a grandfather of Benjamin Franklin. The unusual third story was added in 1815, originally flat and later peaked to prevent leakage. No other house had a full third story until the Jared Coffin House was built 30 years later.

Right: Martin's Guesthouse, 61 Centre Street (1877). This was built by Mr. S. B. Howes and originally named "Wonoma House" after Charlotte Baxter's 1876 poem *Legend of Wauwinet*, in which Wonoma, daughter of Chief Wauwinet, is the heroine of the story.

The house may have been built in Wauwinet. The car was not. It was built by Oldsmobile in Lansing in 1949. Ransome E. Olds produced his first car, a curved-dash runabout in 1903. His cars were popularized in a tune, "In My Merry Oldsmobile," a theme song that prevailed many years after he sold out to General Motors. He subsequently re-entered the business with vehicles using his initials, REO, which is now a familiar crossword puzzle answer for an antique car. Olds had a "66" (page 84), a "76" shown here plus an "88" and the legendary "98." Our family had one of the latter in 1951. It had Hydra-Matic Drive, a "Rocket Engine" and "Futuramic Styling" that included a steering wheel with a lucite dome containing stars and planets. Unfortunately it did not have power steering or brakes and drove like a tank. Olds made station wagons until 1950 when it left the ever-crowding field to Chevrolet, Pontiac and Buick (which offered four series). Olds re-entered the wagon trade in 1957.

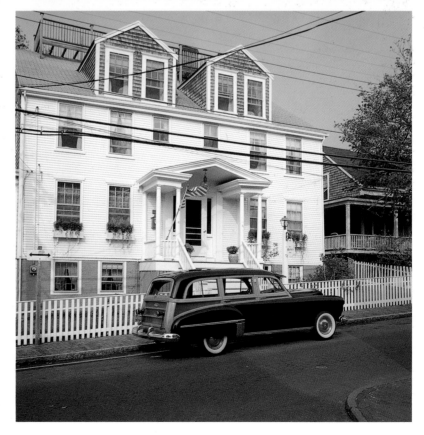

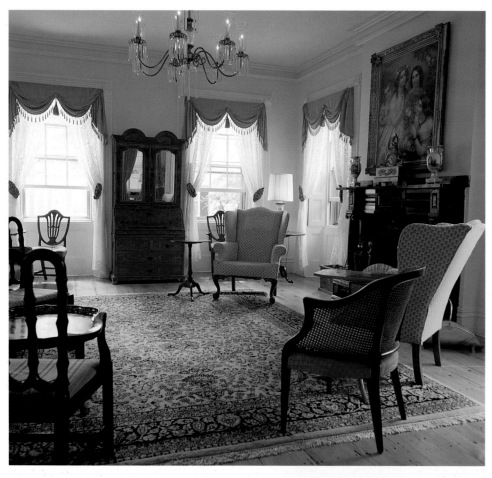

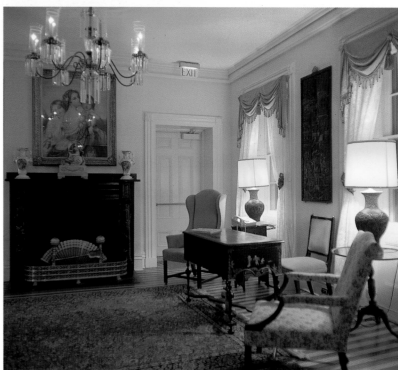

The east and west parlors of the Jared Coffin House, furnished with antiques and paintings of the period.

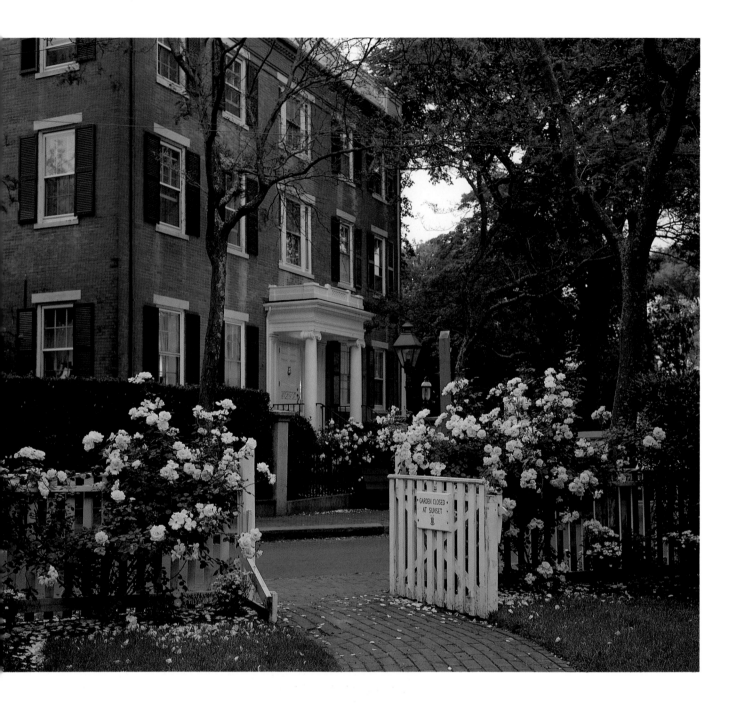

The Jared Coffin House, 29 Broad Street (1845). Even though this was the most magnificent home on Nantucket, Mrs. Coffin had grown tired of the island and her husband foresaw many lean years of island reconstruction after the fire. They moved to Boston the year after it was completed, and it was never again a residence. It reopened the following year as the Ocean House Hotel, under the ownership of the Nantucket Steamboat Company, and is thus Nantucket's oldest inn. It also played an important role in 1870 when the island's economy had reached its lowest point. Two men bought it and began to promote tourism to off-islanders. At the same time the Massachusetts Old Colony Railroad decided to promote Cape Cod and the islands. Tourism was well underway in 1872 when the popularity of fishing for blues was discovered, and the Jared Coffin House (then called Ocean House) was thriving. Even President and Mrs. Ulysses S.

Grant paid a brief visit in 1874. The island we know today is a direct outgrowth of this activity which began over 100 years ago.

The Nantucket Historical Trust acquired the property from Treadway Inns in 1961 and restored it over the next two years with period antiques and furnishings. The decor included needle-work from Erica Wilson and woven fabrics from the Nantucket Looms who had been encouraged to locate on Nantucket and start new interests in handiwork.

Broad Street was the northern boundary of the Wescoe Acres Lots and was laid out in 1678. Like Main Street, Broad Street was widened after the fire. Both provide similar entrances to those arriving by ferry—bold brick buildings (in this case the Whaling and Peter Foulger Museums and the Town Building) providing the gateway to a wide, elm-covered street. Broad Street also has cobblestones, quietly napping beneath a blanket of macadam.

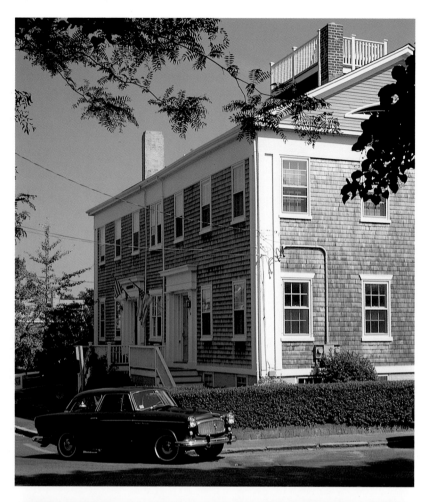

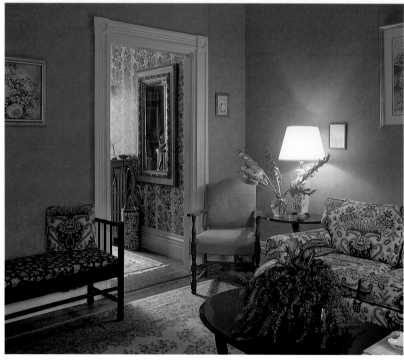

Above and *right*: The Atlantic Silk Company, 10–15 Gay Street (1835). This venture, with both town and state support, was established in 1835 as a supplement to the whaling industry. The street was originally named Coffin Court but was renamed in honor of Gameliel Gay, the mechanic-inventor responsible for the steam machinery in the silk mill. When the subsidies were withdrawn eight years later the venture collapsed and the company's headquarters are now occupied by a lovely guest house.

In the foreground is a 1959 Rambler American, the only car ever discontinued, declared dead and buried yet resurrected three years later when the popularity of small cars revived. American Motors offered push-button Flash-O-Matic transmission on the larger Ambassador models but that was too much for this little car.

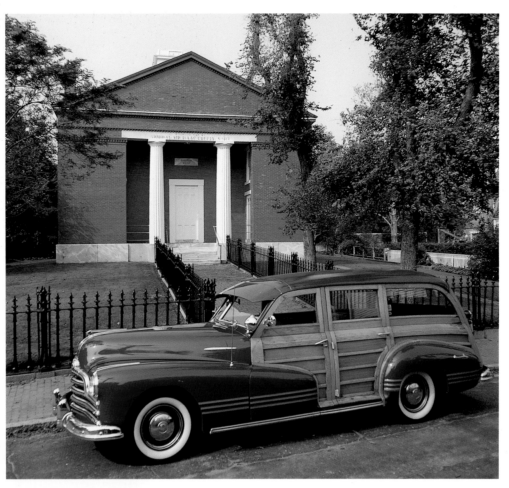

Above: The Coffin School, 4 Winter Street (1852). The school was founded by Admiral Sir Isaac Coffin in 1827 for descendants of Tristram Coffin. A small fee was charged because anything free was often doubted. The car in the foreground is a 1947 Pontiac Streamliner with an all-wood body by Ionia. The sun visor was fine for blocking the sun but it also blocked out traffic lights. To correct this, Pontiac offered a "trafficator," a dashboard prism to see the light.

Left: The John Swain house, 12 India Street (*ca.* 1830). This brick house was built in a transitional Federal-Greek Revival style. The car is a 1946 Ford Super Deluxe. India was named Pearl Street until *ca.* 1850 when many streets were renamed—for noteworthy individuals or in this case to evoke images of another world. By this time many of Nantucket's streets were paved with cobblestones (Main, Broad, Centre, India and Orange, for example) only to be covered later with macadam.

The William Crosby house, One Pleasant Street (1837). This was a wedding gift from Matthew Crosby, who lived at 90 Main Street, to his son and daughter-in-law, Elizabeth Pinkham. Her father was one of the first to chart the Nantucket Shoals. It was a fine marriage, and many delightful parties were given by these royal hosts in their new home. They introduced frozen mousse to the island and had the first Chickering piano. Their home was elegantly fitted with tall, triple-sash windows, marble mantles, silver doorknobs, and hand-blocked wallpaper. But in 1838 a fire destroyed a number of warehouses where vast quantities of William Crosby's whale oil were stored. The 1846 fire almost completely ruined him and the house passed from their hands less than ten years after it was built.

The house is an example of pure Greek Revival, a style that prevailed on the mainland from about 1820 to 1860. Its popularity was due to: 1) the country's focus on the Greek concept of democracy as well as its teachings of law and philosophy; 2) the sympathy shown to the Greeks then engaged in their own fight for independence from the Turks; and 3) the 1812 encounters with the British that awakened a sense of national pride.

At the rear of the Pleasant Street houses is a gully running from Main to Milk Streets. Many of the whale oil manufactories and warehouses belonging to the firms of Starbuck, Hadwen & Barney, and Swain & Coffin were located here in the early 1800s. This explains why the cobblestones went up Main Street to Pleasant but not as far as Milk Street. They were laid to enable the heavily-laden utility carts to move more easily.

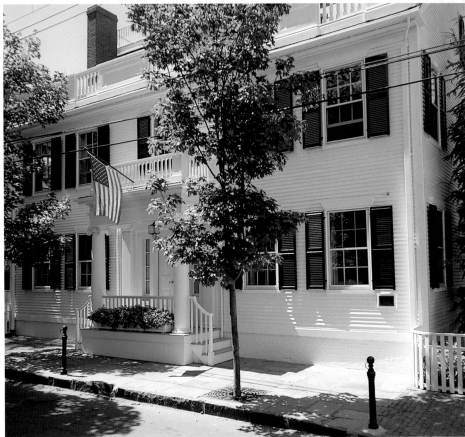

Top: The J. H. Gibbs house, 12 Pleasant Street (1828).

Right: The Isaac Macy house, 7 Pleasant Street (1825). Both this house and its neighbor at 9 Pleasant Street, the Benjamin Easton house (1830), were built by John Coleman in the early Greek Revival style with a Doric portico for Easton and an Ionic portico for Macy. John Coleman and his brother, Frederick, were Nantucket's most influential architects in the 1830s and 1840s.

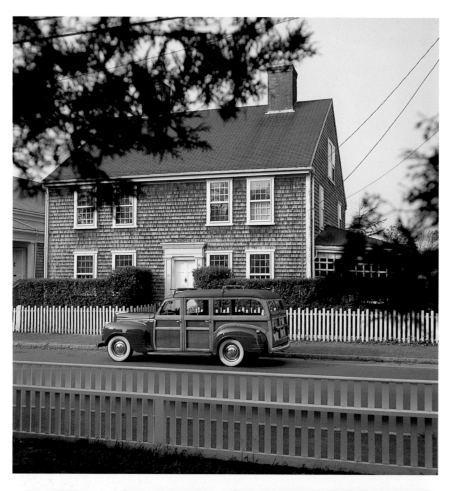

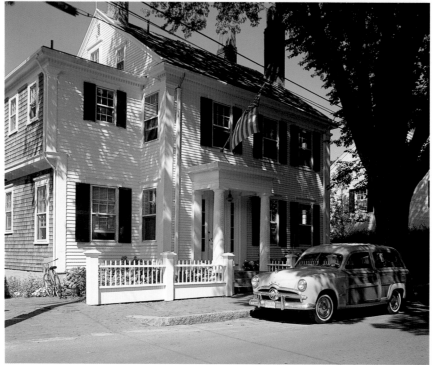

Top: The Obed Macy house, 15 Pleasant Street (1800). Obed Macy was a Quaker historian who wrote the first extensive history of Nantucket in this house. He and his brother, Silvanus, were partners for 47 years in boat building and ship fitting. Rowland H. Macy, who founded a dry goods store in New York, was a grandson of Silvanus and grandnephew of Obed. The car is a 1941 Plymouth Special Deluxe station wagon—the last year Plymouth used running boards. Their last wood station wagon was made in 1950. After Walter Chrysler acquired the Dodge Brothers Company in 1928 he decided to round out his line to compete with General Motors by introducing two new cars with adventurous names: Plymouth and, the same year, DeSoto. The latter dominated New York's taxicab fleet during the 1950s; with such cavernous interiors, they could accommodate an entire third grade outing.

Left: The Benjamin Easton house, 9 Pleasant Street (1830). This house is a fine example of early Greek Revival. The car is a 1949 Ford. Ford offered a two-door wagon only from 1949 to 1951. Thereafter it returned to the four-door models it had offered since 1928.

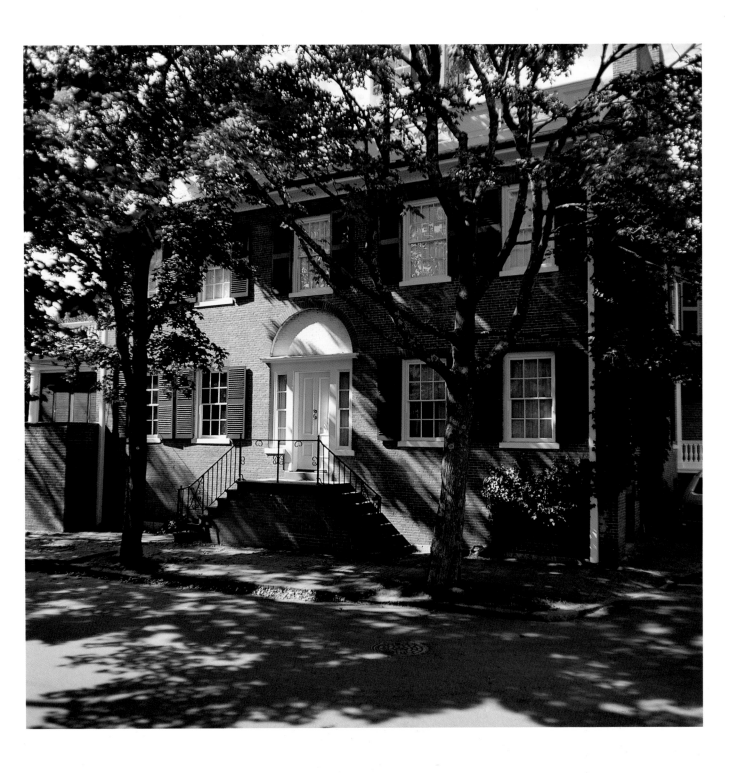

"Moor's End," 19 Pleasant Street (1829–1834). This was the first major brick home built on the island. It was built for Jared Coffin, a successful investor in whaling. Other merchants recognized the social significance of this mansion and soon decided to build their own—all on Main Street. The private garden of "Moor's End" is the largest walled garden on Nantucket. But Mrs. Coffin soon felt that this private estate was too far out of town and persuaded her husband to build an imposing three-story home on Broad Street, duplicating but expanding on the style of the "Three Bricks" of his competitor, Joseph Starbuck.

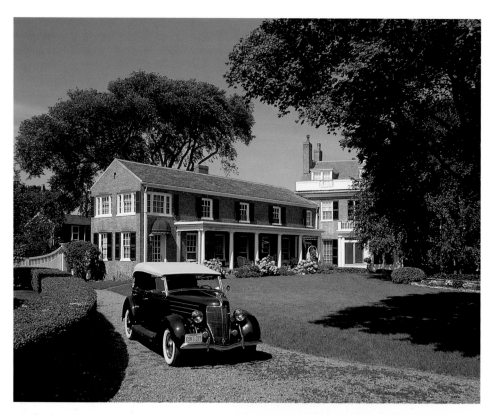

Above: The owner's 1935 Ford four-door phaeton waits patiently in the driveway.

Right: The "Moor's End" living room features whaling murals by Stanley Rowland above a white agate coffee table from the Philippines. This room was once a double parlor and for many years served as the main dining room of the house.

The "Moor's End" dining room features a rare set of fifteen Empire wallpaper panels called "Les Sauvages de l'Ocean Pacifique" designed by J. C. Charvet and made in 1904 by the French firm Joseph DuFour et Cie. The scenes depict natives of the Sandwich Islands and also New Zealand. Two other sets hang in the Museums of Fine Arts in both Philadelphia and San Francisco.

Above the table is an 18th-century French chandelier of bronze, copper and iron. On the mantlepiece is a Greek sculpture, the "Juggler." The table is set for dinner for, and at, eight.

The Silas Jones house, 5 Orange Street (*ca*. 1772, 1830). This is the oldest house in Nantucket with exposed brick ends. Originally the front and back were clapboard. The brick front, with a glass transom and sidelights around the entrance, was added in 1830. The house has an unusual gambrel roof—popular on the mainland but rare on Nantucket. It is of English origin—one of the earliest examples being Henry VIII's Hampton Court (1530–1532).

The early plan of the Nantucket house had a simple massive chimney in the center because of the need to heat all the rooms from one location. Eventually the heat source was divided with chimneys at either end of the house, allowing for a more open and formal interior space.

Orange Street was laid out in 1726 with the opening of Nantucket's third major subdivision, the West Monomoy Division after Wescoe Acres Lots (1678) and the Fish Lots (1717). The Monomoy Lots ran between Quanaty Bank and Pleasant Street.

Union and Washington Streets were added later. Although Orange Street was laid out in 1726 the naming of the side streets did not come until much later at which point Orange was paved with cobblestones.

One hundred seventy-six captains have lived on Orange Street over a period of a century—a record unsurpassed by any other street of its length in America.

During the latter part of the 19th century this street also became known for its inns and hotels. Many residents converted their homes to caravansaries in order to accommodate the island's nascent business of tourism. William Hadwen Starbuck, who had given a new town clock to be placed in South Tower, also chose the intersection of Orange and Main Streets to be the (brief) site of his new horse fountain in 1885. This was later moved down to its present location in Main Street Square.

Above and *left:* The living and dining rooms of the Silas Jones house feature late-18th-century French antiques. The large sofa (*ca.* 1790) is reported to have been traded for safe passage out of his country by a man fleeing occupied France in 1940. The living room paintings are by the contemporary American artist Margite Illka.

Above: The library of 14 Orange Street features a collection of Italian and French antiques, Hudson River School paintings, a portrait over the sofa of Mrs. Hamlin of New Bedford (*ca.* 1770) and a mantlepiece painting by the Englishman John Haley. The needlepoint pillows were worked by the owner, and the miniature of Mad Ludwig's castle on the mantlepiece was a family project.

Right: The graceful staircase is covered with carpeting from the Nantucket Looms, woven by artist and theatrical producer John Volpe.

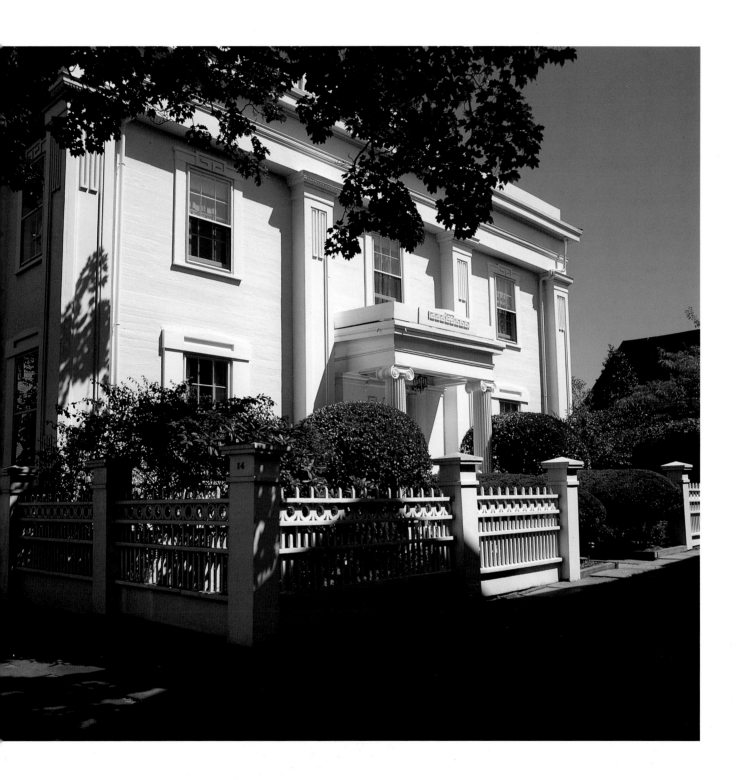

The Levi Starbuck house, 14 Orange Street (1838). This handsome Greek Revival house was designed by William Andrews in a massive square style with wooden sides that have flush boards rather than clapboards. It was completed when the last of the "Three Bricks" was built, seven years before the William Hadwen houses. The middle windows on Orange Street are blind; glazed sashes over closed panel shutters hide a solid wall. The house thus appears to have three full bays on the side whereas it really only has two. The windows contain the original glass and over the years have acquired tints of amber, amethyst and rose. Inside Andrews used elaborate plaster moldings, unusual for Nantucket, and Carl Wendt added his trompe l'oeil touches in 1841.

The house faces south, not the street, and sits behind a monumental fence that sets off its grand entrance.

Right: The dining room of the Levi Starbuck house has a light, airy quality. *Below:* The west parlor contains a delightful collection of Italian and French antiques, as well as a Swedish directoire (1820), the settee at the left in the photograph.

The west and east parlors of the house have been decorated with elaborate plaster moldings based on 17th-century British publications, enlivened by a variety of colors. The rugs are French hand-loomed linen, and many of the pictures are antique embroideries from France, England and America. The wall sconces are English Regency. Originally the dining room was a kitchen which has since been placed in a newer addition. Scalamandré and Clarence House fabrics have been used to accent the warm apricot color of the room.

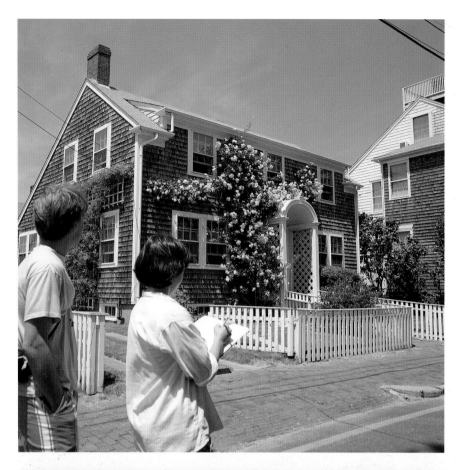

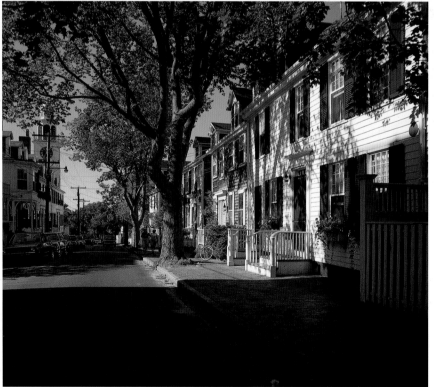

The eastern side of Orange Street was called Quanaty or "long hill" and the western side Wescoe Hill, meaning "at the white stone." *Opposite, top:* The Benjamin Tupper house, 28 Orange Street (1755, 1833). Tupper entertained the famous French historian St. John de Crèvecoeur here in 1772. *Opposite, bottom:* The John Nicolson house, 30 Orange Street (1831). During the peak of whaling many captains chose large houses with double chimneys and elaborate windows and entrance porticos in bold symmetrical designs. The Quakers had favored modest asymmetrical layouts. This handsome five-bayed house follows Pythagoras' golden rectangle: height to width is 5:8.

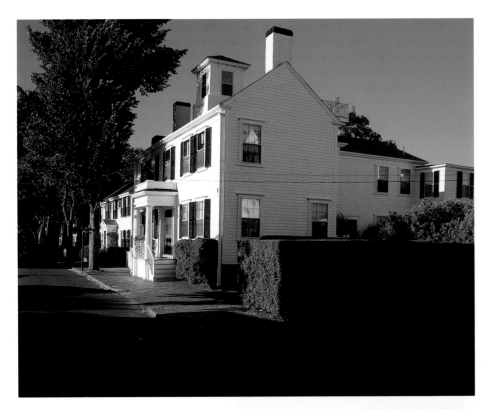

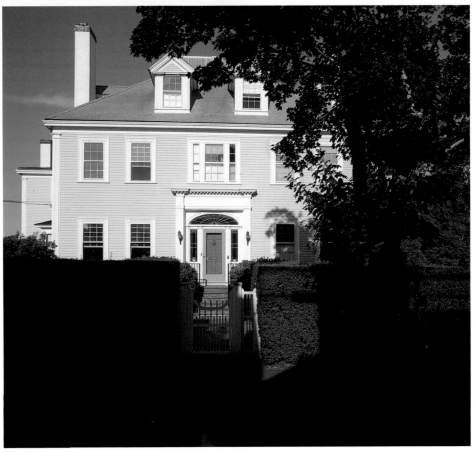

Above and *opposite:* The Seth Folger house, 26 Orange Street (1755). This house is filled with antiques and memorabilia representing a lifetime on Nantucket. The sideboard (*opposite*) originally belonged to President John Quincy Adams and was acquired by the owner's grandfather when Andrew Jackson moved into the White House and disposed of many of the prior tenant's furnishings in a large yard sale.

The gardens of the Seth Folger house. Hydrangeas thrive in Nantucket's sandy soil, and the view from the gazebo is spectacular. This was one of the first dwellings built at this new location and it sits on the highest point of Orange Street—56 feet above sea level.

The top of the garden gazebo contains names of visitors to this house since 1882. The owner's grandfather started Washington's Willard Hotel in 1847 which has been described as a combination of Waldorf Astoria, White House and State Department (*i.e.*, the center of activity) during the 1860s. Visitors to this Orange Street house included Chester Arthur in 1882 and Woodrow Wilson in 1917, who stopped on his way to visit his daughter in 'Sconset. The owner of the house has been coming to Nantucket since he was a young boy in 1903. Plumbing was added in 1908. In 1924 his father purchased a lifetime membership for him in the newly-organized Nantucket Yacht Club for $100.

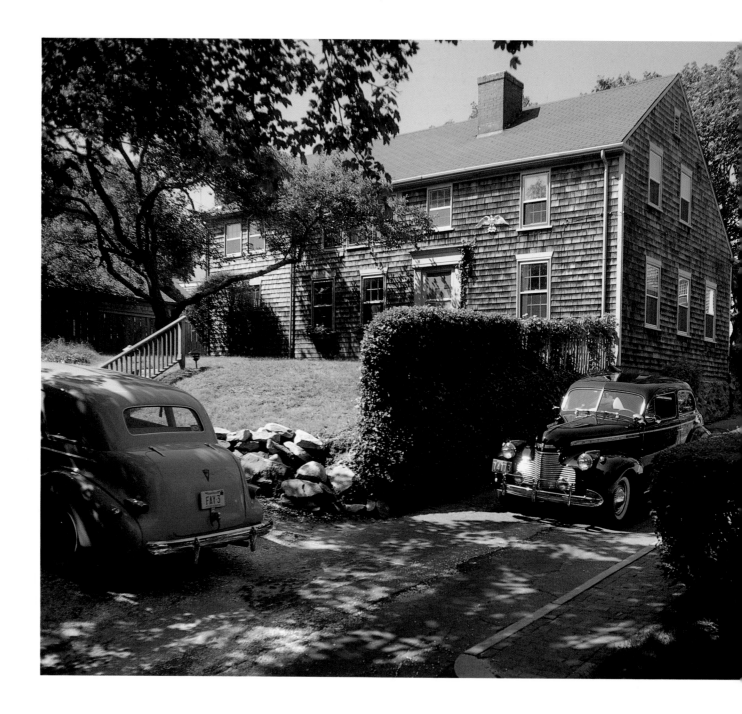

Mulberry Street, showing the David Harris house (*ca.* 1796) on the right and a nicely weathered Sears Roebuck house on the left. David Harris purchased the southernmost lot in the Fish Lots subdivision from William and John Swain in 1795. The Fish Lots were laid out in 1717—narrow lots stretching from Quanaty Bank to the Main Road (now Fair Street) and from the latter to Pleasant Street. The lots began at Main Street and ended at Mulberry. When the West Monomoy Lots were subdivided in 1726, south of Mulberry, Orange Street was put through connecting them to Main Street. The area was densely built, with narrow parallel streets like rungs on a ladder. This was where the people who made Nantucket work actually lived: shopkeepers, sailors and school teachers. A majority of the island's churches are located here.

Mulberry Street takes its name from a large grove of mulberry trees planted here in connection with the Atlantic Silk Company. The Commonwealth of Massachusetts, with the encouragement of Aaron Mitchell, William Gardner, Samuel Tuck and William Coffin, had agreed to subsidize a silk manufacturing operation in 1835 by offering a dollar for every 10 pounds of cocoons raised and another dollar for every reeled pound of silk. The town of Nantucket financially backed the planting of the mulberry trees to

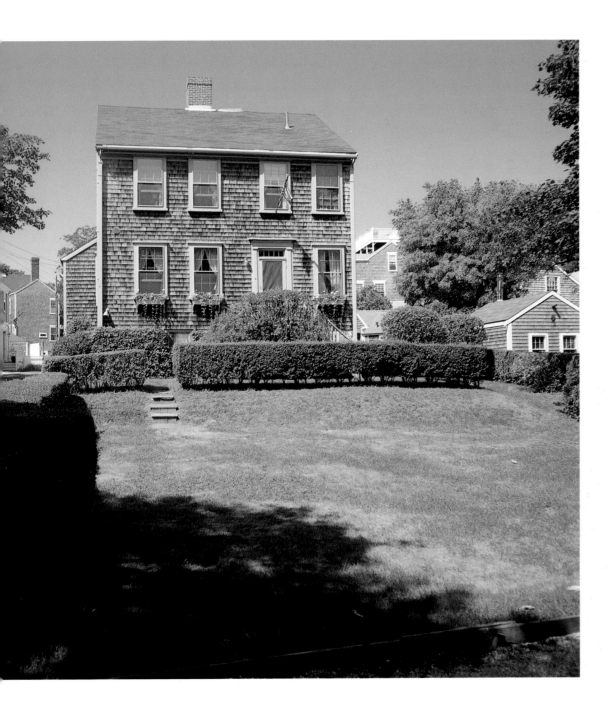

feed the silk worms, with numerous merchants joining in, elated at the thought of prosperity from silk. But when the subsidies ended, the mill shut down, eight years after it began operation. Gameliel Gay, the mechanic-inventor who installed the steam-powered looms at the mill, was commemorated with the renaming of Coffin Court to Gay Street. Mulberry Street was also named at about this time.

At the left is the rear of a 1940 LaSalle Series 50 sedan, and on the street is a 1940 Chevrolet Special. The LaSalle was introduced by Cadillac in 1927 on the latter's 25th anniversary. It was discontinued in 1940. Chevrolet, however, was going strong. This car is named for Louis Chevrolet, a Swiss who moved to the United States in 1900, produced his first car in 1911 and sold out to General Motors in 1915. Over the years it has been our country's best-selling automobile. However during the 1950s this was the only General Motors car without a frivolity. The left tail fin of the Cadillac hid the gas tank lid, the Indian head on the Pontiac hood lit up at night and Buick had its engine portholes. Oldsmobile had a lucite dome on the steering wheel with planets, stars and rings of the Olds rocket moving past.

The David Harris house shows typical Nantucket activities from addressing wedding invitations in the living room (*opposite, bottom*), preparing for Casino tennis (*opposite, top*) to snoozing on the hall settee as Buckles is doing (*right*). Having read the latest Yacht Club bulletin Buckles reclines on his settee to contemplate all the events he will pass up. A portrait of the owner as a young girl hangs in the dining room (*above*).

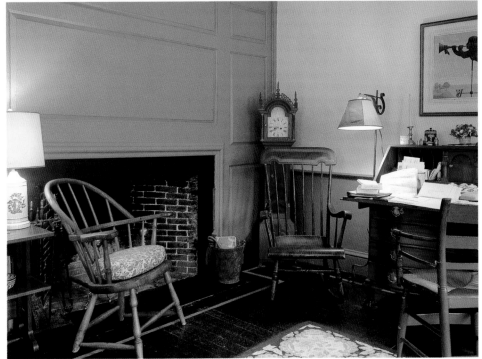

Right: The Henry Dow house, 24 Union Street (*ca.* 1798, 1991). This house is located on one of the only original dry spots on Union Street. It was damaged in a fire and largely rebuilt in 1991 with efforts by many loyal community members.

Below: The Joseph Chase house, 7 Mooers Lane (1745). The street is named for Capt. William Mooers who sailed the *Bedford* into London in 1783, displaying the new United States flag for the first time in a British port. Originally the street was called Judith Chase's Lane after the wife of Capt. Joseph Chase.

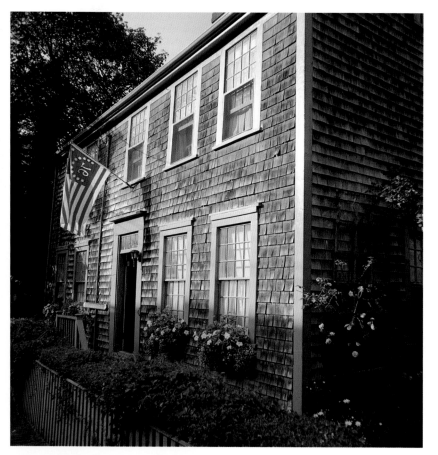

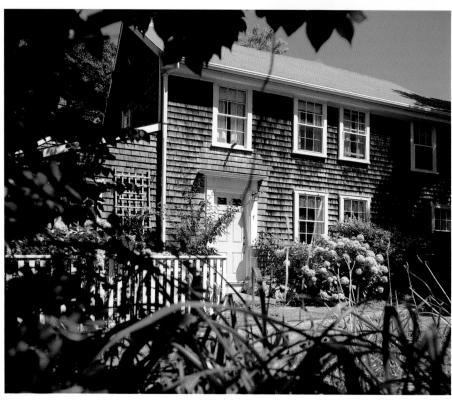

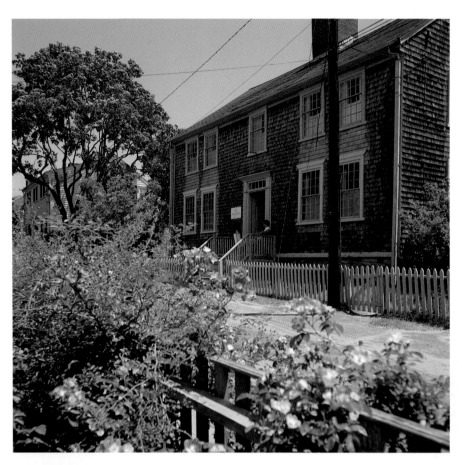

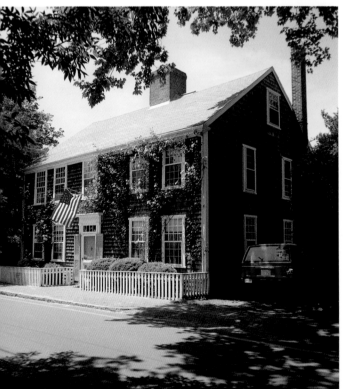

Above: The Jeremiah Lawrence house, 4 Mill Street (1807), also known as the 1800 House. The house is transitional from Georgian to Federal. Eunice Lawrence ran a successful dry goods business here for over 30 years. It is now owned by the Nantucket Historical Association.

Left: The Prince Gardner house, 9 Milk Street (1740), originally located in old Sherburne. After the rustic design of the early houses, by the middle of the eighteenth century Nantucket houses were becoming comfortable. But Quakerism was spreading on the island, and its beliefs in plain living, honest work and simple dress affected Nantucket architecture. Good craftsmanship was prized over ornamentation. This was the style that prevailed from about 1760 until well into the 19th century. The familiar gray cedar shingles were prevalent even then.

The Tristram Starbuck house, 12 Milk Street (1784). This is typical of the many Nantucket homes built between 1760 and 1815. Tristram's successful son, Joseph, lived across the yard on New Dollar Lane and from there it was a short distance to the brick homes of Joseph's three sons on Main Street. The property had a cooper's shop and its own well. During the first half of the nineteenth century it was owned successively by Macy men—Paul, Barzillai and Frederick, all Nantucket merchants. In 1840 it was purchased by Capt. Benjamin Chase for $1800 after a successful four-year voyage on the *Fabius*.

Above: The entrance foyer and dining room have neighboring fireplaces. The one on the left backs up to that of the living room (*opposite, bottom*). The paintings shown here are by the recent owner of the house, Ellen Selden. *Opposite, top:* A 1951 Pontiac Chieftain calls on the house. This is a straight eight-cylinder car, fitted with Cadillac luxuries such as lights under the engine hood and trunk lid, inside the glove compartment and ashtray and, perhaps the most unusual whimsy of all General Motors cars, a lucite Indian head ornament that was also illuminated at night. (It has not been confirmed that it was modelled after a Monomoy Indian.) This car has Hydra-matic Drive but there is no "park" position.

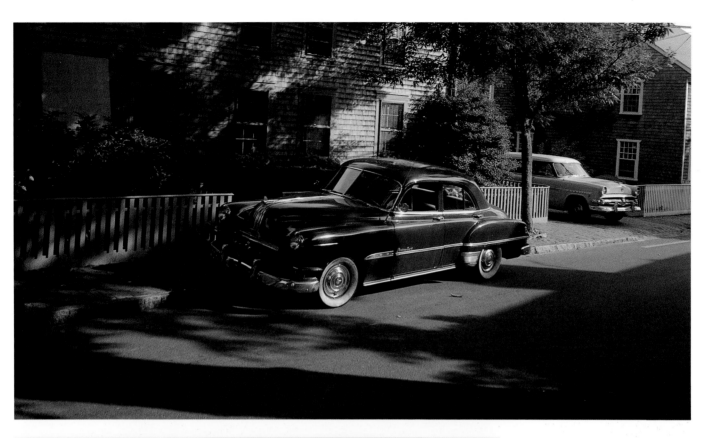

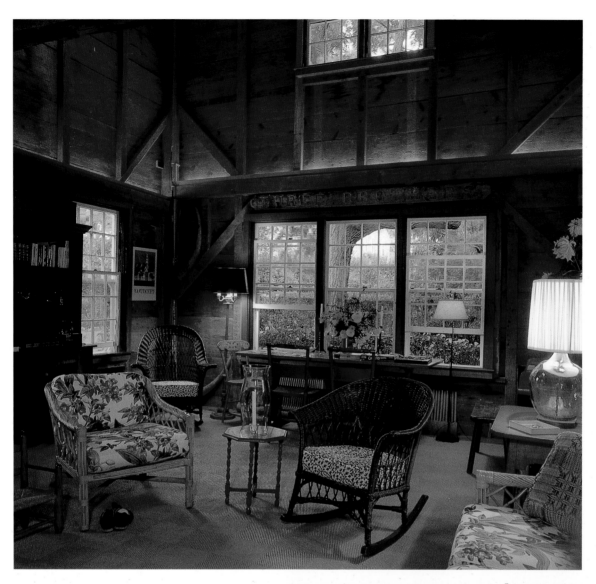

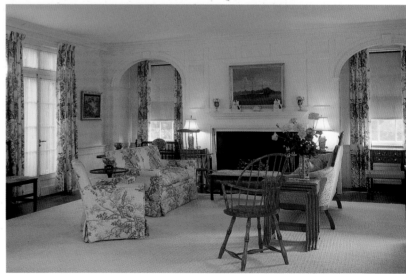

Above: Joseph Starbuck's candle factory, now a guest cottage, and (*right*) the living room of the Starbuck house with a pleasing blend of English chintz and early American antique furniture.

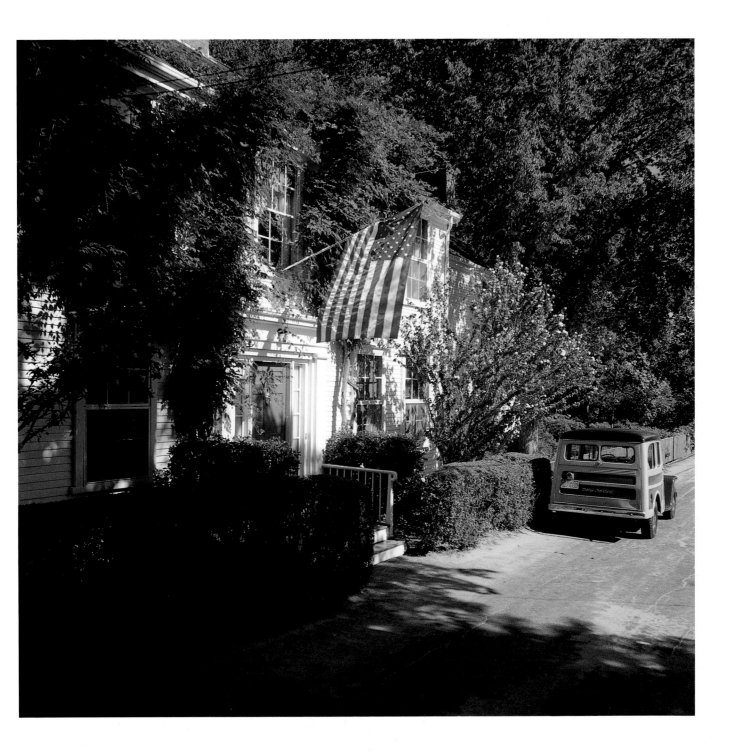

The Joseph Starbuck house, 4 New Dollar Lane (1809). Starbuck was perhaps Nantucket's most successful whaling merchant. He was born around the corner at 12 Milk Street and built this magnificent home, with an oil house and a candle factory, in 1809. He also built the "Three Bricks" for his sons between 1836 and 1838. This was an opulent house for the time and for a Quaker who had recently been put out of the Meeting because he married an outsider, Sally Gardner. Being thus at sea from the architectural restrictions of the Friends, Starbuck set about to build a grand house, with four chimneys so each of the corner rooms could have its own heat, and a central hallway leading from the front door to the back.

Starbuck's prosperity was due to the increased demand for whale oil, Nantucket's staple commodity, and for spermaceti candles—the manufacture of which became an important activity on the island.

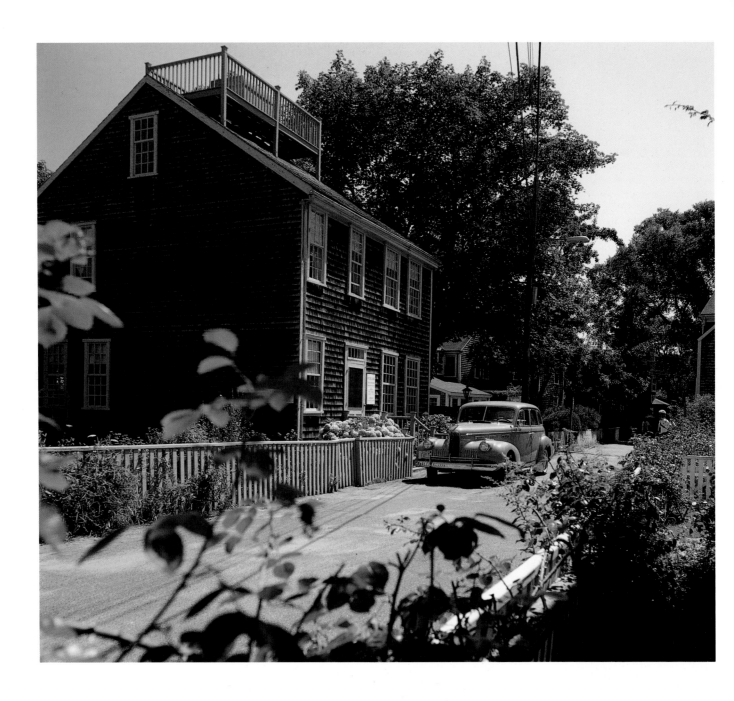

The Hezekiah Swain house (also the Maria Mitchell house), One Vestal Street (1790). William Mitchell purchased the house shortly before his daughter, Maria, was born. He taught her mathematics and astronomy. When she was twelve she charted a solar eclipse and at thirteen captains would bring their navigational equipment to her to be checked and recalibrated. In the evenings she surveyed the sky from the Vestal Street house with a British-made Dollond telescope of her father's. Shortly after, the family moved to rooms over the Pacific National Bank because William Mitchell was a cashier and it was thought depositors, being new to banking, would feel more comfortable if someone were in residence upstairs. This followed a practice popular in Europe and trans-ferred to this country, that of shopkeepers living above their stores.

In 1847 Maria Mitchell discovered a comet, an unusual feat since telescopes were still relatively primitive. She was the first woman to discover a comet, the first woman admitted to the American Academy of Arts, and by 1865 became the first professor of astronomy at Vassar College. (She may have been the first female professor in the country.) Newly-formed Vassar College was itself an unusual institution, dedicated to advanced education of women. The car is a 1940 LaSalle Series 50 sedan (see page 168).

Right: The garden of the Maria Mitchell Association.
Bottom: The Job Macy house, 11 Mill Street (1790). Richard Macy, a Quaker, told his son that if he proceeded with his plans to build a two-story house instead of the acceptable lean-to, he would never set foot in it. It is said he never did.

Quaker houses were self-contained, often with small windows, simple crisp designs, gray shingles, and red trim. The prosperity of whaling brought an experiment with other religions, and, in turn, a more open style of house—one that pushed out from the inside with a variety of bays, porticos and large windows. It was the Georgian style, which offered balanced front facades but still kept the central chimney.

This area, down from Mill Hill, was originally a commons around which the simple gray cedar houses were located. Then came the bustling activity along New Dollar Lane, with shops and homes of coopers, boatwrights, blacksmiths and of course Joseph Starbuck and his candleworks. The pace has subsided and presents a perfect spot for this 1947 Ford woody to take a nap. The car came to Nantucket from Kentucky when it was a baby and has never left. Ford made essentially the same car from 1941 to 1948, stopping production during the war years.

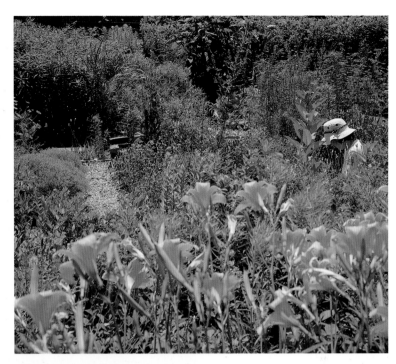

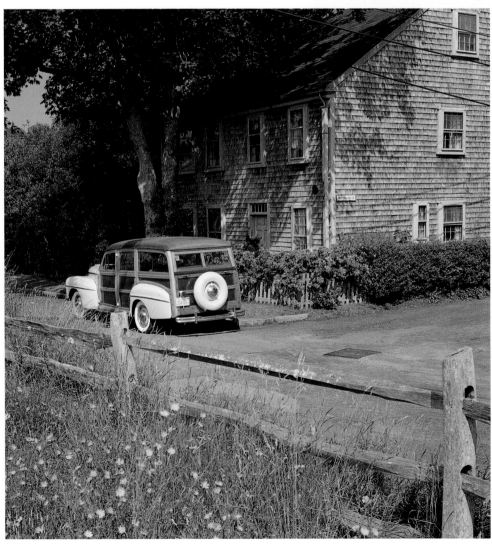

Above: The Matthew Myrick house, 6 Prospect Street (*ca.* 1740). This house was moved here in 1800 from a location near Milk and New Mill Streets, and the family still has a walkway through to Milk Street. Prospect Street was previously known as Cooper Street.

The house was purchased in 1943 for $4,000 at the height of concern over submarine attacks. It had no furniture, but pieces have been added over the years from tag sales, forays to the island dump, and inheritance. A unique feature of this house is the large number of sailing, tennis and golf trophies displayed. This is an unusually gifted family with well over one hundred first places represented.

Right: Training starts early, with these sailing award pennants serving as a reminder to occupants of the bunk beds that greater expectations lie ahead.

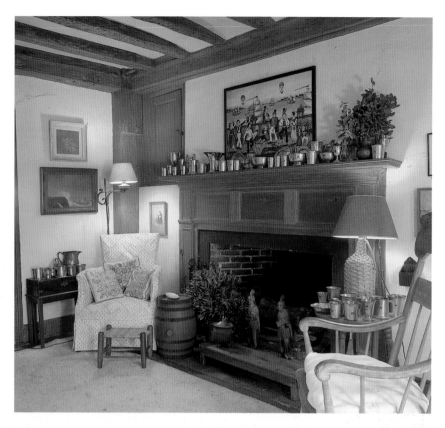

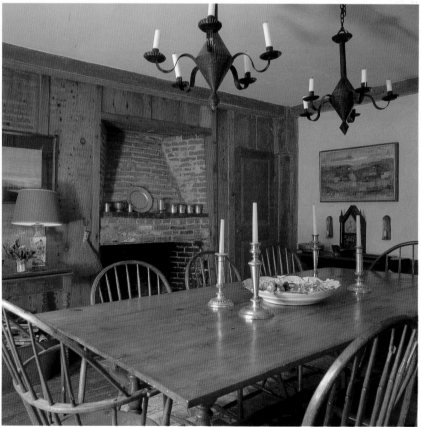

Above: The living room of the Matthew Myrick house and (*right*) the dining room. The collection of pewter and silver trophies, only a small portion of which is visible here, is the largest on the island—all competitively earned.

Flower boxes on Fair Street (*above*) and nasturtiums on New Dollar Lane (*right*). The placid gardens were different then—overwhelmed by the noise and odors of oil extraction and candlemaking, with heavy carts being pulled up the street. The location was dubbed New Dollar Lane in part due to Starbuck's new riches. (It was renamed Risdale Street during an unfortunate period.) Workmen were paid with new dollars every week.

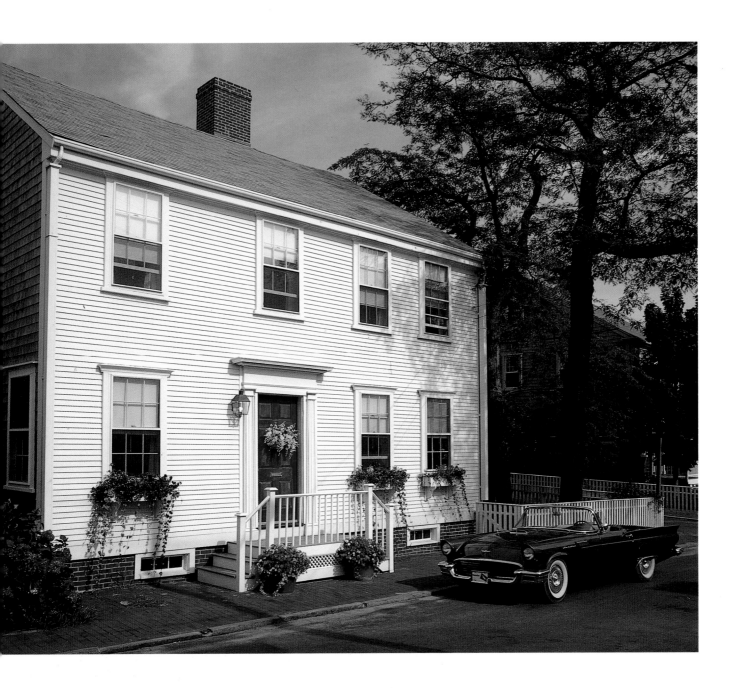

The Frederick Arthur house, 30 Fair Street (1828). Capt. Arthur mastered four whaling voyages between 1823 and 1844. The car is a 1957 Ford Thunderbird. Henry Ford II introduced the Thunderbird in 1955 in response to the popularity of the British Austin Healey and MG. The car was so well received that General Motors contemplated dropping the Corvette. The Thunderbird was one of the first cars to offer safety features such as a padded dashboard, a deep-dish steering wheel and seat belts, none of which anyone paid much attention to then, especially with a roadster convertible. The first car to emphasize safety features, including not only a padded dashboard but a pop-out front windshield, was the Kaiser Manhattan (1953). It drew a few yawns but was a remarkably stylish car. Kaiser-Frazer (1946–1953) was an innova-

tor in automobile design: the first hatch-back sedan, the first four-door hardtop and first modern four-door convertible.

Roland Hussey Macy also lived on this street. He tried various occupations: whaling, prospecting for gold and keeping a shop, all with little measurable success. He therefore left for New York in 1858 and opened a small dry goods store there.

Fair Street is the main thoroughfare of the Fish Lots, Nantucket's second major subdivision (1717) after the Wescoe Acres Lots (1678). Subsequent subdivisions were: the Warehouse Shares Lots (1723), Brant Point Meadow Shares Lots (1735) and Bocochico Shares Lots (1744)—all by the present-day waterfront—and the West Monomoy Lots (1726). Many of the side streets were named beginning in 1797.

Right: Clio ponders the evening meal. *Below:* The dining room of the Woodbox Inn.

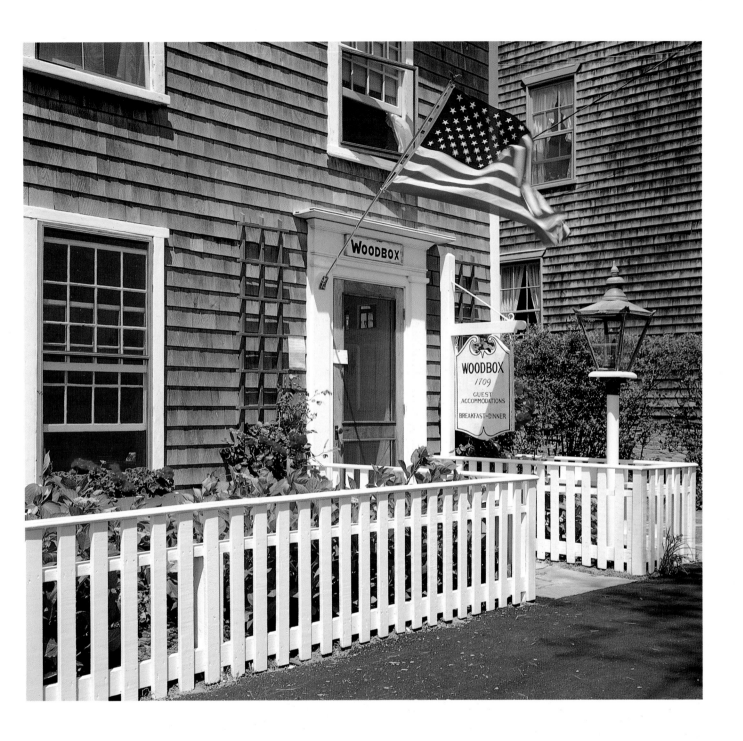

The Woodbox Inn, 29 Fair Street (*ca.* 1740). The original house was built by George Bunker as a lean-to. A second house was built *ca.* 1800 next door at No. 31 as a full two-story house. Subsequently the earlier house was enlarged to match. The two buildings were joined in 1931. The Woodbox Inn is one of Nantucket's oldest inns and restaurants—a popular spot for dining as well as a longer stay.

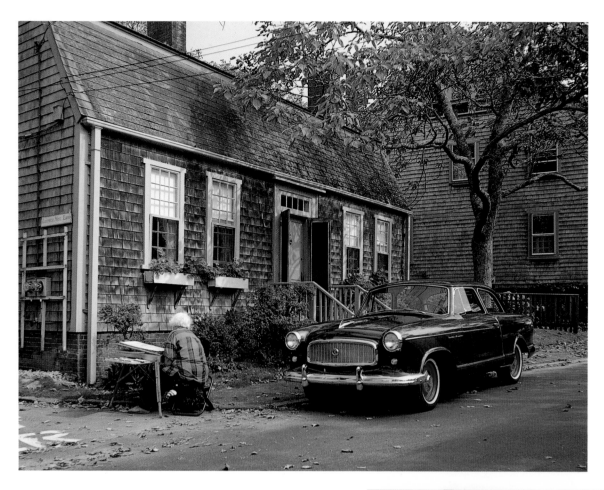

Above: The George H. Gardner house, 8 Pine Street (1748). The house remained in the Gardner family until 1780 when Capt. Paul Pinkham bought it. When he lived here, Capt. Pinkham was keeper of Great Point Lighthouse and was the first to chart the Nantucket Shoals—from the tower of the light.

The house has one of the few gambrel roofs on the island. The word "gambrel" comes from an old French word "gambe" for leg. The unique roof design resembles the hind leg of an animal. The house has an academic address—Pine Street between School Street and Lucretia Mott Lane. The latter was a Quaker who became an outspoken abolitionist in the 1800s, working with Elizabeth Stanton and Susan B. Anthony in founding the Women's Suffrage Movement. Pine Street was once Hayscale Lane, School Street was Gardner's Lane (after the owner of this house) and nearby Mooers Lane was Judith Chase's Lane (after a resident there). Many of the side streets were officially named in 1797, and the main streets with British ties were renamed. Hence Queen Street became Gardner Street and Crown Court became Quince Street. Federal was added to this roster (which already included Liberty), with Union and Washington coming later.

Outside, the owner's 1959 Rambler has returned to visit.

Right: Tucker keeps watch over the foyer activities.

Above: The rear sitting room was originally a workshop to which additional windows and warm panelling of boards from Nantucket attics were added in 1942. The house was purchased by the owner's parents in 1941 from Augustine Lawrence who was a Harvard classmate of Franklin Roosevelt and whose family had lived here for many years.

Left: A four-panelled screen (American, *ca.* 1850) depicts sailing ships from a harbor setting. Note the glass transom over the door which led to the old borning room.

Right: The kitchen of the George Gardner house and (*above*) the front parlor. The house originally had a central chimney, the base of which is visible in the kitchen cellar. A new flue was subsequently added on the south side of the room.

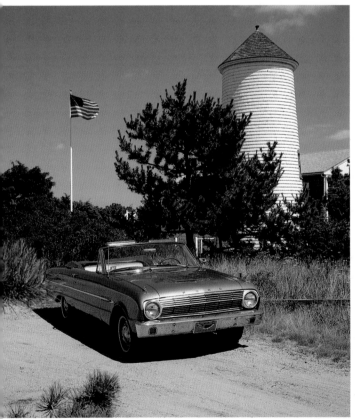

Above: The rear lawn of a Hulbert Avenue residence offers splendid panoramas of harbor arrivals.

Left: One of the "Bug Lights" on Pawguvet Lane. There are two such lights near Jefferson Avenue built in 1838 as navigation aids. Prior to their relocation from Brant Point in 1921, when the two lights were properly aligned, a skipper was assured of entering the channel correctly. Today Brant Point has orange flag markers, and the original bug lights are now summer residences, visited on occasion by this 1962 Ford Falcon convertible.

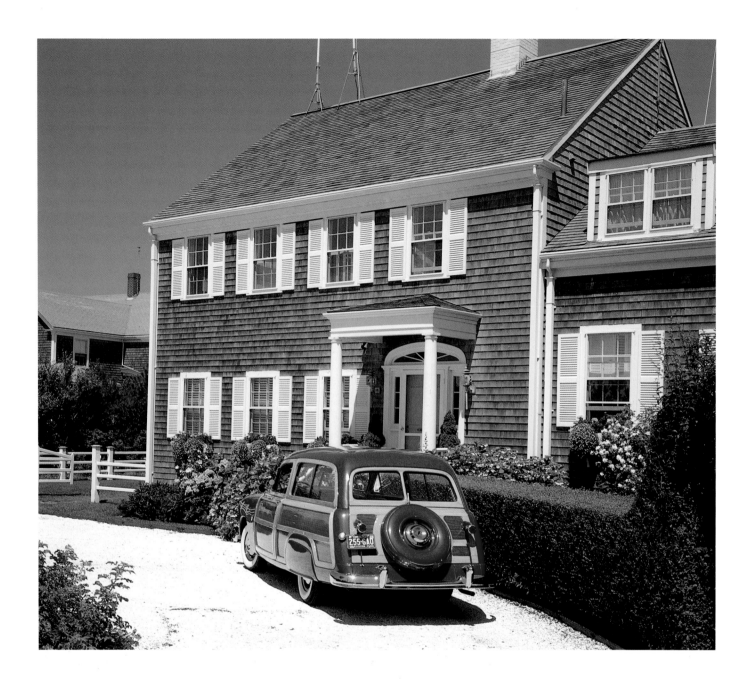

A summer cottage, "Weather Edge," 61 Hulbert Avenue (1921). Hulbert Avenue is named after one of the first families to live here, in an area called Beachside. The Nantucket Hotel (1883–1884) dominated the area on the shore west of Brant Point. Hulbert Avenue was a sandy slough that was drenched at high tide. It was filled in by the hotel to keep the area from flooding. Unlike houses on the Cliff, these were designed with minimal lawns because their owners were more into sailing than garden parties. The majority of Hulbert Avenue homes were built in the 1930s–1940s whereas the grander Cliff Road homes date from before and just after World War I. Many homes have docks and moorings in the back yard, reflecting the owners' interest in sailing and swimming. The homes also lack the wide verandas typical of the Cliff, representing a new era when evenings were not spent rocking on the porch but rather inside listening to the radio or television. The car is a 1951 Ford with Ford-O-Matic Drive and a Magic-Air heater. This was the last all-wood Ford station wagon made (it has an interior roof and door panels of wood as well). It was also the only time Ford offered a two-door, 9-passenger wagon, making the climb to the third seat an athletic challenge.

Opposite, top: George Davis, interior designer and trompe l'oeil artist, makes notes next to some of the work done by his colleague Bruce Dilts. *Opposite, bottom:* The living room of this house was designed by Mr. Davis. Shown is a striking all-white floral arrangement by Jessica Woodle incorporating her Casablanca lilies.

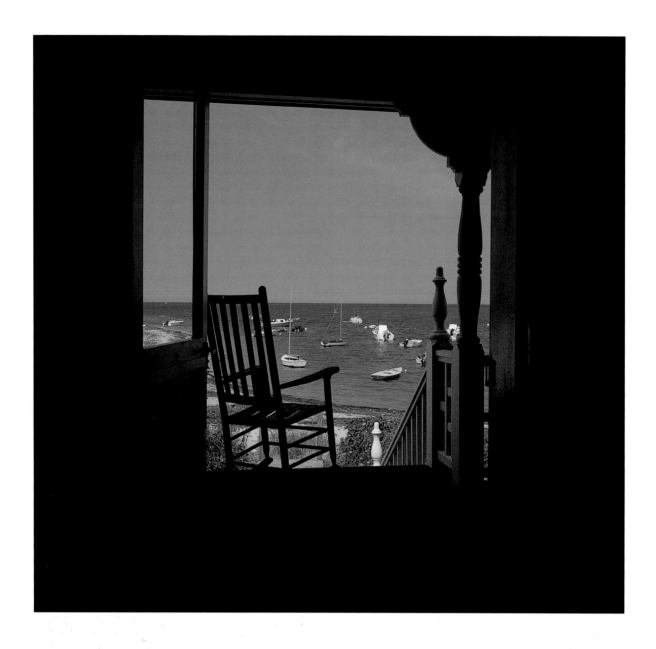

The Edwin Hulbert house, 73 Hulbert Avenue (1880). This was the first residence built along the street named for this family. Edwin Hulbert was the discoverer and subsequent operator of the Calumet and Helca copper mine. A later suit about it so discouraged him that he subsequently moved to Rome. Originally the Nantucket Hotel presided at the eastern end of the street, but it was eventually taken down as more vacationers discovered a preference for owning homes rather than staying as guests at an inn. Woodrow Wilson visited here as a guest of the Peck family when he was on the island in 1917. The house is noted for its Victorian features including a wide porch with uninterrupted views of the entrance to the harbor.

In 1975 the house was moved two hundred feet closer to the water. A pool and extensive landscaping were laid out in 1980. It is now the home of Joyce and noted sculptor Seward Johnson of Princeton whose lifelike bronze sculptures may be seen throughout the country.

With the development of Hulbert Avenue in the 1920s Nantucket had three main summer groups: the Cliff Road group—social and golf-oriented, who largely contributed to the island's golf clubs; the Beachside (Hulbert Avenue) group—sailing enthusiasts who organized the Nantucket Yacht Club from the old Athletic Club; and the 'Sconset Bluff group—who established the 'Sconset Casino due to their interest in tennis. To these three must be added a fourth group which evolved in the 1960s—the Historical group—composed of the many individuals interested in the purchase and restoration of the island's trove of old homes.

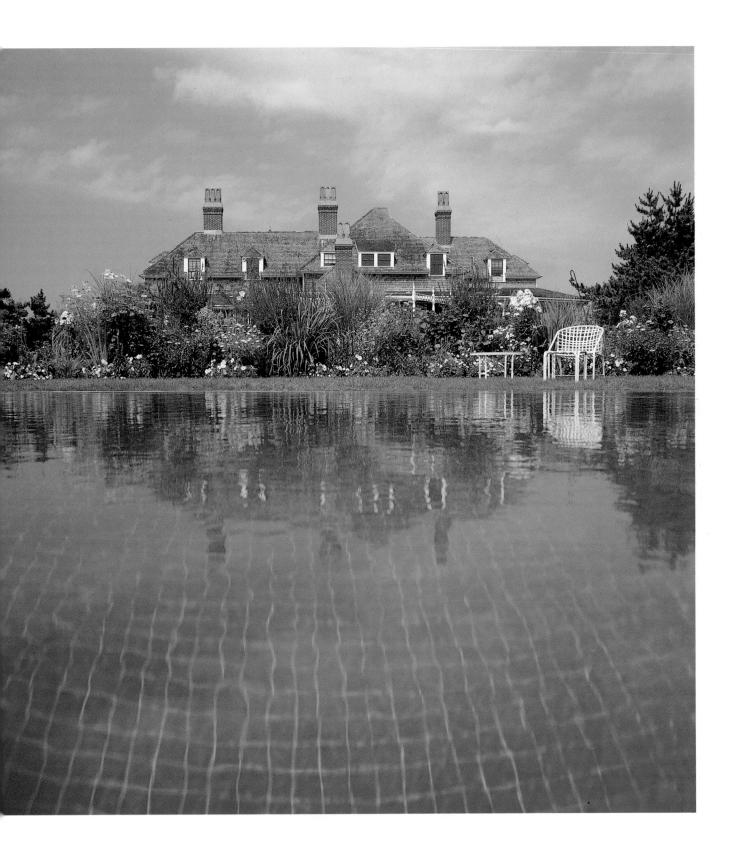

Above and *opposite:* Summer homes on the Cliff. The first Nantucket summer homes were built along the Cliff Road area (then called North Street) with unlimited access to the water. Homes along Hulbert Avenue came later. A public way ran along the Cliff in front of the houses as does one along the Bluff in Siasconset. Many of the Cliff houses were grand edifices designed to be run by large staffs.

At the location of the above house stood the Sea Cliff Inn, designed by Robert Slade and opened in 1887. For eighty years it dominated the area and was a factor in the name change from North Street to Cliff Road. It was the first Nantucket hotel built in the Queen Anne style with both shingles and clapboards plus a variety of dormers and roof details. The hotel had two large parlors, reception rooms, a billiard parlor and a 300-seat auditorium. It also had a half-mile boardwalk to the beach at the West Jetty so its patrons would not have to trudge through the sand dunes. One of the hotel's guest houses still stands on Cliff Road. The main building was razed in 1972.

Above: The Folger Hotel, 89 Easton Street (1891, 1904). This property was purchased by Charles Folger from Elijah Alley in 1888. A large hotel opened in 1891 as the Point Breeze Hotel—three full floors on a high basement where the bowling and billiard facilities were located. The hotel boasted the latest conveniences, including electrical signal systems (operated by its own generating plant) and telephones. Electric lights came shortly thereafter. An adjoining pavilion, built in 1904, still stands today; the original structure was destroyed in a 1925 fire.

Right: One of the island's newer hotels is the Breakers located next to the White Elephant Inn on Easton Street. It carries the same name as a guest house that was razed in 1972.

"Innishail," 11 Cliff Road (1895). The name of this large summer home (9 bedrooms, 6 baths and 5500 square feet) is Gaelic for "Heaven of Rest." The house includes a large collection of styles plucked from different architects' repertoires. It has double gambrel roofs with a massive chimney off center and balanced by two large dormers. Windows include round, square, Palladian and double-hung sashes ranging from 4 over one to 15 over one. Three styles of railings are used. It was built by the Nevins family and operated as a summer guest house until 1907. Frederick and Edith Meyer purchased the home in 1915. Mr. Meyer was an early associate of the Curtis Brothers in starting the *Saturday Evening Post*. The Meyers were participants in the formation of the Sankaty Head Golf Club (1921) and the Nantucket Yacht Club (1924). Mr. Meyer died in 1929 from influenza; his wife died in 1959 and the house is presently owned by their grandchildren, the Flint Ranneys.

Above and *opposite:* The White Elephant Hotel (1963, 1989). The first White Elephant Hotel on this site was owned by Elizabeth Temple Ludwig in 1920. It was originally an assemblage of old houses and buildings she began gathering in 1917 on a prime spot near the Children's Beach and the new Nantucket Athletic Club. It re-created the grandeur of the Nantucket Hotel and even incorporated two of the latter's wings into its structure. The name of the hotel derives from colleagues questioning Mrs. Ludwig's business acumen in purchasing such a large and rambling building. (Some may have thought she was a lineal descendant of King Ludwig II of Bavaria who was into castle building on a large scale.)

In 1962 Walter Beinecke and the Lawrence Millers (father and son) bought and razed the old hotel, replacing it with a splendid new one designed by Errol Coffin (who also did the Jared Coffin House restoration). It has become the island's leading waterfront hotel.

In front of the hotel is a 1956 Ford Crown Victoria. The model was also called a four-door hardtop convertible. The top did not go down, but with no support pillars the openness of this four-door sedan was equivalent to sailing. Note Ford's stylish two-tone paint colors and wrap-around windshield, remnants of a time when automobiles had more flair.

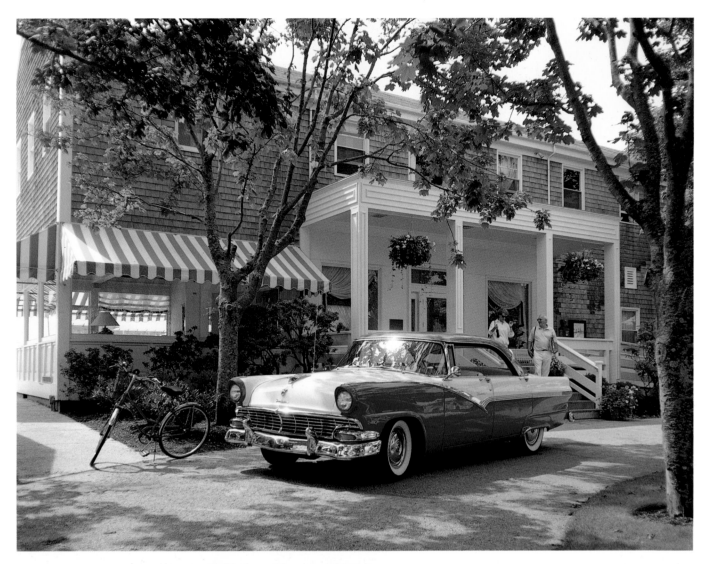

Left: Dining *al fresco* on the patio of the White Elephant Hotel on Easton Street. The street is named after George Easton (1785–1875) whose family were real estate promoters and also owners of a wholesale cranberry business on the island. The street is the continuation of Chester Street after Cliff Road and North Water Street. In the early 1800s there was a rope manufacturing operation here, later followed by a marine railway station.

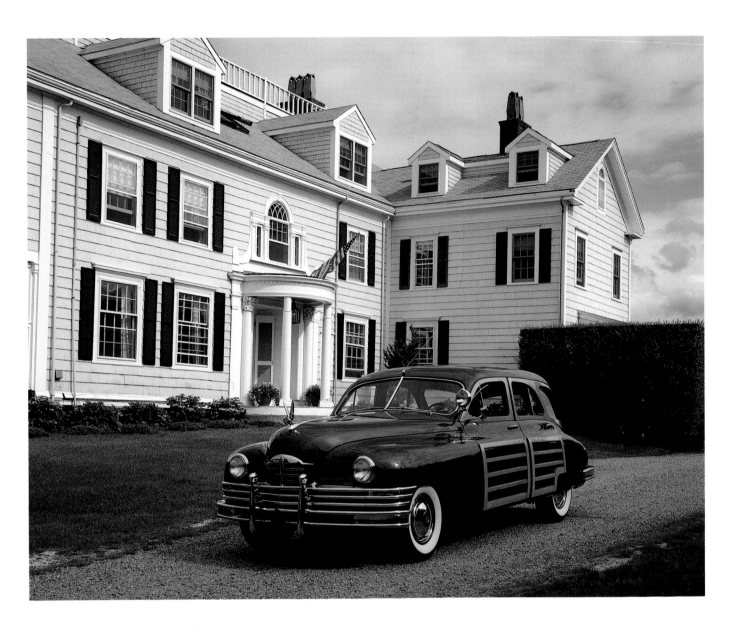

The Westmoor Inn on Cliff Road (1917). This lovely Federal-style house was built as a private residence by Wilhelm Voss of New York who had the foresight to marry into the Vanderbilt family. Unfortunately, like Jared Coffin's before it, this spacious private house proved too remote and the social sirens of the Hamptons kept the Vosses from really occupying it. It changed hands many times before becoming an inn under the Holdgate family in 1953.

The car is a 1949 Packard Eight Station Sedan, a concerto in wood and metal. This is one of the last beautiful Packards made. The company was founded in 1890 by James Ward Packard and produced America's best cars, pioneering in the development of the gasoline engine, ignition, transmission and braking systems. It was the first to offer a radio, and as early as 1938 it had air conditioning and power windows. Pierce Arrow may have been more upscale but Packard was the choice of businessmen and the White House. "Ask the man who owns one" and "Getting there is half the fun" were two of our century's most familiar advertising slogans. The latter was used by Cunard Lines to promote its posh way of travel (posh being the Pacific & Orient Lines' acronym for port out starboard home—the preferred way of sailing to the Orient from England in order to be always on the shady side). When inquiring about a Packard the company simply said to ask the man who owns one, do not bother with *Consumer Reports.*

So what happened to Packard? The ten years, 1948 to 1958, brought more changes to the American automobile than any decade before or since. The immediate post-war years were forgiving. Pent-up demand allowed everything that moved to sell: Kaisers, Frazers, Crosleys, Willys-Overlands, and even Tuckers. Sears Roebuck had its own brand, the Allstate (made by Kaiser). But by 1948 the "Big Three" started to promote innovations such as the high compression V-8 engine, power steering, brakes and windows, the wrap-around windshield and fully automatic transmission. Cadillac, Lincoln and Chrysler's Imperial had the resources of their companies' high-volume, lower-priced cars to support these engineering and stylistic advances. Packard did not. It kept up, but no longer led. In 1954 it merged with its old competitor, Studebaker (a firm tracing its origins to 1852 and once the largest wagon manufacturer in the world) and its marque disappeared in 1958. The great dowager expired, more or less gracefully.

Above: The Unitarian Church, 11 Orange Street (1809, 1830). This was built as the Second Congregational Meetinghouse by Elisha Ramsdell. It became Unitarian in 1824 and the front tower was added in 1830. Its metonym is South Tower.

Right: Old North Vestry (1725). This is one of the oldest continuously-used church buildings in the United States. It was moved from the edge of town to Beacon Hill, where the "Big Church" stands, in 1765. The original vestry was so well constructed that in spite of the disassembly and move, all of the doors to the pews swung easily on their hinges afterwards. A bell was installed in 1800, the first on the island.

Opposite: The First Congregational Church, 62 Centre Street (1834, 1850), also known as Old North Church. It was built by Samuel Waldron of Boston on the site of North Vestry which was moved a few feet to the west. Originally it had only three windows on the side but in 1850 the church was lengthened with the imposing front added. Construction was completed in 1968 when the familiar spire was added to the tower—lowered by helicopter. The steeple is 125 feet high and the observation platform is 94 (count 'em) steps up from the ground. The car is a 1949 Ford station wagon.

The Churches

Above and *opposite:* The First Baptist Church, One Summer Street (1841). The original plans by Frederick Brown Coleman called for a front portico but this was eliminated. The frame for the church came from Maine. The steeple received a 1600-pound bell, cast in Troy, New York, in 1854. This is perhaps Nantucket's prettiest church, with graceful unpretentious lines. The steeple was replaced in 1961 and needs replacing again.

The first religious group on Nantucket was the Religious Society of Friends (1708). The Quakers first came to Nantucket in 1670 and, until the 1840s when they began to lose their hold, a degree of severity prevailed. Homespun clothing of gravest color (or none at all) was the mode, women wore no makeup or jewelry, and no dancing was allowed. If there were painted portraits in the home, music or a marriage to an outsider like a Baptist or Presbyterian, for example, one was exiled from the Friends' meeting.

Because the Quakers were so prevalent on Nantucket in its early years, it was only with the dissention among the Friends in the 19th century and the rise in other Protestant sects that other churches were built. By this time they had to be strung along the streets wherever a suitable lot could be obtained. There are no churches on a prominent village green like elsewhere in New England. Nantucket's churches represent all of the basic styles of the last century: Meetinghouse (North Vestry), neo-Gothic (Congregational), Greek Revival (Baptist, Methodist, Unitarian) and Romanesque (Episcopal and Catholic).

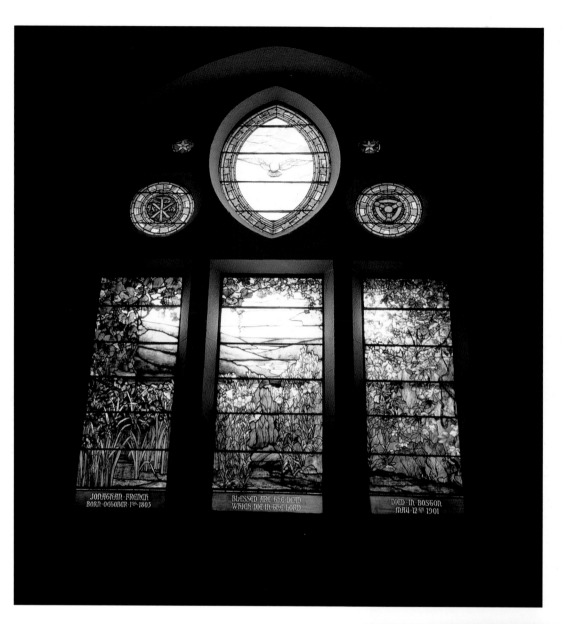

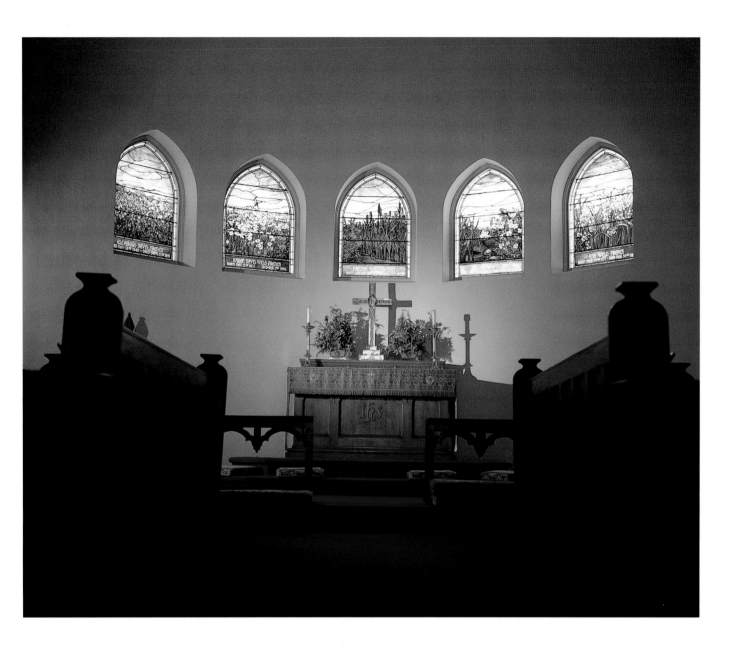

Above and *opposite:* St. Paul's Episcopal Church, 20 Fair Street (1901). Trinity Church was where the Episcopalians first worshipped as a congregation. This was an old Quaker meetinghouse on Broad Street just east of the Ocean House (now the Jared Coffin House). It had been retired by the Quakers, and the Episcopalians, leaning back to the traditional design of the Anglican Church, covered the wooden walls with plaster and turned it into a granite-looking structure. It was not able to hold up its image, however, and burned in the 1846 fire.

The present church was built with the benevolence of Caroline French, daughter of a prominent Boston and Nantucket merchant, Jonathan French. She presented the congregation with a true granite Richardson Romanesque church with brownstone trim, pointed arches and Tiffany windows. In many respects it reaches back to the type of European church that prevailed in 1000–1200. Its massive stones and turreted tower reflect a differ-

ent era than the plain, white clapboards of Nantucket's other churches.

Opposite, top: The western windows form a typical Tiffany display, with a distant landscape enclosed on both sides by trellised flowers. In the center is a white dove. These windows are dedicated to Jonathan French. *Above:* Over the altar are five jewel-like windows of Nantucket wildflowers, each dedicated to a member of Miss French's family (sister, brother, mother, grandmother, uncle). In 1970 Erica Wilson designed a set of 32 needlepoint chair seats for the chapel to coordinate with the windows—all Nantucket themes—called the "Song of Creation." Members of the congregation worked on them. And in 1990 the steeple finally got its own bell, a gift of the family of Mr. and Mrs. J. Wilson Fowlkes, Jr., with special care taken that its tone be harmonious with the bells on Old North and South Towers.

Above: St. Mary's Our Lady of the Isle Church on Federal Street (1897). This is a neo-Romanesque structure translated in a very Nantucket manner with gray shingles and white trim. Originally Federal Street marked the edge of Wescoe Acres Lots (1678). But the dunes were leveled and the Bocochico area was claimed in 1743. Unfortunately none of the buildings here survived the devastating 1846 fire.

Opposite, top: The Unitarian Church or South Tower (1809) built squarely on the "Street of Captains" with no setback. The congregation purchased the large Portuguese bell in 1811 and hid it from the British during the War of 1812. Then they ran out of funds to install it. A prosperous Boston congregation got wind of this and, having just completed a new church with a belfry but no

bell, wrote to ask if the Nantucketers would like to sell their bell. The reply, sent on the next packet, was a terse inquiry as to whether the Bostonians might rather sell their church. The bell was finally hung in 1815 and rung by hand until 1957, when it was electrified. The custom of ringing three times a day began in 1811 with the Revere bell in Old North Church. At first it rang only at night to warn people to return to their homes. Later, it was continued three times a day and in 1848, when the South Tower bell and clock became the only official timepiece for the town, the practice was transferred there. Today the bell rings exactly 52 times. No one is sure why but probably it is because that is approximately three minutes' worth, and it was easier for the bell ringer to count strokes than watch a clock.

Right: The interior of South Tower. The famous Goodrich organ was installed in 1831 and is now the oldest American-made organ still in its original setting. In 1843 Carl Wendt, a Swiss fresco artist who introduced trompe l'oeil painting to America with the decoration of the old Treasury Building in Washington, painted the magnificent interior. It is therefore one of the oldest examples of trompe l'oeil in this country. He used a subtle palette of warm and cool grays, providing a baroque touch to the church, which has now been carefully restored.

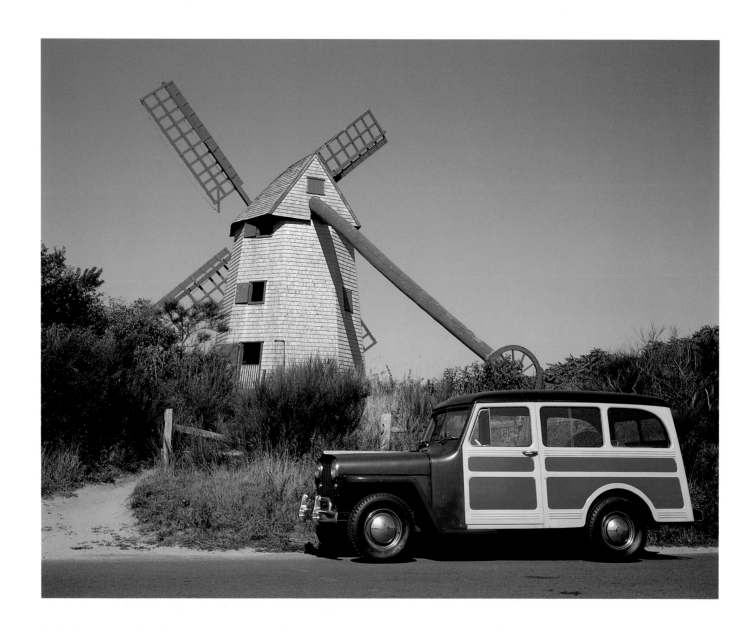

The Old Mill (1746). Originally there were four mills on Mill Hills or Popsquatchet Hills. This one was designed and built entirely by one man, Nathan Wilbur. It is held together with hickory wood pins; nails were too expensive then and bolts were unheard of. The top rotates into the wind with the help of a fifty-foot mast, which follows a stone track on the ground. Canvas sails are added to the blades to help catch the breeze. A brake activated by an oak beam and heavy stones keep them from turning too fast.

The "nether" or bottom grindstone is on the second floor allowing corn meal to be poured into a hopper below. This two-ton granite stone can be raised or lowered depending on the friction needed to balance the velocity of the wind.

Various mills have been built over the years starting with a water mill at Lily Pond (1666) and a tide mill (1675). Windmills became the answer in the next century. Their turn passed, however, and in 1822 the Old Mill was sold for firewood to Jared Gardner for $20.00, who subsequently discovered it would be easier to repair than dismantle.

The mill was put up for public auction in 1897 and acquired by the Nantucket Historical Association with funds provided by the benefactor of St. Paul's Church, Caroline French. It has been restored to full operating condition and is a tribute to its original designer that it is still going strong.

The car is a 1950 Willys-Overland Jeep Wagon. This is the fore-runner of the famous Wagoneer and built so solidly that, as my uncle used to love to demonstrate, the inside could be cleaned with a hose. Unfortunately it drives like a John Deere tractor. Like the Old Mill, the familiar Jeep is a survivor, passing from Willys to Kaiser (in 1954), to American Motors (1970) and now Chrysler. The Grand Wagoneer was introduced in 1962 and for many years was the only luxury four-wheel-drive station wagon on the market. It was made in the old Willys plant in Toledo, got an average of 10 miles per gallon and was retired from production in 1991 after an unprecedented run of almost 30 years.

Around Nantucket

Travelling about the island has not always been as easy as today by car. In fact cars were not permitted on the island until 1918. When Clinton Folger brought an Overland from the mainland in 1913 in order to deliver the mail to Siasconset, he was forced to tow it to the Milestone Road with horses before he could proceed on the state highway. (Occasionally, he motored through town in the winter and was arrested for defiance.) Few of the original cars are still operating on Nantucket today although there are legacies of Overland's Jeeps here and there as well as a handful of vehicles of the 1920s and 1930s. More prevalent are the handsome woodies of the 1940s, mostly Ford beach wagons that have now been trundling families for three generations.

There are only three major paved roads leading out of town—the Milestone Road to Siasconset, the road leading to Polpis and Wauwinet, and the Madaket Road. Many of Nantucket's open spaces are broad moors laced with sandy trails that criss-cross everywhere and lead in all directions but out. The openness is only fully appreciated when flying across the island. Then one can see the clustering of architectural structures around the harbor and in the island's main villages. The rest is a gently undulating carpet of greens and browns with occasional splotches of pond reflections.

Tucked away are secret treasures—a vast hidden forest of ferns and tupelos, an open field of white daisies, an outdoor dance patio, and herb gardens no larger than a cat boat which bring endless delight to their owners. Herbs are grown on the island for their beauty, aroma and seasoning. But many of the gardeners are learning more about herbs' uses beyond the kitchen counter. Other gardeners have discovered the joy of pools and ponds in their backyards or the pleasure of trellised roses blanketing their summer cottages. From the smallest plot to an open meadow Nantucket has an alluring charm.

Included in the following pages are views of the many outdoor activities that have made Nantucket special to our family over the years: picnics and beaches, golf, tennis and sailing, hiking across the moors. Please take your time now; there is a lot to see.

Garden hideaways offer a perfect spot to read, whether it is the *Boston Globe (above)* or *Mother Goose (right)*. These children are in a special secret garden, a private outdoor dancing patio nestled under the Cliff. Many of the turn-of-the-century summer homes have large porches with gliders and rockers, but few have an outdoor ballroom.

Secret Gardens

Gardens on Mooers Lane (*above*), and Centre Street (*opposite*). Capt. William Mooers sailed the *Bedford* into London in 1783 displaying the new United States flag for the first time in British waters. The garden on Centre Street belongs to the David Joy house. Capt. Joy was a master mariner and later a whaleship owner. One of his ships, the *Peru*, was the first to enter Nantucket harbor by means of "camels," while the *Constitution* was the first to exit in this manner.

Right: "Moor's End." This is Nantucket's largest private garden, a large maze of boxwood and roses on Pleasant Street. Most of the box was planted by the Jared Coffins and has survived almost 150 years. The Greek temple in the background, housing a sculpture of the Muses, is a folly—a term used by the British for architectural focal points in their elaborate gardens. This garden is not recommended for beginners or those on a low operating budget.

Two secret gardens that offer privacy with minimal upkeep are a water garden (*above*) and a simple, comfortable reading rock set in a grove of hemlock (*left*). The water garden is self-contained—just a pool, pump, some water lettuce, duck weed and a few fish. The recipe is simple and the tranquilizing effects intoxicating.

Opposite: Secret herb gardens outside kitchen doors. These provide pleasure for the soul (when working with the plants) as well as the palate. Chives and basil are perhaps the most widely-used all-around seasonings. Certain herbs do not mix well (sage and dill for example) while a combination of thyme, rosemary and marjoram can provide a delightful flair to roasts and stews. Starting with providing tasteful seasonings, herbs have become increasingly used in medicine and industry.

Above and *opposite, bottom:* An herb garden in Shimmo, which is an Indian word for "spring." The owner has planted a full-service garden including gray and green santolina, lavender, foxglove and geraniums.

While thyme, rosemary, tarragon, sage and basil have worked their way well into chefs' fingers, other herbs have been around all along to help in areas outside the kitchen. The best-known of course is digitalis or purple foxglove. But in the first century, Discorides, the Greek physician whose list of 600 herbs was the basis of the earliest printed herbals, used the bark of the willow tree to ease the aches and fevers related to colds. This compound is the same that is now formulated into aspirin. (Socrates had often said if they could only find a cure for the common cold how much better the world would be.) Rosemary, probably among the most beloved of all herbs, was used in warm water baths to soothe the joints. Herbal teas have been used as tranquilizers

(valerian root), energizers (ginger or borage) and everything in-between. Rose hips are a major source of vitamin C and garlic is considered an important stimulant. At the prescription counter today it is estimated that 50% of medication contains some natural products and 25% may be extracted solely from plants.

New attention is being focused on herbs for use in industry. The new Chemergic Garden at the New York Botanical Gardens gathers herbs used for oils (rapeseed, jojoba), fibers, hydrocarbons, starches, medicine, dyes and insecticides, according to Eleanor Gambee, former President of the Herb Society of America. The society is now emphasizing herbs as substitutes or supplements to existing resources in an effort to meet rising demands from industry and the expanding population. It is comforting to know that whatever the problem, a solution is often found right under foot.

This jewel is tucked into a corner of a lot off Orange Street. It provides a wonderful mixture of colors, aromas and textures all summer long.

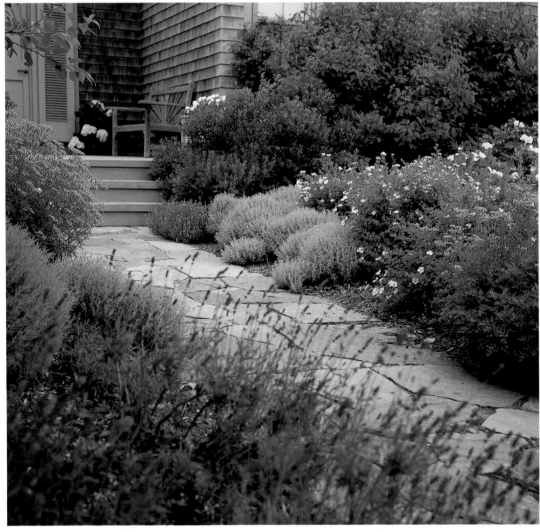

Above: This young golden retriever loves the shade of his hydrangea plants.

Left: Giant pompoms of *Allium gigantium* form a lovely contrast to the daylilies behind. The *alliums* are a large group of mostly hardy plants that are grown for ornament as well as food, including chives, shallots and the common onion.

Opposite: A garden path in Shawkemo is lined with lavender, phlox, coreopsis, lilies, sedum, bellflowers and dianthus. Throughout the summer, it offers a progression of color that is rewarding to the gardener and visitor alike.

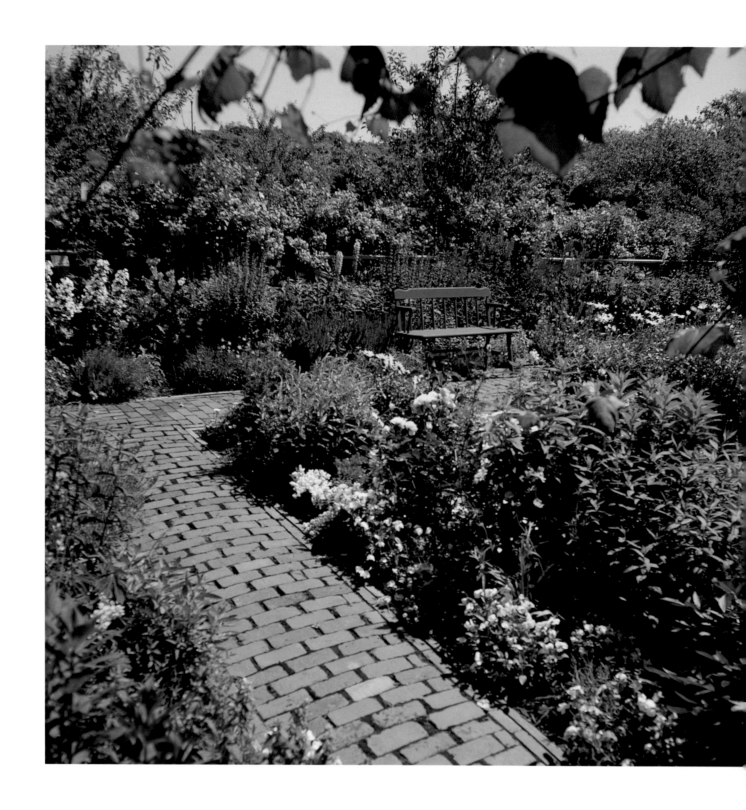

In Polpis is a cutting garden belonging to two extraordinary people. After selling a family business on the mainland they have retired to the island and have been involved in more community activities than almost anyone else—donating time and treasure without reservation. The garden retreat is thus seldom used. But when it is, it stands ready, always blooming whether people are watching or not—dispensing beauty in the same manner as its owners. The beds are filled with delphiniums, marguerites, snapdragons, phlox and larkspur. The old bricks form a new path to lead one into and around this summer bouquet.

Opposite and below: Nantucket water gardens offer memorable tranquility in a small space. Many have recently been designed by Larry Cronin who incorporates water lilies, lotus, pickerel weed and zebra weed plus a variety of irises. He adds a few ornamental carp, the Japanese *koi,* to keep mosquitoes at bay—not only around the pond but for some distance.

Water is a simple element in a garden, known for its calming effects as the gentle splash of a fountain silences the street sounds. The plants and the fish are engaged in their own private world.

Left: A Greek athlete stoops to sniff clumps of catnip, rue, hollyhock mallow in the background and lamb's ears in the foreground.

A formal herb garden by the sea. Tucked away at the eastern edge of the island is a jewel of a garden, 30 by 40 feet, anchored by a pair of old blueberry bushes that have grown into trees. The garden is laid out into four quadrants with pea pebble paths representing the four rivers of life that watered the Garden of Eden as well as the four corners of the earth.

The garden is a wonderful mixture of grays and greens with seven varieties of thyme ringing a center of boxwood. The designer chose to incorporate the box because of its historical association with herb gardens, its delicate leaf and distinctive fragrance. Garden height is given by foxglove, lovage and stalks of angelica. Clumps of lavender define the pebbly walks and quadrants which are filled with gray-green herbs—the color of Nantucket itself. Bee balm, dill and sage add a special fragrance while lamb's ears contribute to the texture of the garden. And for the feline members of the family, a few clumps of catnip plants are judiciously included.

Right: Gray santolina forms a billowy wave washing up against a weathered fence. The fence was put up in 1983 and left to take on a natural look. The narrowly-spaced pickets create a rhythm of graceful garlands. *Below:* Full sun shines down on the garden with only the old 9-foot blueberry bushes (now trees) providing a shady spot. Herbs do particularly well in full sun and are amazingly resilient to periods of drought. They do winter kill however and must be carefully cut back each spring—not a task for those who think only of tending their gardens with a riding lawnmower. The designer has even included clumps of costmary which is also called Bible Leaf because its broad, fragrant leaves were often placed in abbey bibles to keep away a musty smell. Rosemary plants are kept in their own pots; they are one of the few herbs that cannot survive our cold winters. Certain basils and sage are similarly delicate, but the vast majority simply die out and are reborn the following year.

Daisies stretch as far as the eye can see. This extraordinary field is located on the property of the University of Massachusetts in Quaise, which means "at the place of growing reeds." Summer daisies form a showy blanket spread out at the water's edge. The name derives from Old English words for "day" and "eye." This variety is part of the chrysanthemum family, *chrysanthemum leucanthemum,* is often considered an herb and is a hearty soul in New England fields and gardens. The American white daisy is called the oxeye and its blossom actually consists of two groups of flowers —disk flowers in the center surrounded by ray flowers.

In 1964 the University of Massachusetts received a gift of 115 acres of Quaise land from the estate of Steven Peabody. Once a dairy farm, this has been turned into a year-round field research station, with accommodations for fourteen students. The property includes ponds, swamps, a salt marsh, harbor beachfront and lots of open fields, providing almost an entire laboratory of flora and fauna on the island.

The University of Masachusetts is a land-grant college, founded in 1862 as the Massachusetts Agricultural College, with presently five campuses in the state and additional field stations such as this.

Open Spaces

Above: The Franklin Memorial on the Madaket road. The mother of Ben Franklin, Abiah, was born near this spot in 1667—the youngest daughter of Peter Folger who was one of the original settlers and played a pivotal role because he was able to negotiate with the Nantucket Indians. A museum downtown is named for him, and as for the Franklins, another volume might be required.

Right: Off to Cisco Beach on the Hummock Pond Road. John Cisco was an unsuccessful developer of land on the south shore who is best remembered for a beach. Nana Huma was the name of one of the sachems or Indian chiefs who lived here, and the pond's name derives from Nanahumacke Neck. The cyclists are enjoying one of our country's first recreational fads. It began in the mid-1880s with the introduction of the safety bike that replaced the intimidating high wheeler.

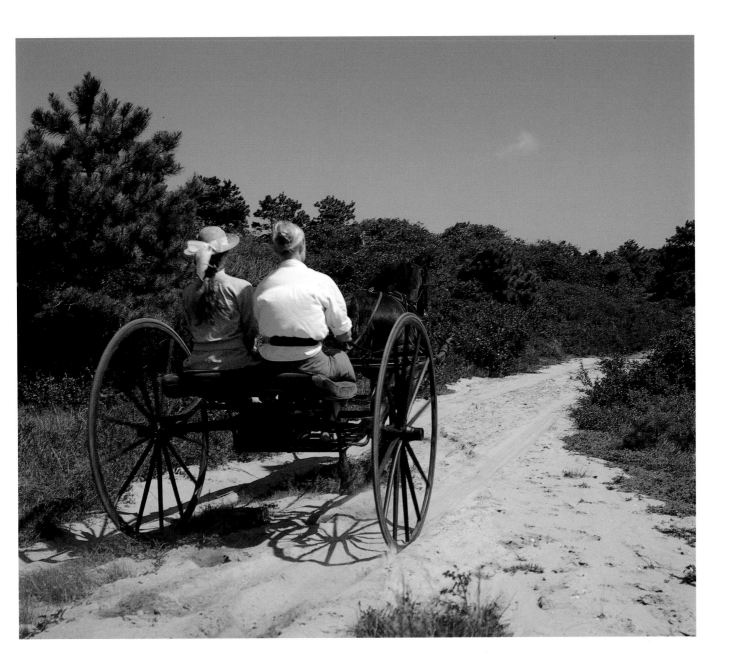

A ride through the moors in an open carriage. Heaths, or "moors" as they are commonly called, are unique in this part of the world. The ground cover is dominated by members of the *Ericaceous* family: bearberry, low bush blueberry, and huckleberry. Also present are bayberry, heather and broom crowberry. Sun, fog and the warmth of the Gulf Stream combine to give the plants all the nourishment they need. Many of these plants, like grass, spread from the base when the tops are nipped off. When Nantucket was into sheep raising, heaths dominated the island. Since the early part of this century, however, scrub oak and other brush have reclaimed much of the heaths. Nevertheless, Nantucket has a greater variety of vegetation than any other spot of similar size in America. Many of her plants have been imported—heath and broom from Scotland, ivy from England, even rugosa roses from Japan.

Nantucket's topography derives from a glacially deposited moraine forming kames (hills) and kettles (valleys) and occasion- ally ponds. Kettles and ponds were actually blocks of ice at one time. Glacial advances brought gravel and rocks down its path, depositing them along steadily melting edges. The Ronkonkoma Moraine is a large such deposit which forms most of the southern edge of Long Island, as well Martha's Vineyard and Nantucket. Large blocks of ice remained under the gravel, eventually melting and forming kettles. When filled with water they became ponds. In recent years Nantucket winds, rain and tides have combined to create an ever-changing coastline with the distinctive points of Coatue, Great Point and Eel Point.

There are no stop lights on Nantucket and only a few stop signs. The countryside unfolds easily because most of the popula- tion is clustered in Nantucket town or at the extremities of the island. There are only three major paved roads—one to the West (Madaket), one to the East (Siasconset) and one to the Northeast (Wauwinet, Quidnet). The rest of the open space is broadly laced with unpaved tracks in sand or soil.

Above: Nantucket quarter horses. This breed was developed in the Colonial era from Arabian ancestry. The name comes from its superior speed (faster than a thoroughbred) at short—*i.e.*, quarter-mile—distances. The horse was a favorite in the early West, known for its endurance under a saddle.

Opposite, top: Queen Anne's lace covers Nantucket's roadsides and meadows with bold snowflakes during July and August. This remarkable flower is actually a carrot. It is named for the wife of James I of England who spent many afternoons with her ladies in the garden at Somerset and who challenged them to produce a pattern of lace as lovely as the flower of a wild carrot. The flower is a compound umbel, made up of 75 smaller umbels each of which contains a colony of smaller florets. The florets are one-eighth inch in diameter and have five petals surrounding a royal purple center. There are 2500 florets (count 'em) per umbel, giving the flower its lacy appearance.

The root of Queen Anne's lace is tough and stringy. During World War I attention was turned to developing plants with greater nutrition. It was discovered that the carrot leaves and roots were an excellent source of vitamin A. Further studies showed that carrots grown in temperatures above 60 degrees developed a plumper root and an increase in carotene, producing the bright orange carrot we are familiar with today.

Below: Cornfields at "Moor's End Farm." This plant, a member of the grass family, is native to America and was brought back to Europe by Columbus and others. It is the second most widely-planted crop in the world, after wheat, with the United States producing about 50% of the total.

During the post-whaling Depression, Nantucketers tried to return to farming only to find the same old problems—poor soil and a short season. The new resort hotels imported everything in the 1890s, adding further to the decline of farming. But now two large farms, "Moor's End" and "Bartlett's," have managed to attain a level of stability and contribute to everyone's table with a wide variety of vegetables and flowers.

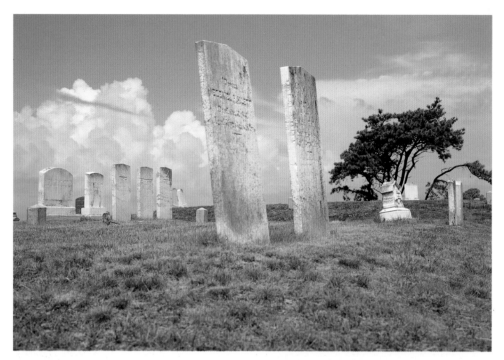

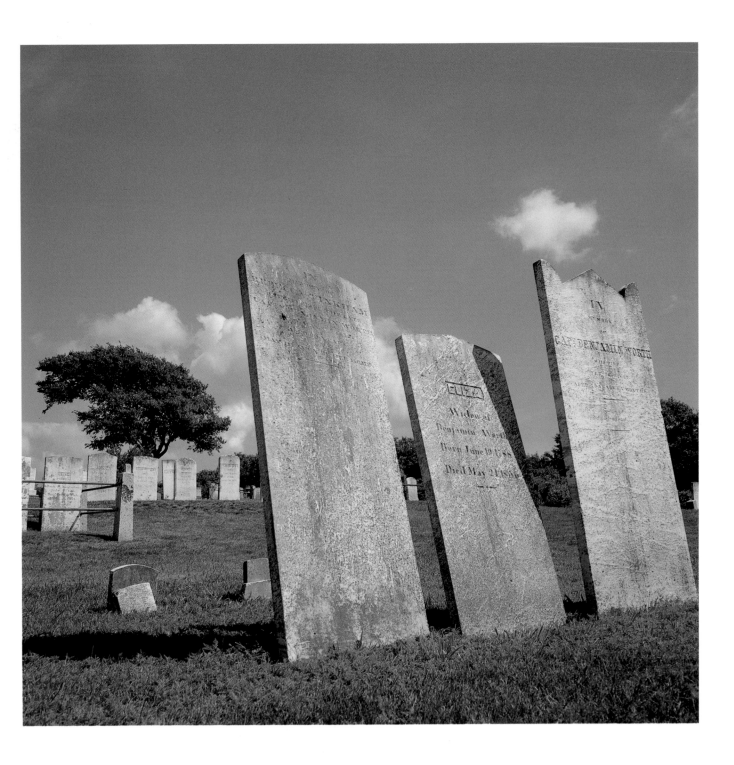

Like the list of their ships, the gravestones of Nantucket's whalers tilt in the wind. *Above* is the Old North Cemetary plot of Capt. Benjamin Worth who spent more years at sea than at home and yet returned safely to retire on the island without losing a single member of his crew. *Opposite, top* is Prospect Cemetery off Milk Street with the gravestones of Deacon Ezekial Hallett and his wife Patia (who died at the age of 92 years, 11 days in 1885), little

Marion, and, on the right, Charlotte and Barzillai Burdett who owned Old North Wharf at the turn of this century.

Opposite, below is the Quaker Cemetery (on Saratoga Street), containing over 5,000 graves with no markers. The Quakers had little tolerance for earthly symbols. The simplicity which prevailed in the early years of Nantucket's architecture and dress was due to their influence.

Look at the lilies of the field and learn from them. They do not work or spin. Yet, I tell you, even Solomon in all his glory did not dress like one of these. If that is us how God dresses the grass in the field, which lives today and tomorrow is thrown into a stove, how much more certainly will he put clothes on you—who trust him so little? Do not worry then and say "What are we going to eat?" or "What are we going to drink?" or "What are we going to wear?" The people of the world run after all these things. Your father knows you need them all. First be eager to have God as your king and his righteousness, and you will get all of these other things too. So do not worry about tomorrow. Tomorrow will take care of itself. Each day has enough trouble of its own.

Matthew 6:28–34

Left: Gibbs Pond, in the center of the Cranberry Bog property. John Gibbs (also known as Assassamoogh) was a Nantucket Indian, a minister and a Harvard graduate. The Nantucket Indians were part of the Wampanoag tribe, which settled in lower Massachusetts. Gibbs Pond is the island's second largest freshwater pond after the east side of Hummock Pond. Long Pond and Sesachacha Pond are brackish in parts.

Below: The Shawkemo Hills are a gentle roll of kames and kettles, crisscrossed by a web of paths leading everywhere but out. Shawkemo means "middle field of land."

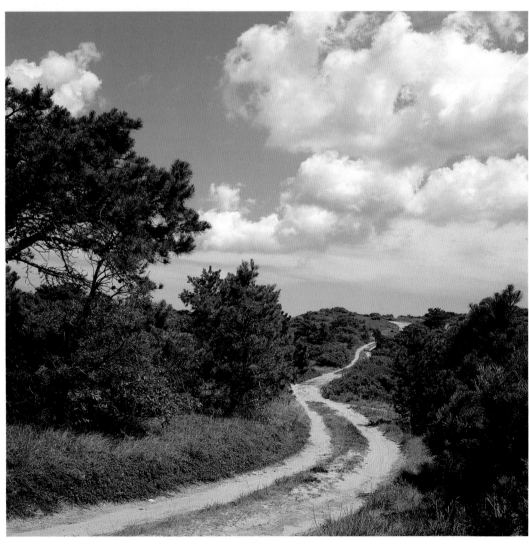

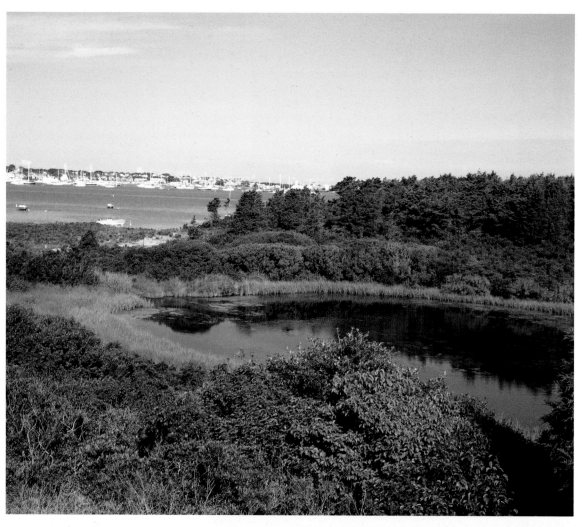

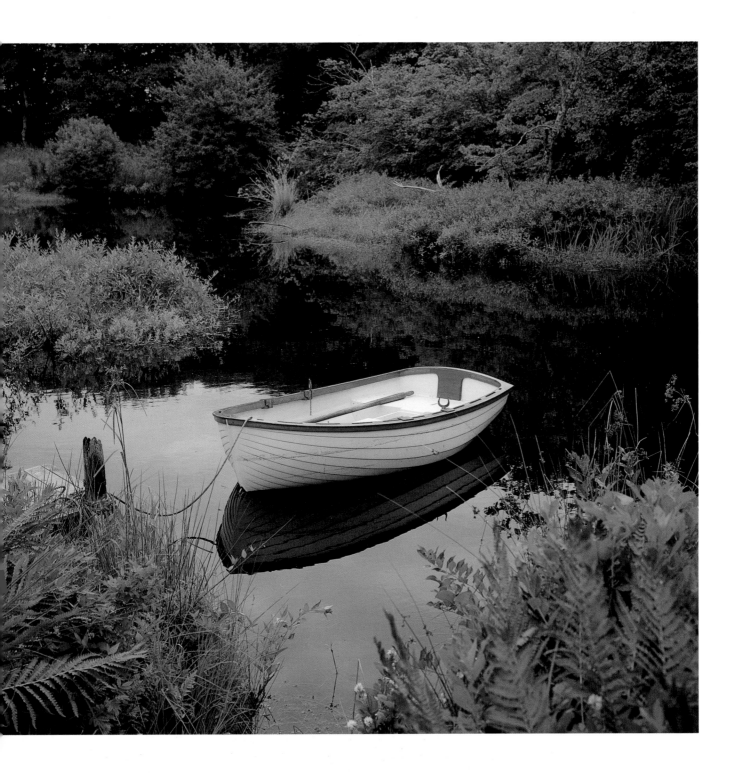

Opposite, top: Pest House Pond in Shimmo. Beginning in 1763 smallpox victims and those with other communicable diseases were settled in this quiet spot across the harbor from town. The practice was discontinued shortly thereafter, however.

Opposite, bottom: Cosmos by the sea. This is an herb of Mexican origins named for the beautiful Greek word meaning order, ornament and universe. Its delicate, showy flower is aptly named.

Above: A lapstrake wooden dinghy in a Polpis pond. The boat is named after the popular dinghies on the East Indian coast and it is of lapstrake construction, *i.e.*, overlapping strakes or hull planks. The ring of ferns gives away the secret that this is a freshwater pond. The little boat does not go very far. It sits quietly tethered, ready for an imaginary voyage or an afternoon's napping spot.

Above: Reyes Pond. This little jewel is named after José Reyes, Nantucket's most famous basket maker who lived near here in Polpis. It is ringed with pitch pines, tupelo trees and arrowwood flowers. *Opposite, top:* The Shimmo shoreline offers pleasing views of the upper harbor. *Opposite, bottom:* One of the Mirror Ponds on the Massachusetts Audubon Society's property at the eastern edge of the cranberry bogs. This is a hidden kettlehole pond with fresh water that fluctuates widely depending on the rainfall. There are two mirror ponds near Sesachacha that are popular with deer and other wildlife because of their calm spring water.

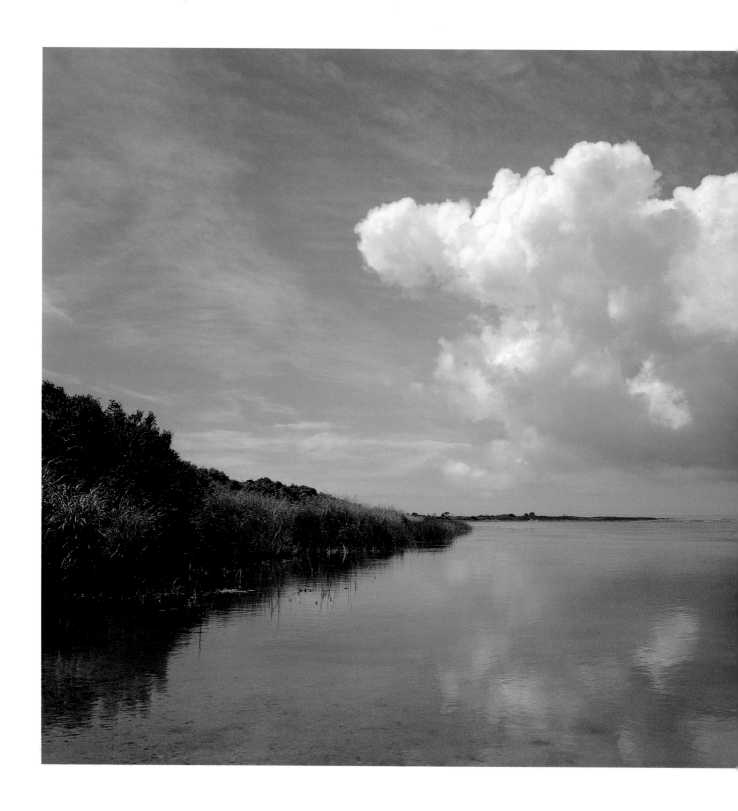

Sesachacha Pond. Originally this large pond was open to the sea and formed a protected harbor like Capaum. Quidnet, on its northern edge (a name meaning "at the point") was the last settlement of the Indians on Nantucket. These were native Americans, part of the Wampanoag of Rhode Island and Massachusetts whose chiefs included Wauwinet and Nana Huma. One of the meanings of Sesachacha is "blackberry grove." It may have been for this as well as for the protected fishing grounds that the area was popular. Many of the early fishing shacks of Siasconset were located here but were gradually moved south as the pond closed

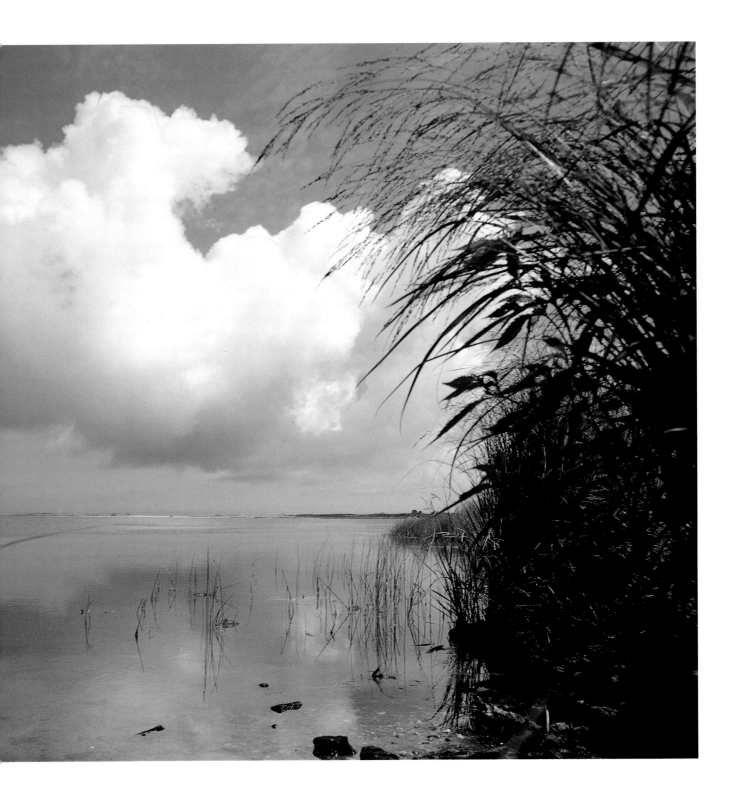

up. The last building was moved from the pond in 1820. During this century the pond has been opened manually at irregular intervals, most recently only after many committee studies. It has become a favorite spot for fishing, sailing and swimming on the Quidnet side.

Right: Morning spin. This stalwart soul has been riding since the early part of the century. She leaves the Cliff every morning at 6:00 a.m. for a trip to Siasconset and back. For those of you bored with Nautilus machines you might try this. It works.

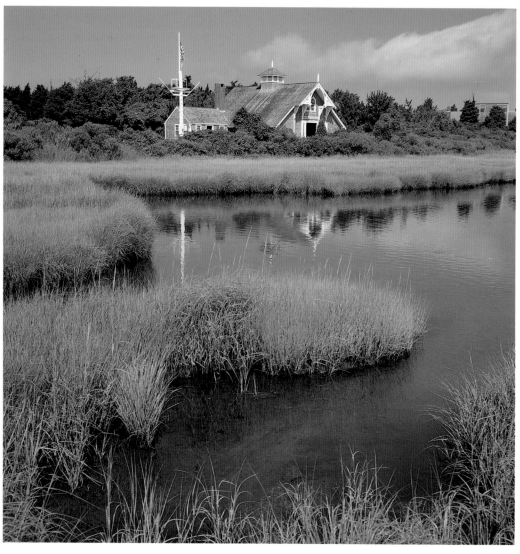

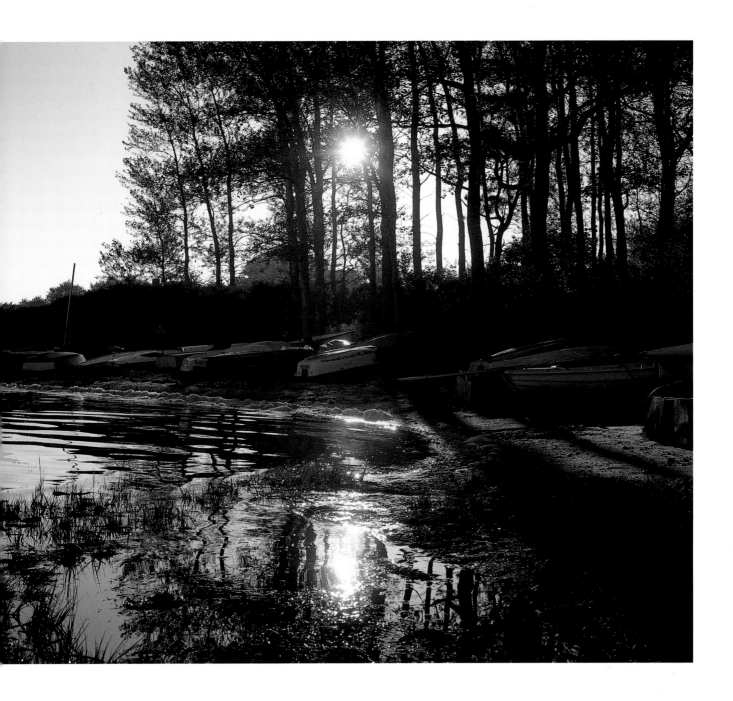

Above: Polpis means "divided harbor" and is the only harbor on the island where trees grow down almost to the water's edge.

Opposite, bottom: The Nantucket Lifesaving Museum, built in Quaise as a replica of the original Surfside station (1874). Despite the lighthouses, built and supervised by the United States Government since 1789, as well as the charting of the shoals, ships still continued to run aground. Over 500 shipwrecks occurred on the Nantucket Shoals, which are a large series of submerged sandbars east and south of Nantucket often only with 3 feet of water over them. The lightship *Nantucket* was stationed at the southern edge of these shoals. Several refuge houses were built on the island in the late 1700s by the Massachusetts Humane Society. The oldest remaining structure of its organization is the boathouse on Muskeget, built in 1883. The United States Lifesaving Service, founded in 1868 on the New Jersey coast, merged with the Revenue Cutter Service founded by Alexander Hamilton when he was Secretary of the Treasury, to form the U.S. Coast Guard in 1915. It is the only such service under the Department of the Treasury's jurisdiction. After the 1956 collision between the SS *Stockholm* and the SS *Andrea Doria,* the captain of the latter tried to steer the beautiful Italian liner to the Nantucket Shoals in order to keep her from sinking too far but she was unable to make the trip.

Opposite: Maxcy's Pond near the junction of the Cliff Road and the Madaket Road. This is named for whaling captain John Maxcy, who returned in 1823 with his ship the *Factor.* (He was possibly nicknamed Max Factor.) Unlike the activity of surf casting, pond fishing is a remarkably quiet and relaxing pastime. Often the pond is motionless and the only sounds are those of occasional gulls overhead. There are no cattails here; only deep, clean water. This was the site of the western sheep-shearing pen.

Above and *left:* Long Pond in Madaket is popular for crabbing. It is brackish, due to its connection to the Madaket harbor, and it is large—approximately seventy acres. Cattails are claiming its edges now.

Left: High tide at Brant Point brings a treasure of bay scallop shells, soft-shell clams and moon shells all interwoven with eel grass.

Below: The late afternoon sun highlights the delicate colors and shape of bay scallop shells.

Daisies and scallops. Nantucket is best known for its bay scallops and offshore bluefish which are among the most abundant in the world. The market for scallops did not develop on the mainland until the 1880s. In 1881 scalloping began on Nantucket and soon it became the major livelihood for its winter residents, as they discovered New England's finest scalloping grounds right in the main harbor and also at Madaket.

These shells are piled up and ready to be spread on driveways and paths to give a neat and weather-resistant surface.

There are over 400 species of scallops whose shell designs have been used for centuries. During the Middle Ages scallop shells were worn in hats by those wishing to indicate they were on a pilgrimage.

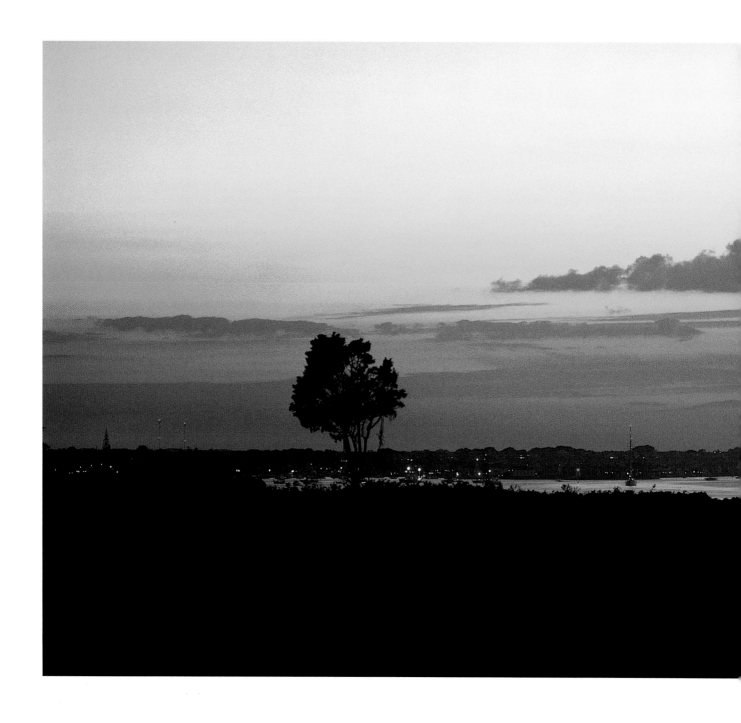

At the end of the day a setting sun accentuates the cloud formations with color and highlights absent until then. Meteorologists classify clouds into ten categories according to a system outlined by an Englishman, Rube Howard, in 1803. The four general types all take Latin names describing their appearance: cirrus (lock of hair), cumulus (a pile), stratus (extended) and nimbus (grab the foul weather gear).

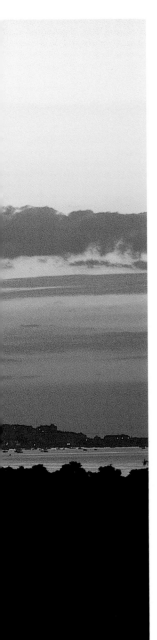

Above: G. S. ("Greg") Hill is an accomplished painter who produced his first work, of boats, at age twelve. His media are oils, watercolors and pencil. His first show on Nantucket was in 1977 and he has been a regular summer visitor since 1979. Greg is shown using a mahlstick, a device of Dutch origin (*maalstok,* meaning painting stick), which provides steady support for artists doing intricate work on vertical surfaces.

Opposite: Bill Welch came to the island in 1967, saw the ocean for the first time, fell in love with the place and never left. His impressionistic style uses over 70 different pigments—in watercolor no less. He paints from light to dark, a trickier technique but yielding dramatic results.

Nantucket Artists

Sybil Goldsmith's studio and home are filled with memorabilia. *Opposite, top:* In the the living room her grandmother's wedding gown (Worth, Paris, 1880) hangs on the wall, and the brass fireman's hat on the table was her rain hat at college. Over the mantle is a model of the *Spray* (1899) while a model of the *Charles W. Morgan* under construction in New Bedford (1841) sits in the coffee-table case. The needlepoint pillows are by the artist of her cat and dog.

Opposite, below: A collection of miniature furniture made by 18th-century cabinetmakers for sales purposes, together with her collection of "whimseys," decorate a shelf in her living room. The whimseys are made of one piece of wood, contain numerous chambers with free-floating globes and cubes, and were made by sailors at sea. The artist also has made one but fortunately has returned to painting.

Mrs. Goldsmith came to the island at the age of two and knows it better than anyone. During the past 50 years she has filled 20 volumes with photographs of paintings she has done.

Eric Holch is best known for his brilliantly-colored serigraphs or silk screens of unhurried summer days, when the sun is strong and the flowers are in full bloom. One can look at his pictures in mid-winter and instantly be transported back to warmer, carefree days. He uses a process whereby each color is applied in a separate pull, often with up to fourteen colors in an image. His series are generally limited to 200. Mr. Holch has been coming to Nantucket since 1947, and both he and his mother, sculptress Rita Holch, are members of the Nantucket Artists' Association.

The Artists' Association of Nantucket was organized in 1945 and until 1950 had the only gallery on the island. Its home was the Thomas Macy Warehouse on Straight Wharf (1846) purchased in 1944 by the Nantucket Foundation, Inc. under the leadership of Everett Crosby and named for a member of the foundation, Kenneth Taylor. Crosby had completed an extensive survey of properties in 1940 and was a strong advocate of preserving the old and disguising all aspects of commercialism downtown. By the 1960s the Artists' Association was attracting a large number of new members from the island including Mary Sarg Murphy, Philip Hicken, Maggie Meredith, George Davis and Frances Arkin.

In 1958 the Kenneth Taylor Galleries were passed over to the Nantucket Historical Trust, then sponsored by Walter Beinecke, George Jones and Henry Coleman. In 1980 the Historical Trust began proceedings to pass the Galleries to the Nantucket Historical Association, the transfer of which was completed in 1984. Four years later the Historical Association took over the premises of the Thomas Macy Warehouse for its own historical and educational displays while the Artists' Association relocated to new quarters, presently on Gardner Perry Lane as well as "The Little Gallery."

Right: Officers of the Nantucket Artists' Association pose for a summer portrait by photographer Jack Weinhold. Their Little Gallery is shown in the plate (*above*) which was originally a stable next to the Old Blacksmith's Shop (now the Four Winds Gift Shop). In 1770 there were approximately 40 blacksmiths active on Nantucket, attesting to the increase in whaling and the necessity of large quantities of ship fittings and whaling gear.

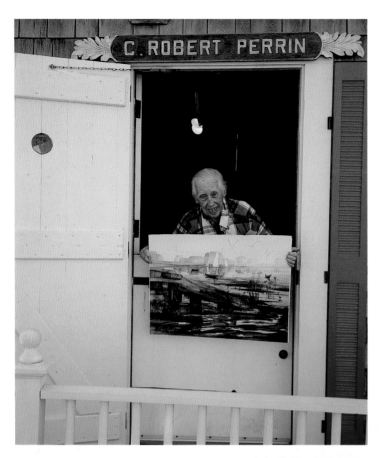

Left: Robert Perrin is the island's senior resident artist, having first come in 1946 fresh out of the U.S. Navy. He has been known for evocative puddle paintings, using watercolors that fill the paper with a freshness that, he believes, is unmatched by oil paints. His puddles have been an inspiration to this photographer.

Below: Marshall DuBock is one of the only prominent artists who was born and raised on Nantucket. He paints with watercolors in crisp detail, often showing each brick or cobblestone in his downtown scenes.

Donn Russell, printmaker, sculptor and painter, was born in Boston and has exhibited widely throughout New England as well as New York, Connecticut, Florida and London. He is shown applying a color to his silk screen.

Serigraphy is the art form of silk screening, in which inks or pigments are passed through silk or a synthetic fabric stretched across a frame. The color is applied at one end and drawn across with a flat tool such as a squeegee. Masks are cut out to block the areas not receiving a particular color. Stencil painting was used by the Chinese beginning in about 1000 A.D. but not until the 1800s was the technique popular in Europe and even then it was used primarily by the French for coloring fabric. Serigraphy started to become popular in the U.S. in the early 1930s and grew in the 1960s with the interest in bold, vivid patterns and colors.

Making use of the bank's wide friendship steps, this artist records the scene at Main Street Square. He is using oils which became popular in the 1500s and by the 1700s were the most widespread technique in Europe. (Before the 16th century watercolors were the medium of choice.) Acrylics have been popular for the past twenty years and use synthetic binders for the pigments rather than natural ones.

On the roof of the Pacific National Bank was a small observatory built by William Mitchell who was a cashier from 1837 to 1861. He had been a teacher and was interested in astronomy. Into a household filled with telescopes was born a daughter, Maria Mitchell, who became one of the country's foremost astronomers. In 1847 she was the first woman to discover a comet, peering through one of her father's instruments, and the following year she was the first woman admitted to the American Academy of Arts and Sciences.

The Boat Basin (*top*) and Easy Street Basin (*right*) offer colorful vistas to paint, photograph, or simply to sit at and "watch the pass." These artists are using oils in a difficult palette knife application.

Above: Darryl Zudeck paints in the dunes at Step Beach while Marilyn Chamberlain teaches a morning class at Quidnet (*left*). Miss Chamberlain paints in an impressionistic way but uses light with a spiritual sensitivity. The light from within, flowing from the artist into the painting, adds a special quality to her work.

Above: Tom Dunlay is seen painting in the soft light of early morning and also late afternoon. He has been a regular Nantucket feature since 1979 and has developed an unusual impressionistic style.

 Right: Portrait photographer Terry Pommett is taking images of a young island couple while Gene Mahon records the event. Both gentlemen have been colleagues for many years.

As early as 1848 the Ocean House (now the Jared Coffin House) advertised "good accommodations for sea bathing." In 1864 Eben Allen erected a structure on the shore for bathing, with changing rooms available from 10:00 until 1:00 and again from 4:00 until 7:00. A later establishment, the Cliffside Shore Bathhouses, received a steady flow of customers with the opening of the Sea Cliff Inn in 1887. It had a long boardwalk down to the water to a spot on what is now known as Hulbert Avenue. Charles Hayden, who established his Clean Shore Bathing Rooms in 1869 at the present-day Children's Beach, set up a branch operation in 1880 near here.

One of the island's most popular beaches is Jetties Beach (*top*) located next to the western jetty. This embankment lining the harbor entrance was built with 500,000 tons of stone in 1881. Jetties were first proposed by the U.S. Congress in 1803 to help keep sand from accumulating across the entrance to the harbor. Various opinions and indecision resulted in no action being taken until 1881, well after the whaling industry had ended. *Left:* A view from the top of Step Beach.

To the Beach

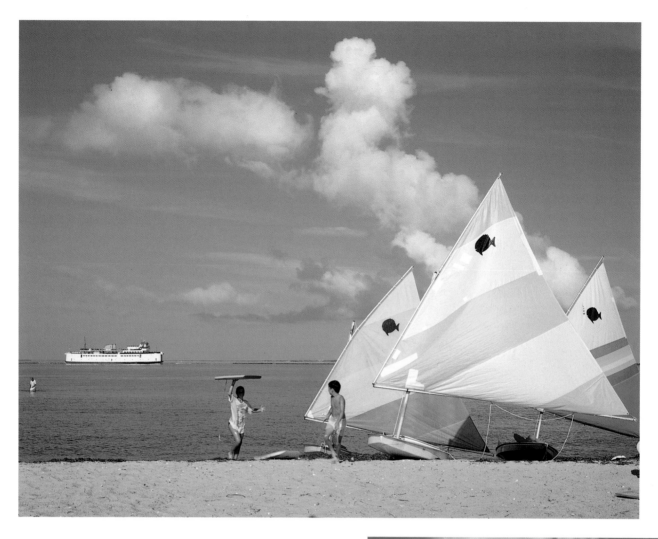

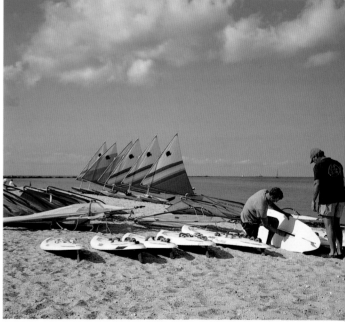

Above, right and *opposite, below:* The Jetties Beach is an active spot for sailboards, Sunfish and catamarans. The first sailboard (*right*) was patented in 1969—it was a board connected to a mast with a universal joint, and designed by Fred Payne, Jim Drake and Hoyle Schweitzer. Presently there are almost 10,000 in use, with large fleets in the U.S., Germany, Holland, Denmark, South Africa and Japan.

The Sailfish (*above*) incorporated a fixed mast on a surfboard, thought up in 1947 and put into production by Alex Bryan and Cortlandt Heyniger by their namesake company: Alcort Incorporated. The larger Sunfish came in 1952 to accommodate an expectant mother who needed a small cockpit to hold her onboard. The 14-foot Sunfish has proliferated to almost 300,000 units in over 30 years, clearly the most popular sailboat ever made and selected by *Fortune* in 1989 as one of the 25 best-designed products in America.

The *Eagle* is seen entering the channel between the two Jetties.

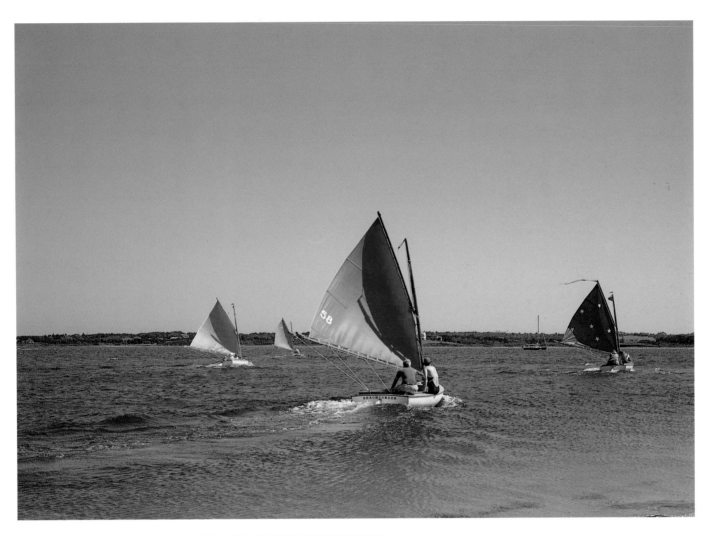

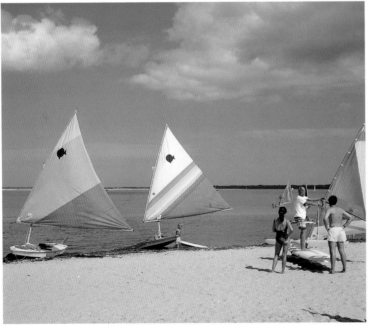

Above: Rainbows racing off Coatue. These are catboats developed in 1921 by John Beetle and presently made at the Concordia Yacht Yard near New Bedford in the old-fashioned way: cedar sprung over steam-bent oak frames.

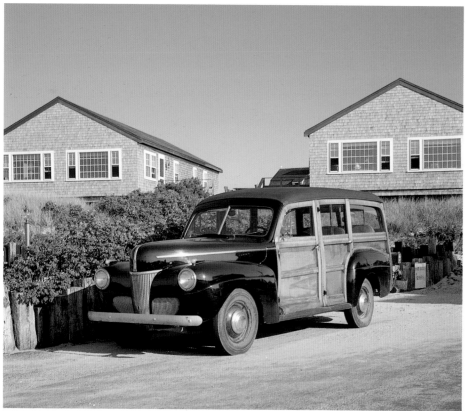

A 1955 Ford Thunderbird (*above*) and a 1941 Ford Deluxe (*left*) at Cliffside. Those with good eyes will note a small hole in the base of the woody's grille where a hand crank could be inserted as a manual starter. With the arrival of the large, high-compression engine, this feature was, by necessity, quietly eliminated.

The Galley Restaurant at Cliffside is the only one in Nantucket where one can sit on a beach-front patio surrounded by fresh petunias. It is a French bistro specializing in seafood and beautiful sunsets.

Petunias are herbs that are native to Brazil and Argentina and are members of the nightshade family. The name derives from an old French word, *petun*, for tobacco. Like herbs they will winter kill and come back the following year, but most often they are replanted.

Sand sculptures, kites and beach umbrellas have been summer-time favorites for generations. The large beach umbrellas, such as the ones shown here at Cliffside Beach, derive from the original purpose of shielding one from the sun, not the rain. In fact its name comes from the Latin *umbra* or shade. Often it was a symbol of rank: the Egyptians and Babylonians permitted only the nobility to have them. In the early 1700s they began to be used against rain when the heavy wood and oil cloth umbrella was developed in England (where else?). Lightweight parasols came into use in the 1800s.

Kites have been flying since time immemorial, and in Korea and China they often warded off evil spirits when flown from the house at night. Kites are also hawk-like birds of prey whose name derives from an Old English word for owl, *cyta*. America's most famous kite flyer was Benjamin Franklin who may have practiced here on the beach during the summer of 1750.

Cliffside Beach. This was originally called Conrad's Beach after Murray Conrad who opened a bathhouse in 1924. Its pavilion was frequented by guests in silk suits and hats. Four hundred wooden changing rooms were rented twice a day to meet the demand. No one would even think of arriving in swimming attire. Now the club is private with members assigned the same large beach umbrella for the season. Older members have the more desirable places near the water while the newer ones have to wait their turn. Overnight accommodations were added beginning in 1970 and expanded in 1983 and 1984. Much of the club's old changing rooms' wooden siding has been reclaimed for bedroom panelling. Additional renovations were made in 1986 and 1990.

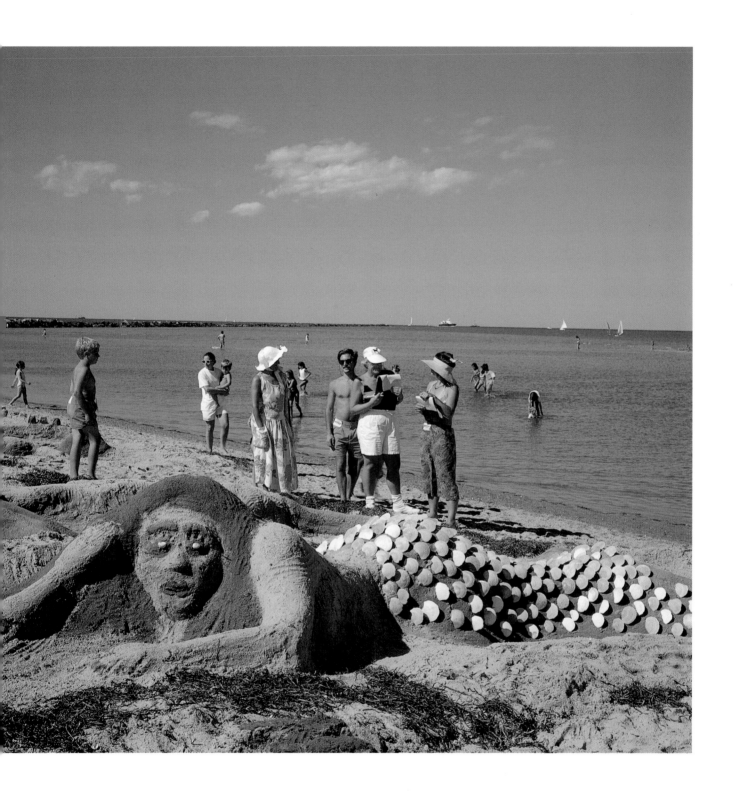

A reclining mermaid, complete with red seaweed hair and scallop shell scales, commemorates the annual Sand Castle Day at Jetties Beach. For over twenty years this popular event, originated by the Nantucket Island School of Design, has drawn young and old in a contest of good spirits, with entrants divided into age groups and everyone virtually guaranteed a prize.

Nantucket's beaches offer the perfect spot for an afternoon of gull feeding (*opposite, top*), a gam with friends *(opposite, bottom)* or catching up on one's summer reading (*above*). An extraordinary characteristic of the island is its 55 miles of clean, sandy beaches. Buffeted by wind and currents, the sand continues to recast itself in new dunes from old patterns.

The popularity of Surfside on the south shore was promoted in 1879 when Peter Folger organized a railroad. Originally it was to run from Steamboat Wharf up along the Cliff, out to Long Pond, south to Surfside and eventually to 'Sconset. Plans were changed and grading began in 1880 for a simple and direct run to Surfside. On July 4, 1881, the first train made the trip—with all used equipment. The engine, named after Tristram Coffin's wife, Dionis, was purchased from the Danville, Olney and Ohio River Railroad in Illinois and the two open passenger cars (with glass windows at the ends to keep cinders out of people's eyes) came from the Long Island Railroad. Henry and Charles Coffin climbed aboard the land boom by purchasing a large hotel in Rhode Island, transporting it on seven barges, and reconstructing it at Surfside in 1883. But winter storms eroded the railroad bed and service became increasingly unreliable. A new line to 'Sconset proved more trustworthy and 'Sconset became the center of attraction. By 1887 the Coffins' 100 Surfside lots were sold at auction for $2.80 each, the hotel was boarded up, and eventually the sea reclaimed everything.

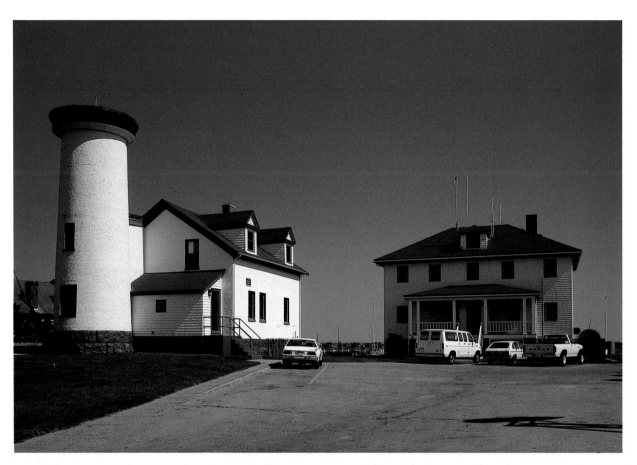

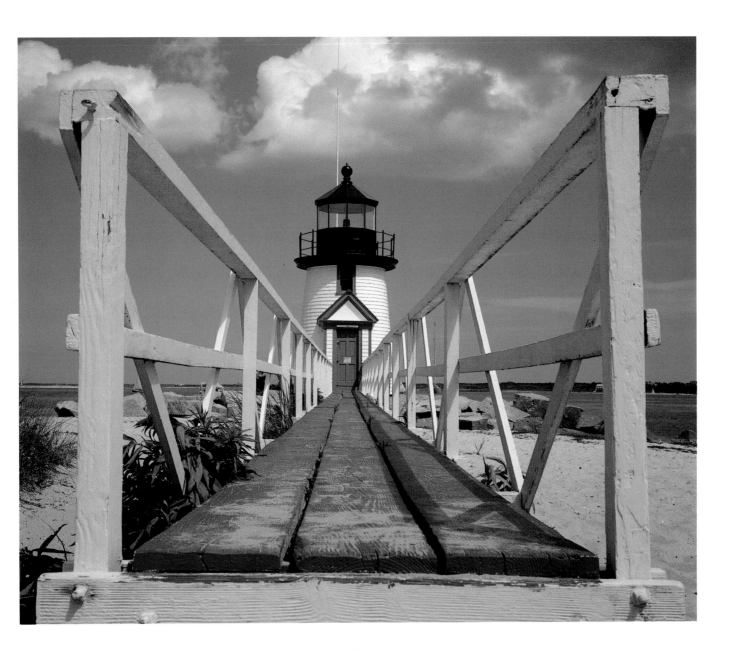

Brant Point Lighthouse has been the focal point of Nantucket's harbor activities since 1746. It is the site of the second lighthouse built in this country. The first was on Little Brewster Island off Boston (1716). The red occulating lamp (this means it is on more than off) can be seen for 10 miles. Red marks the starboard or right side of the channel entering from seaward. The cycle is four seconds: three on and one off.

Brant Point is also the official headquarters of the U.S. Coast Guard on Nantucket. This organization began in 1915 with the merger of the Revenue Cutter Service, formed by Congress in 1790 to keep pirates at bay and to collect import duties, and the Lifesaving Service (1868).

Nantucket's first involvement with life saving began with the construction of a humane house at Great Point in 1794. The house was part of a string of shelters set up along the coast by the Massachusetts Humane Society. By 1832 Nantucket had 13 shelters. When the above-mentioned Lifesaving Service was created, one of its first stations was built at Surfside in 1874. A second one was built on Muskeget in 1882 and others at Coskata and Madaket. After Brant Point became the official headquarters for the Coast Guard on Nantucket, the Madaket and Coskata stations were phased out. The latter, a large hip-roofed building (*opposite, top*) was moved down the harbor on a barge to serve as the Brant Point's personnel barracks.

The big boys' toys on the beach (*opposite, bottom*) are buoys and mooring balls. The moorings are scattered about the harbor while the buoys line only the harbor channel between the Jetties. The one on the left is a nun and at the center is a can. The nuns line the port side of the channel and the cans the starboard. They are frequently seen playing at night.

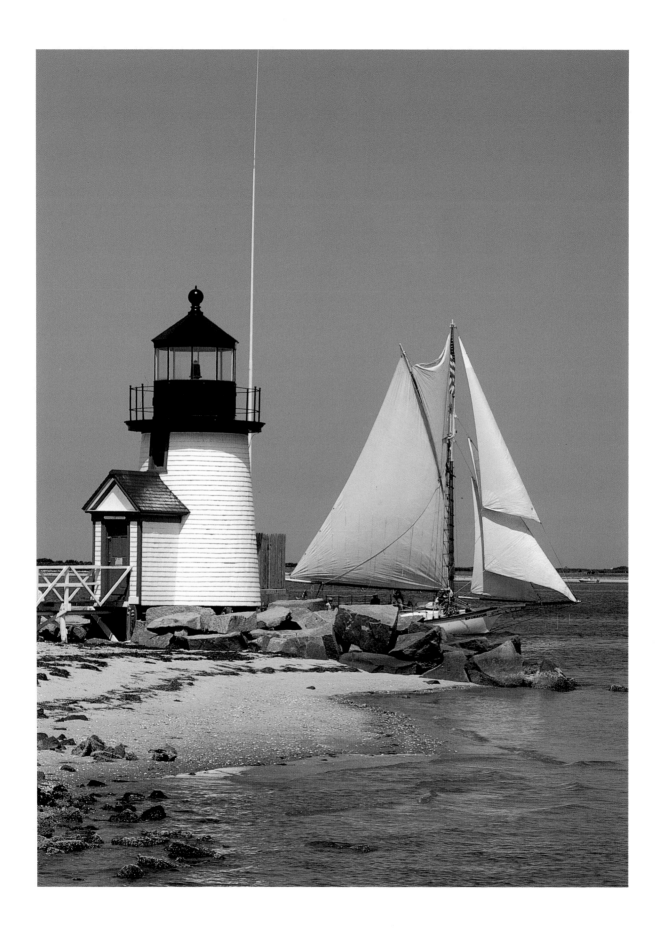

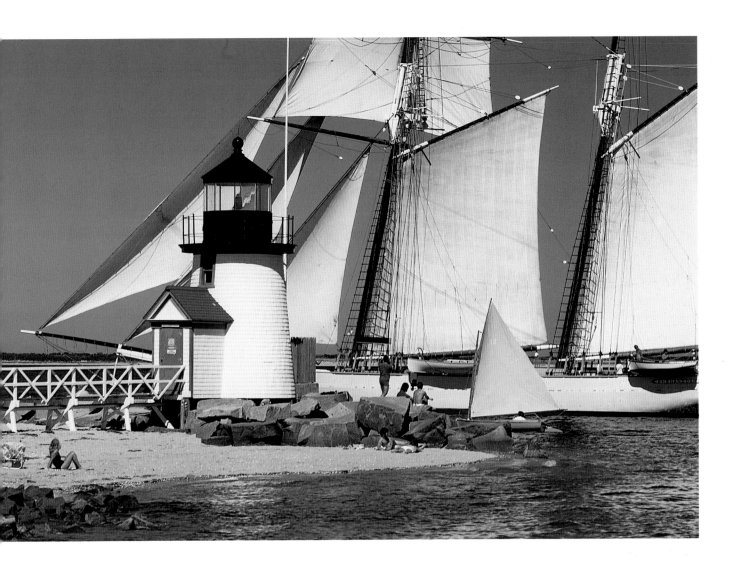

Rounding Brant Point. *Opposite* is the popular *Endeavor,* a Friendship sloop named after a fleet of fishing craft built in Friendship, Maine. These turn-of-the-century sloops are characterized by long bowsprits capping a clipper-type bow, a bold sweeping sheer, a saucy and curvaceous stern, and a large gaff-rigged mainsail with at least two jibs and other sails to keep passengers busy.

Above: The *Shenandoah,* a 150-foot topsail schooner that is a 1964 replica of an 1860 revenue cutter. Schooners have two or more masts, with the taller mainmast behind the smaller foremast. A yawl has two masts with the mainmast in front, and a sloop has only one mast. The *Shenandoah* was built at the Harvey Gammage Shipyard in South Bristol and is the only square-top schooner without auxiliary power under American registry. Its

sails offer enough power, and their enormity dwarfs Brant Point Lighthouse in the photograph, despite the fact that the outward-bound vessel is on the far side of the channel. (The word sailing derives from the Old German word *sigelen* and the Old Norse word *sigla.*)

Shipbuilding began on Brant Point in 1810. Over the next 20 years a ropewalk was added as well as a saltworks. The former was so named because it contained a long enclosed boardwalk down which workers carried and laid fiber strands which were woven into rope (which derives from an Old Norse word, *reip).* The saltworks was a commercial operation making cakes of salt by extraction from seawater. These businesses were later replaced by the large Nantucket Hotel which in turn was replaced by summer houses beginning in the early 1900s.

Woodies at Cisco Beach (*opposite*) and their four-legged predecessors at Miacomet (*above*). John Cisco had a beach house here during the 1930s. His grandfather was with Brown Brothers in New York and owned substantial property on the South Shore. Miacomet means "place where we meet"—an appropriate name for a beach. *Opposite, top:* The island's most famous car, "Madagascar Jack," is a 1931 Model A Ford, named for a hero in an Edouard Stackpole adventure novel. It became the pen name of George DuBock, the writer, who also manufactured fishing drails under the name. The car is as good as a four-wheel-drive vehicle, goes to the beach regularly and has made numerous trips to Great Point when the weather and fishing conditions were right. It is believed to have traveled approximately one million miles.

Opposite, bottom: 1935, 1938 and 1940 Ford station wagons. The term "station wagon" was the popular form in Westchester. Along the coast they were "beach wagons" and among fisherman,

simply "woodies." Ford built the first mass-produced woody in 1928 (using lumber from its Iron Mountain forest) although numerous wagon manufacturers supplied bodies for Model T's and other marques before then. Ford continued to make all-wood models through 1948 and then switched to wood trim and finally fiberglass by 1952. Buick's Super and Roadmaster were the last all-wood station wagons in 1953.

Ford is credited with developing the station wagon as we know it today beginning with the 1941–48 models. There are approximately six of them on the island (see pages 30, 44, 179, 268 and 338), some of which have never left since they first arrived. The first wagons were built in the 1920s, but it was the post-war move to suburbia and the second car that set the stage for the station wagon. All along Ford offered a V-8 engine; Chevrolet did not introduce one until 1955. Those with a discerning eye can see the legacy of the 1941–48 car in the contemporary Taurus model.

Nantucket at Work and Play

Opposite: Lemonade vendors on Lily Street—not the first nor the last to embark on this endeavor but always a unique experience for those involved.

Above: Archery practice at the Nantucket Boys' and Girls' Club. This organization provides evening and weekend activities for youngsters between the ages of 7 and 18. It plays an important role in establishing values and shaping the lives of its 500 members. The Nantucket Boys' Club started in 1944 in the Opera House building on South Water Street, opposite what is now Hardy's (and was previously the A&P), moving to its own building in 1949 on Francis Street and finally to its new facilities on Sparks Avenue in 1966. It has admitted girls since then.

Picnics at the Atheneum (*above*) and in Something Natural's lunch boat (*left*) have attracted children of all ages for generations. The word is French—*piquer* (pick) *nique* (trifle)—but the pleasure is universal.

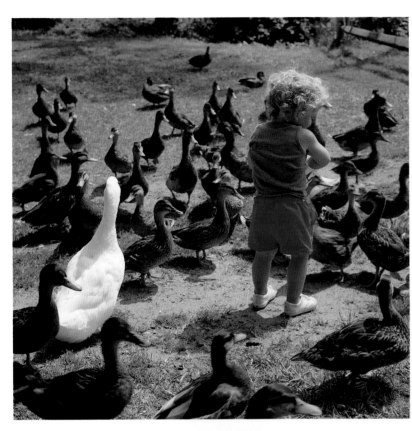

The mallards picnic at Consue Spring on Union Street. The pond is partly the result of the construction of the railroad grade across the marshland. Consue is the Wampanoag word for "extensive bog."

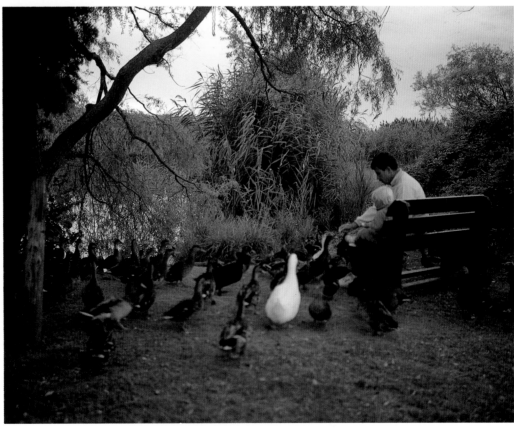

Nantucket's structures need frequent attention due to their age and the exposure to salty winds and rain. The average house will take two to six weeks to paint and the process has to be repeated every seven to eight years. Cedar shingles last considerably longer given the nature of the wood and the length of the overlap of the shingles themselves. Cedar trees were once abundant on Coatue (which means "pine tree place" or "place of sharp points"). The warm ochre color of fresh cedar changes to a weathered gray in two to three years.

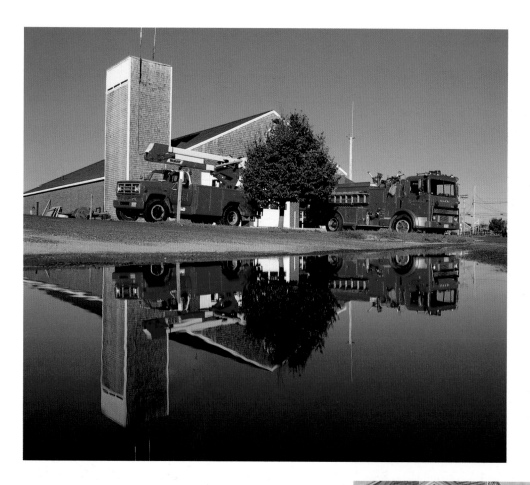

Above: The Fire Department's new headquarters on Lower Pleasant Street (1981). The staff has 21 permanent employees plus 50 volunteers. The trucks are a 1989 Ford bucket truck, on the left, and a 1974 Mack Class A pumper on the right. Until the turn of the century, most fires were fought with bucket brigades. Each house had a leather bucket with which water was drawn from the nearest cistern and continuously passed down to a hand pumper. Often hoses were too short to reach the cistern (or other water source) and hence the need for the brigade. Sometimes a trough was placed next to the pumper to gather the water. Pumpers had rival teams which occasionally would fight while the house burned.

Still in daily service are a 1947 Dodge truck (*right*) and a 1966 Hood Divco milk truck (*opposite*).

Left: The Nantucket High School, 10 Surfside Road (1955, 1990). The school was started by Cyrus Peirce in his 15 Orange Street home in 1832. Horace Mann, America's leading proponent of free public education, was a colleague and co-founder. He started the first "normal school" in Lexington and asked Peirce to be its principal. Returning to Nantucket, Peirce organized the schools into four classifications (primary, intermediate, grammar and high school). He demanded scholars' understanding and refused to accept shallow recitation.

The car belongs to a former teacher. It is a 1957 Lincoln Premier. With 14-inch taillights it tweaked Cadillac's long claim in this area and served up fins that were almost dangerous. This car weighs over four thousand pounds and requires a boat hook to secure articles from the forward section of its trunk.

Above: A Nantucket Jeepster at the airport. Once the car of choice on the island, this convertible has all but disappeared. The Jeepster was Willys-Overland's successful introduction of a civilian equivalent of the familiar World War II Jeep which was commissioned by the U.S. Army in 1939 for a general purpose vehicle, nicknamed the G.P. or Jeep. This 1949 version still retains the Jeep look with angular fenders, outside hood latches and a step over the rear fender for easy access to the back seat (when the top is down). Jeepsters were made from 1948 until 1951.

Opposite, top: The "Landmark House," 144 Orange Street, provides subsidized accommodations for senior citizens. For many years it was known as "Our Island Home," a place for retired whaling captains. The new "Island Home," built behind Landmark House in 1981, has a capacity for 45 residents of all backgrounds. The town first purchased a farm in Quaise and built a house with 32 rooms in 1838, which burned in 1844. There was such an outcry in town because of its remote location that only ten years after

a new structure was built, it was decided to move it closer to town. The large building was cut into six sections and dragged by oxen on rolling logs along the rutted Polpis Road to its present site.

Opposite, below: The Nantucket Cottage Hospital, on Prospect Street (1957). Organized in April 1911, the hospital began operations in three old homes on West Chester Street in 1914. Patients were asked to bring their own blankets, and the kitchen doubled as a nursery. Additional structures were added or acquired so that by 1941 the hospital had 5 buildings with a capacity for 26 adults, 3 children and 5 babies. The midnight collision of the SS *Andrea Doria* and the SS *Stockholm* in 1956 brought the hospital many clients. The entire Gifford family of Nantucket was sailing home from a vacation in Italy on the *Andrea Doria* but all survived. The 1958 crash of a Northeast Airlines plane brought fresh challenges to the hospital which by then had new facilities on Prospect Street. It is presently one of the island's largest employers.

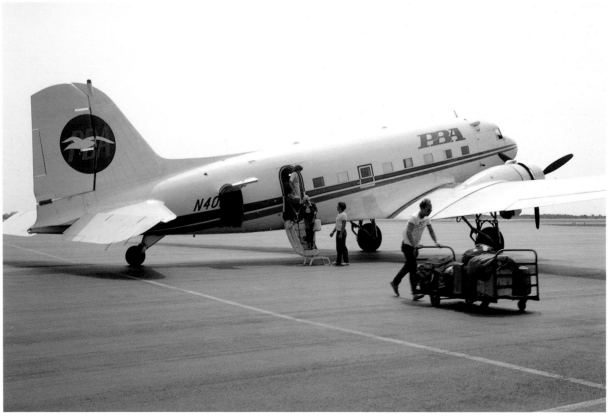

At the Nantucket Memorial Airport are a "Shorty 360" made by Short Brothers Ltd. in Belfast (*opposite, top*) and a familiar DC-3 (*opposite, below*). Having already set a world record for flying hours, this latter aircraft set a new record every time it took off. It was made by Douglass Aircraft of Long Beach, California, in 1936. The control tower (*above*), built in 1960, has seen many planes come and go, as well as airlines. After Northeast disappeared into Delta, who tried flying DC-9 jets onto the short runway, Nantucket was abandoned by the trunk carriers. A string of experiences followed: Executive, Air New England with its rainbow tails, Will's, Cape & Islands, Gull Air and PBA whose basic plan was ingenious—all types of aircraft at all times plus a shuttle to New Bedford, all with inadequate pilot training, however. Like Grade B movies that come and go without lingering memories, there have also been Vermont Air and Brockton (better known as a trucking line). Basically the only way to handle flying to Nantucket is to allow an extra day. Better yet . . . take the ferry (*left*).

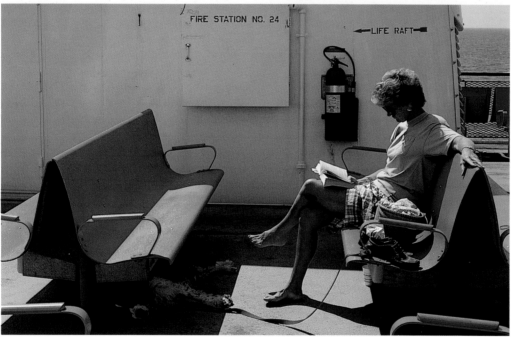

Getting there is half the fun. While this may not be Cunard Lines, the Steamship Authority's ferries provide a leisurely, two-hour respite from the rest of the world. There are no telephones, fax machines or computers on board. Just old-fashioned reading and relaxation. The Woods Hole, Martha's Vineyard and Nantucket Steamship Authority is a public service organization run by the communities it serves. New Bedford service was eliminated in 1960 and Hyannis added in 1972 although Hyannis service first began in the early 1830s.

The original *Eagle* was Nantucket's first steamer (1818) and in fact inaugurated the first scheduled power service in New England which unfortunately proved uneconomical and the ship was sold that fall.

Feeding the gulls is a favorite pastime. Ring-billed gulls and herring gulls are among the species on Nantucket—all members of the *Laridae* family and correctly referred to as simply gulls, not sea gulls.

Sighting land from the bridge of the *Eagle*. The excitement of the first glimpse of Nantucket after being surrounded by water is a special feeling shared by young and old. The experience of the whalers was similar if only more intense. It is a far different sensation than the last leg of a flight where the fastening of a seatbelt and subsequent bump on the tarmac are the way a new destination is thrust upon the traveller.

Ferryboats serving Nantucket are, clockwise from upper right: the *M. V. Brant Point* (1973) operated by the Hy-Line, the SS *Eagle* (1987) and the SS *Uncatena* (1965, 1972), both operated by the Steamship Authority, and the hydrofoil *Nantucket Spray* (1989), an unsuccessful attempt by Bay State Cruises to provide fast surface transportation from Boston. The voyage took three hours and provided Mai Tais and *mal de mer* in a first-class setting.

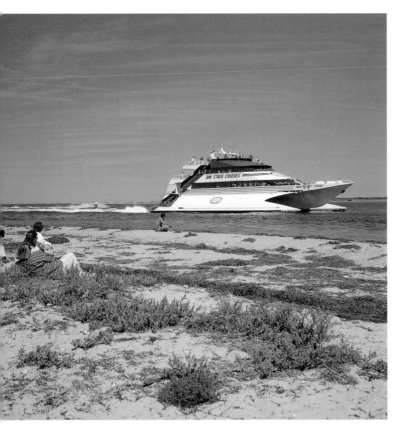
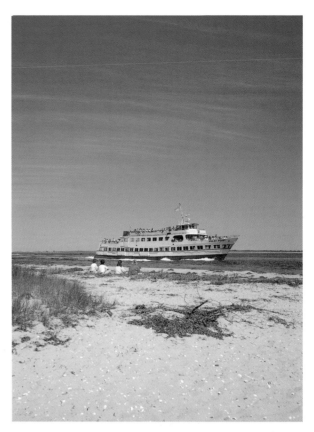

The Swain Cottage. Getting to 'Sconset has not always been an easy task. For over 100 years the road was a series of deep ruts running across sand and moors, offering a lurching and memorable trip, with coach wheels occasionally lost in transit. Peter Ewer erected milestones in 1824, the road was smoothed over in 1894 and finally paved in 1910. It was called the State Road and received a 3-foot-wide cycle path in 1896, the cost of which was paid through private subscriptions. It was one of the first state roads in the country with an adjacent bicycle path.

When automobiles became popular on the mainland they were forbidden on Nantucket. However an enterprising mail carrier, Clinton Folger, reasoned that travel on the Milestone Road was permitted since it was a state road and outside of the town's jurisdiction. He proudly drove in from Siasconset to the edge of town, then hitched a team of horses to the front end and let them tow the car while he made his rounds. The selectmen finally relented and allowed cars in 1918.

Five

Siasconset, Wauwinet and Madaket

The little fishing village at the eastern end of the island, overlooking the vast preamble of Spain, had its origins at the same time as Nantucket's relocation from Sherburne to the Great Harbor. The place was called Siasconset ("place of many whale bones") and shortened by the English settlers to simply 'Sconset. During the spring and fall cod-fishing seasons, fishermen journeyed the seven miles from town on the deeply rutted paths to plow the waters off Sesachacha. They built simple shelters to store their equipment and stay over.

Eventually the men's families discovered the journey to 'Sconset offered a pleasant change from town, and the fishing shacks underwent a period of eclectic embellishment. First came the "porch," which was an open-air kitchen. Then came the "wart," a small addition at the opposite end of the house that was only large enough to contain a bed and dresser. As the one-room shanties began to grow, second-hand materials were collected from town and incorporated into the expanding houses: old doors and windows of varying sizes as well as parts of shipwrecks on the shoals. Many installed a hanging loft with steep steps resembling those of a coastal schooner.

By the 1830s and 1840s 'Sconset had become a favorite spot for whaling captains and their crews to visit when they were home from a voyage. It offered a needed respite from the unfamiliar bustle of life in Nantucket center.

The railroad, however, briefly changed all that when it reached 'Sconset in 1899. The village experienced its own development explosion and became Nantucket's Newport. Large fashionable summer houses were built for the townspeople who wanted to get away for a while. They preferred a more spacious and stately style of home to the dwarf fishing shacks. This was fine with the theatrical set from New York who, thanks to Edward Underhill's promotion, began to discover the little "doll houses" and who were enchanted with the idea of crawling in and out of doorways and bending down to clean out the wart gutters.

The story of 'Sconset is one of isolation and retreat. While Nantucket has gone through various stages of growth and prosperity, the simplicity and solitude of 'Sconset has remained essentially the same throughout. Gone are the local offices of Western Union and New England Telephone, the coin-operated laundromat, the Kozy Beauty Salon and the Chinese take-out restaurant. The only activities in the village are the morning gams at the Post Office, blueberry muffin breakfasts for cyclists from town, shopping for provisions at the market and above all of this, the pleasant pings and pongs from the Casino tennis courts. Today 'Sconset peacefully naps in the warm summer sun and sea air, pulling a blanket of roses over her gray cottages in July.

Above: "Seldom Inn," 5 New Street (*ca.* 1830), an appropriate name for a summer cottage. This house was moved in from the Bluff to New Street at the time of the 1841 gale.

Right: "The Maples," on Center Street (*ca.* 1720), also known as the Eliza Mitchell house. This house has rare wooden hinges and steps leading to a sleeping loft with risers slanting inward to provide more foot room on an otherwise steep staircase.

"Auld Lang Syne," 6 Broadway, believed to have been built by Mitchell Coffin around 1675. He hired Indians to fish for him during the season while he remained on shore to cook. This is the oldest building on Nantucket, and looks it. It has a large living, dining and sleeping room plus a kitchen porch on the north and a small storage wart on the west. It has been changed very little over the past three centuries.

Siasconset was first settled in 1675. Its early cottages included "Auld Lang Syne," "Shanunga" and "Nauticon Lodge." In 1758 a grid plan was laid out by the town of Sherburne with 27 narrow lots along Siasconset Bluff, each to be 3 rods wide (about 49 feet). Center and Shell Streets were added in 1790 at which point the following were clustered along the bank in their present settings: "Shanunga," "Rose Cottage," "Nauticon Lodge," "Martin Box,"

"George Gardner," "Dexioma," "Snug Harbor" and "Eagle Cottage." Down from the Bluff is a long stretch of beach facing the Atlantic Ocean on which grounded whales were first discovered. Apparently this happened more than once because the Indian name of Siasconset means "place of many whale bones."

Originally the Siasconset houses were simple rectangles, all looking alike. In the late 1700s warts were added to some of the old cottages, and in the early 1800s sheds were added at the opposite end (such as "Auld Lang Syne," "Shanunga," "Heart's Ease" and "Eagle Cottage"). "Dexioma" added another wart at this time instead of a shed. During the 1840s and 1850s roofs were raised and gables extended ("Nauticon Lodge," "The Maples," "The Corners"). "Martin Box" not only raised its roof but extended its front as well.

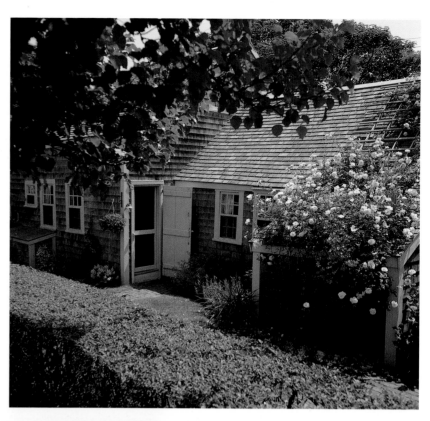

Above: "Shanunga," 10 Broadway (1682), the oldest section of which was moved from Sesachacha. The house was named later by Capt. Baxter after a whaleship that went aground in 1852 at Tom Never's Head.

Left: "House of Lords" (1753), 15 Broadway, built by Gershorn Drew and named in honor of three fishermen who thought highly of their accomplishments.

The bedroom of "Shanunga" has charred upright beams on either side of the bed indicating the earlier presence of a large kitchen fireplace. It has an unusual wooden chimney flue which has been plastered over and serves the living room. This is perhaps the oldest house in 'Sconset although its neighbor "Auld Lang Syne" (1675) may be the oldest building. "Shanunga" has also served as a store, a post office and a tavern. Bill Baxter brought the mail out from town during the 1830s and 1840s, tooting his fish horn as he rode over the hill onto Main Street and collecting a penny for each letter or paper delivered (a considerable sum in those days). His mother-in-law was Betsy Cary who ran a tavern here beginning in 1835. 'Sconset became a popular destination for young couples to go to from town for an evening, visiting Betsy Cary's pub (this same house) and returning by carriage in the late hours. Her tavern had become popular when it was discovered that the ice cream she sold contained a strong flavor of rum.

Most of the early 'Sconset houses have sleeping lofts hung from the rafters—a Welsh design unique in this country. The stairs are steep and narrow, reminiscent of coastal schooners. Wooden chimneys, widely used in England in the 1400s, were still being installed in 'Sconset as late as 1820. These were plastered over boards. Also at this time the houses began to be plastered inside, which caused some controversy because of the general 'Sconset ethic that no one should be better than his neighbor. To maintain the equilibrium many people started gentrifying. But life remained simple, with no running water, cooking over an open fire, and in the evening just a chat.

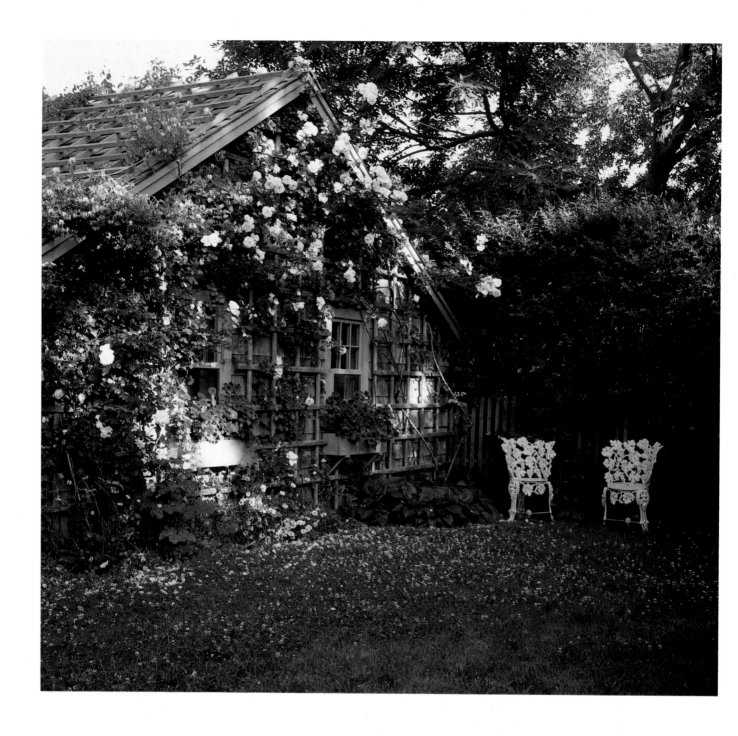

"Doll House" (*ca.* 1895), 10 Evelyn Street. This is one of the little houses owned by Edward Underhill, a regular summer visitor who purchased, remodeled and rented small cottages from an office on Fulton Street in New York. By 1890 he had three streets of rental houses including an extra room on wheels that could be dragged around to accommodate large families. He made his houses small—replicas of the early cottages—with low eaves and ladders leading up to children's sleeping lofts. Due to Underhill's promotions, 'Sconset became popular with the New York acting community (theatres being closed in the summer due to a lack of air conditioning) and was, in effect, a summer extension of the Lambs' Club.

One of the principal and yet unofficial duties of the Marconi wireless station was to transmit the results of the New York Giants' games to summer residents. The Lambs' Club members would gather at the Ocean View House to "listen" to the game. Whenever the Giants won there was much celebration. When they lost, flags were lowered to half mast and the village was filled with gloom.

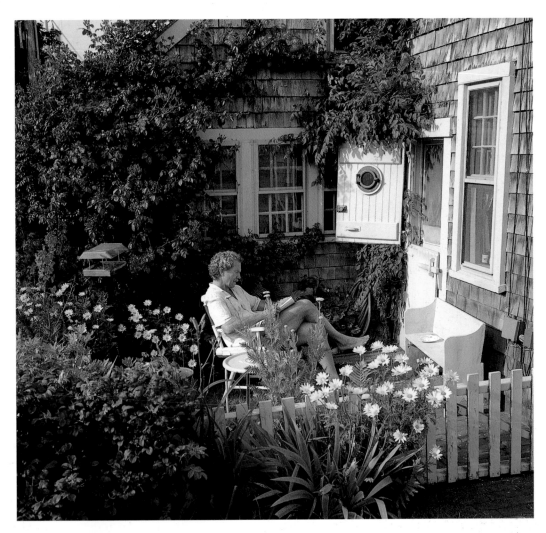

Above: "The Corners" at Pump Square (*ca.* 1730), also known as "Meeresheim," a word of Dutch/German origin meaning "sea home." This house has had the most complicated evolution of all the early cottages, starting with a T-extension (*e.g.*, "Auld Lang Syne" and "Dexioma"), then a kitchen "porch" followed by enlarged warts on the north and south, ending with a split gable "flounder wing." The reader in the photograph seems unaware of such historical activity.

Left: "Martin Box," 16 Broadway (*ca.* 1780), built by Obediah Folger on land inherited from his father, Barzillai Folger. Originally this was a long, low structure resembling a rope walk. But it was small: the great room was only 9' x 12½' and the two staterooms only 4½' wide each. During the 1860s the walls were pushed out, with the south wall keeping its original roof line, coming closest to the ground of most 'Sconset houses. The oversized flag dramatizes the effect, with the house resembling a large martin birdhouse.

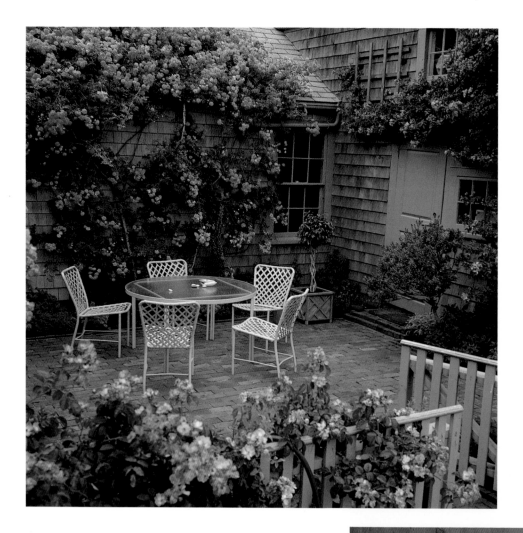

"Snug Harbor," 9 Broadway, built by Seth Folger (*ca.* 1785). This was originally a rectangular house to which a wart was added facing Front Street and the ocean. In the living room next to the wing chair are a family-made clover-leaf candle-stand and rug-hooking stand. The lady of the house is working a rug on the stand. She also made the four lightship baskets (one for each daughter). The ship in the box is 19th-century English.

The dining room of "Snug Harbor" (*above*) contains many lightship baskets, including an ice bucket, as well as a floral painting—all made by the lady of the house. On the English sewing table are a pair of black forged candlesticks with shades (old family pieces) which have hooks so they could be hung on the back of a ladder back chair for reading at night. Ladies with long hair chose other activities. The sitting room (*right*) was once a daughter's bedroom and now is used for golf clubs. The table was made by the owner's father. The lamp is Sandwich glass and the fabrics and wallpaper are by Hinson Fabrics.

Above: The living room and (*left*) the kitchen of the George Gardner house. One can sense the presence of the ocean just steps away. A steep staircase by the chimney has a door beginning on the second step, allowing more room for the passageway from living room to kitchen. The Windsor chairs are old but not original, meant to be used and not just admired.

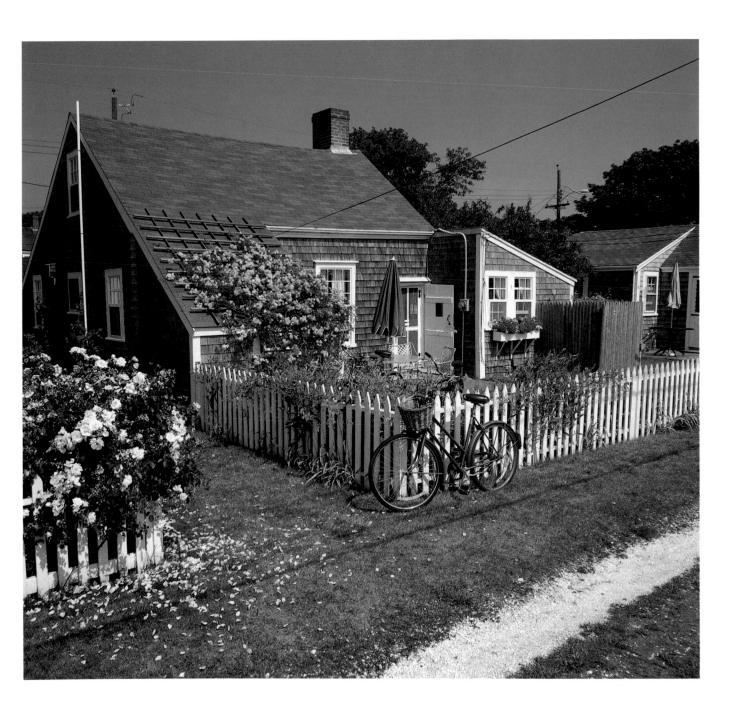

The George Gardner house, 5 Broadway (1740). Like most of the early houses on Broadway the entrance was originally from Front Street as shown. A cascade of summer roses says this is definitely 'Sconset. The great room of this house is larger than most (11' x 17') and there are three identical staterooms on the first floor, all mortised and pegged together as a single unit. The overall spacious design appears influenced by the architecture of the whalers in town rather than the local fishermen at 'Sconset.

The house was purchased by the Nantucket Historical Association in 1910 for $1500 and used as a library, with shelves across the boarded-up living room fireplace. The house was sold back to the Gardner family in 1939 for $1200 (a loss), and upon removing the fireplace shelves, they found the old kettle on its stand where it had always been. In the living room (*opposite, top*) is a large basket made by Mitchell Ray in 1928 as a wedding present for the owner's mother. Mother and aunt worked the needlepoint pillows while the son, Forest Rodts, painted "September Evening" in 1990 which now hangs over the mantlepiece. The wall needlepoint is by his sister. The chair on the right was built for George C. Gardner, the owner's great-grandfather, who lived in the house in the 1880s. The house is one of the oldest on Nantucket presently occupied by descendants of its first owner.

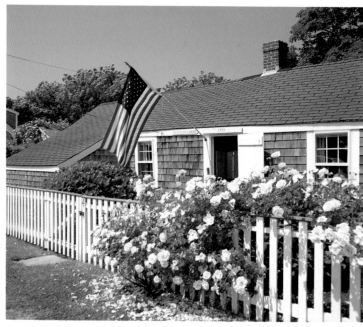

Above and *right*: "Nauticon Lodge," 4 Broadway (1734), one of the oldest 'Sconset cottages. The name Nauticon is an early variation of Nantucket, appearing on a 1630 map.

The dining room of "Nauticon Lodge." This cottage has been in the owner's family since 1938 when it was purchased and for the first time wired for electricity. Furniture has been acquired over the years at auctions on Nantucket and in the Boston area. The ladder back chairs belonged to the grandmother of the owner. The owner has also done extensive wall and lampshade stencilling throughout the house. An original Seth Thomas clock (Plymouth, Connecticut, 1875) ticks away in the dining room. In the living room (*opposite, top*) a little girl peeks out from her frame above the floor lamp. It is the owner, as a child, who was paid fifty cents an hour by Gladys Lee, proprietor of a Center Street gift shop, to sit for her portrait. The white chair was a gift of the latter. Behind it is a corner post which encases one of the supporting tree logs. The sitting room board wall is one of the house's original walls. An unusual feature of this house are metal louvers with chains to open their shutters and let out smoke, similar to a feature common in medieval England.

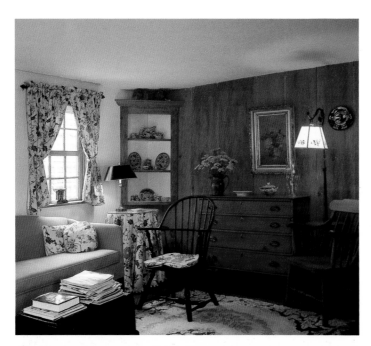
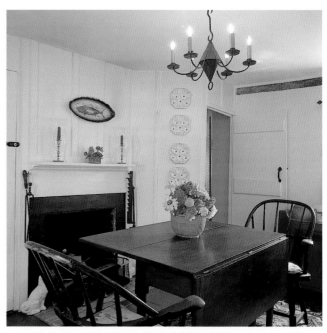
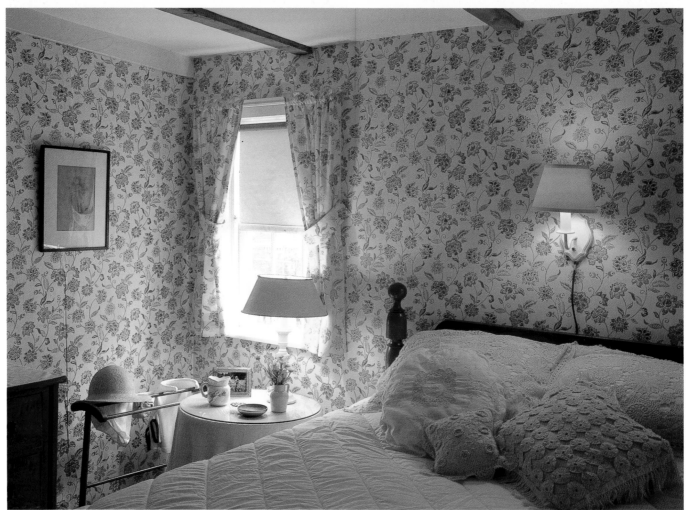

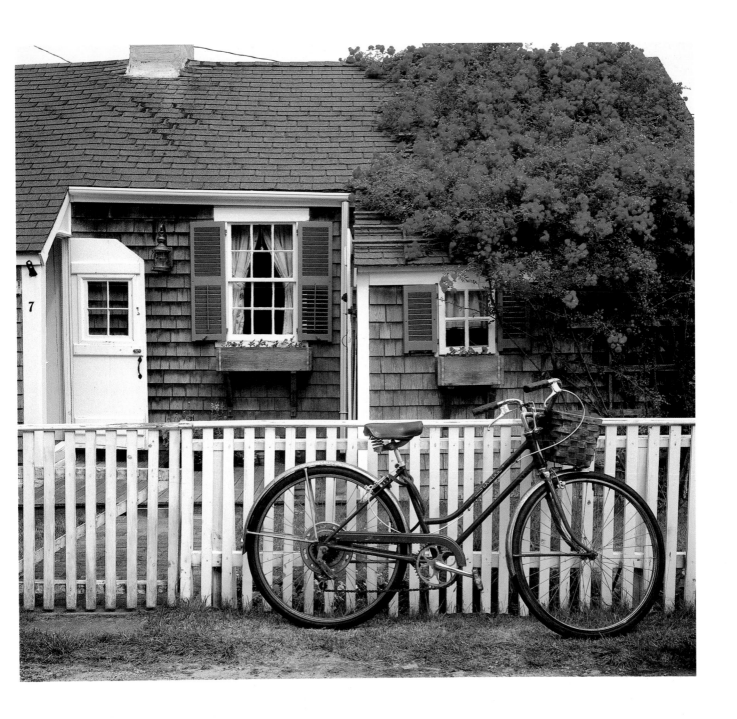

"Dexioma," 7 Broadway (*ca.* 1780). This was also known as the Capt. George Wilbur house. Its name derives from a Greek word meaning the clasp of right hands, *i.e.* a handshake or simply "welcome." It was selected by a Harvard professor of classics and family member in the late 1800s. The southern portion (great hall and twin staterooms) is the original cottage. The kitchen and its warts were added about 1840. The kitchen is now the parlor and the great room is the dining room. The present kitchen was formerly a boathouse. Leading between it and the main house is a pantry with a trap door concealing an in-ground circular storage room lined with cobblestones, an early Frigidaire.

The living room (*opposite, top left*) contains numerous early American antiques, including a Hepplewhite chest and Windsor chairs. In the dining room (*opposite, top right*) are Pennsylvania Windsor chairs with blunt arrow front feet and a mahogany Queen Anne table, all 18th century, a wall fish plate from the 17th century, four French oyster plates (*ca.* 1875), a contemporary Nantucket ceramic basket made in 'Sconset by Verity Chisolm and flowers from the owners' garden. In the master bedroom (*opposite, bottom*) are a cannonball bed (*ca.* 1825) from Martha's Vineyard on which are pillows made from antique fabrics and laces. The straw hat rests on a 19th-century quilt stand.

"Eagle Cottage," 23 Broadway (1787). This was built by Thomas Hiller, master of the Coffins' Barkentine, *Lydia*. Numerous warts were added and then consolidated into larger rooms during the 19th century. The great room (*opposite, top*) has an unusual splayed fireplace (the front is 4½ feet wide but the back is only 2 feet) in order to throw off heat. Its hearth projects 3 feet into the room. The original wide floorboards give a rich color. Hiller sold the cottage to his son-in-law, Samuel Folger, a successful blacksmith and ship owner. His son, James, was a California gold rush prospector and eventually started what is known as the Folger Coffee Company. In 1856 the house passed to another of Samuel's sons, Henry Clay Folger, whose son became president of Standard Oil Company in New York and whose extensive collection of Shakespeare adjoins the Library of Congress. In 1861 Capt. William Baxter purchased "Eagle Cottage" after returning to the island where he operated a 'Sconset stagecoach called the *Side-Wheeler Swiftshure*, delivering mail and newspapers from town for a penny apiece. Henry Tucker and later Edward Lawrence were succeeding owners. Lawrence also ran a dry goods store at the corner of Main and Orange Streets, the Boston Dry Goods Co., which had previously been H. M. Macy & Co.

315

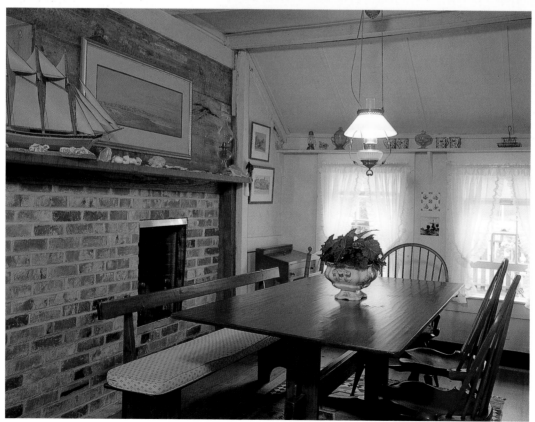

"Heart's Ease" on Center Street (*ca.* 1690, 1807). It is presumed that this small house was moved from its original Sesachacha location and expanded in 1807. The entire south gable end was extended 4½ feet in 1807 when it was owned by Uriah Swain. Reuben Starbuck added a 9-foot-wide kitchen porch in 1820 at which time he plastered the "great room" (which was only 11 feet long) to please his new wife. Over the room is a hung sleeping loft with ladder-like steps leading up next to the wooden chimney. In the bedroom (*above*) is a black walnut bed that has been in the family for 5 generations and was once used by Washington Hunt when he was Governor of New York. The hickory chest belonged to Dr. Algernon Crapsey when he was rector of Trinity Church on Wall Street, was moved to Rochester on a canal barge and eventually to 'Sconset. The pitcher and washbowl are reminders of an earlier time. In the dining room (*opposite*) are a hanging oil lamp from upstate New York, a model of a gaff-rigged schooner with metal sails, and various sketches and paintings by J. B. Reid and Wendell Macy. The hole for the original wood-burning stove's pipe appears above the mantle because this was originally a kitchen. The house has been furnished with family antiques as well as more modern treasures from Island Attic Industries.

The "Summer House," 17 Ocean Avenue. This appealing inn consists of new and old cottages tucked under roses or behind lush garden plants. The guest houses were built in 1941–1942 around a restaurant called The Moby Dick. For the past 200 years visitors have been taken with the simple beauty of 'Sconset. Gazing from the porch of the cottage where he was visiting in 1772, Hector St. John de Crèvecoeur wrote:

I had never before seen a spot better calculated to cherish contemplative ideas; perfectly unconnected with the great world, and far removed from its perturbations. The ever raging ocean was all that presented itself to the view (of this family); it irresistibly attracted my whole attention; my eyes were involuntarily directed to the horizontal line of that watery surface, which is ever in motion, and ever threatening destruction to these shores. My ears were stunned with the roar of its waves rolling one over the other, as if impelled by a superior force to overwhelm the spot on which I stood.

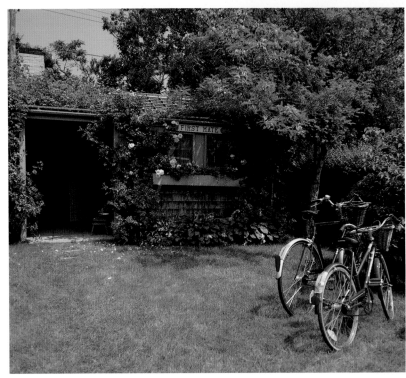

319

Left: A 'Sconset garden is the perfect place to catch up on summer reading. *Below:* "Castle Bandbox," 16 Shell Street (1814). This was built by Capt. Edward Joy's father from an old shop that originally stood on Mooers Lane in town. Like the George Gardner house, it has three state-rooms of equal size. The fence was installed in order to keep cows from coming inside. The lumber was given by Edward Joy's uncle, Benjamin Worth, who was seven times more at sea than at home. Capt. Joy was an early chronicler of 'Sconset in the 1820s. His uncle, Reuben Joy, lived in "Nauma" on the 'Sconset Bluff as well as at 109 Main Street—next to his father's house at 107 Main Street, the Zaccheus Macy house, a.k.a. the Reuben Joy homestead.

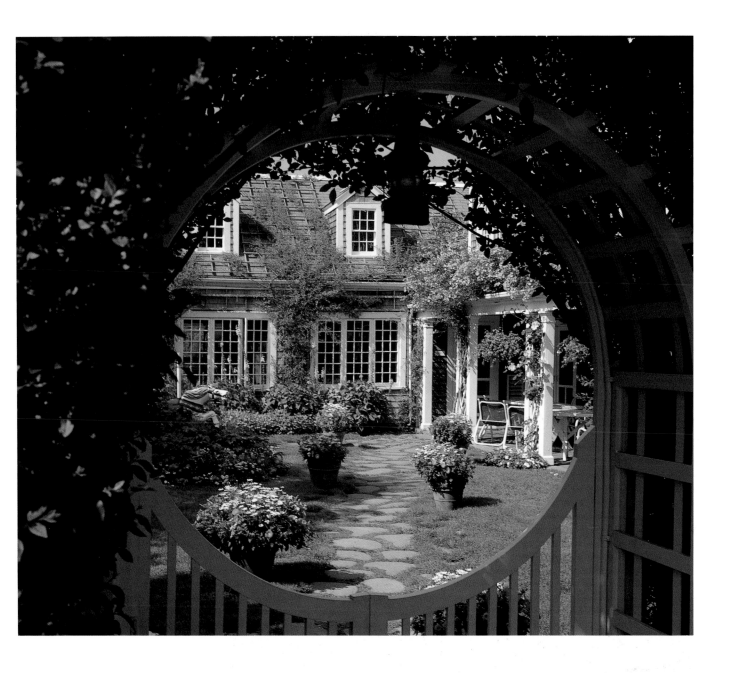

The "Chanticleer," 9 New Street (*ca.* 1810). The left portion was a fishing cottage belonging to Charles Paddack and originally located on the Bluff. Uriah Bunker moved it in 1836 when New Street was laid down and additions were made to the eastern side. Paddack was so concerned about its low six-foot ceiling that he did not permit men to dance the hornpipes unless they entered into a bond with him to pay for any damage to the overhead plaster.

Roses covering the Chanticleer are typical of this village which many consider the rose capital of the world. The varieties of roses include:

(1) New Dawn—a shell pink double hybrid rose (June–August) with 6–8 blossoms per stem.

(2) American Pillar—a rose that is more than 100 years old, and is a cross between a native prairie rose and a hybrid perpetual rose. It has deep pink or red flowers and only one row of petals, hence it is a single rather than double rose. It is very sturdy, capable of outcompeting grass and weeds, and is 'Sconset's favorite.

(3) Dorothy Perkins—an old rambling rose imported from England in the late 1800s. The last rose of the group to bloom with small, 1" double bright pink flowers.

(4) Excelsa—a deep red rose most often seen in 'Sconset and a near twin of Dorothy Perkins.

Roses are given trellises not only to increase their ability to climb and keep from sending shoots under shingles and gutters but also to increase air circulation under the stems. The constant breeze combined with salt spray (salt is often referred to as Nature's fungicide) keeps most common rose diseases in check.

Above: The bridge at 'Sconset over South Gully. This was originally built in 1872 by Charles Robinson to promote his building lots on the west side of the gully, dignified with the name "Sunset Heights."

Right: The rotary. On the right is the 'Sconset Cafe which is where Cliff Eddy's Siasconset Book Store used to be. His taxi stand was outside. Not so long ago, the village had a library (in the George Gardner house), a barber shop just east of the Market, the Kozy Beauty Salon on Shell Street, a Holdgate laundry, a branch of Pease's Garage and even branches of New England Telephone Co. on Shell Street and Western Union on Park Lane.

The car is a 1957 Ford Thunderbird, the first model to offer seat belts and a padded dashboard. Note the wraparound windshield and the car's mutant tail fins. Unlike General Motors and Chrysler, Ford and Mercury eschewed fins in the 1950s.

Above: Pump Square. The well was dug in 1776 and for over 100 years villagers would gather here and wait in line to draw their water. Behind the Jeepster is "In and Out" (*ca.* 1730), with a kitchen porch added *ca.* 1830 that later became a two-story wing. In 1840 the top of the great room was finished with a curved ceiling resembling a ship's cabin. The floor even sinks along the side walls. All that is missing is a mast through the middle of this experience.

Left: The stable of "Nauma" (*ca.* 1710) on the right and "Sea Spray" (1796) directly behind the Plymouth. Nauma is the Indian name for Sandy Point, now Great Point. The house was moved from Sesachacha on a raft along the coast by Reuben Joy. It was raised on stone boulders which have since settled unevenly, giving a list to the main parlor. Henry Chandlee Forman and his family lived at "Nauma" for 41 years, sleeping in the old rope-net beds and covering the windows with fine cotton to keep out the summer moths. "Sea Spray" was moved from the section of town called Guinea by Frederick Pitman around 1851. He added two stateroom warts and a kitchen.

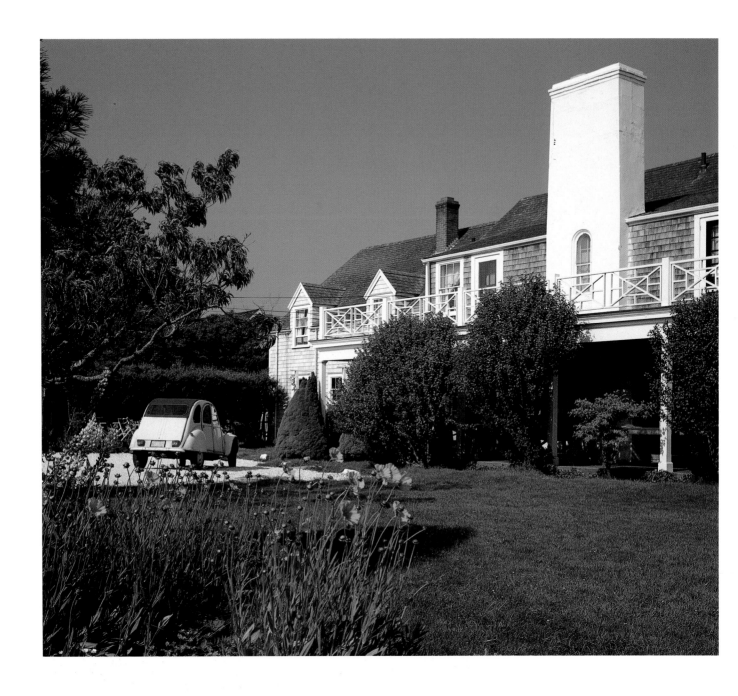

The Wade Cottages on Shell Street. This was originally built in 1929 by a prominent New Yorker, Frank Edward Wade, as a large summer family compound. The car is a legendary Deux Chevaux, which was first introduced by Citröen at the Paris Auto Show in 1948 at a price of $650. It had a two-cylinder air-cooled engine with only two horsepower (hence its name) and came in a four-door model, with removable seats for picnics, and a two-door van. Production terminated on July 27, 1990, 42 years later, a unique record.

Nearby on Bunker Hill was Nantucket's famous Marconi Wireless Station, erected in 1901 at the suggestion of the *New York Herald*. Its owner and publisher, Gordon Bennett, was also a yachtsman and had commissioned Guglielmo Marconi to put up two stations on the shore and on two ships to cover the 1899 America's Cup races in New York Harbor. The news vacuum for transatlantic liners had long vexed many passengers. Now, with a wireless on the *Nantucket* lightship stationed on South Shoals, and a relay at 'Sconset, news could be transmitted to and from the travellers at sea. The popularity grew instantly with passengers waiting up to three hours to transmit messages. In 1908 a young immigrant from Minsk, David Sarnoff, who had been an office boy at the Marconi Company's New York office, became one of the four operators at the 'Sconset station. He later went on to become the founder of RCA.

Above: "Gone Crazy" (1938) in Codfish Park and (*right*) "Takitezie" (1814) on Center Street, whose names say everything.

Above and *opposite, top:* "Green Chimneys," 20 Main Street (1858). This house originally was a two-story three-room house with a barn in back and a stable behind the barn (*opposite, bottom*). Various owners have added to the house, connecting the barn and stable so that presently there are 17 rooms including a ballroom. The current garage was once a bedroom and it is still decorated with floral print wallpaper. In 1967 Mr. and Mrs. Roy Larsen purchased Green Chimneys so that off-island developers would not turn it into a motel. One rainy weekend, the current owners' family developed its own version of "Monopoly" with casino draws such as "Holdgate's has just dyed all your clothes purple, collect $50," "Roses pull down section of your roof, pay $200," and "Get out of Boston free." A mortgage deed to the Old Mill was $140. Extras were: upright condition, bag of flour, fire extinguisher and a good Indian story. Nobadeer was priced at $120 with extras being: undiscovered beach, sandbar, lifeguard, Frisbees and a beach party. Extras to the deed for one of the "Three Bricks" included mortar, cobwebs, a widow's walk and a ghost.

Above, left: One of the east bedrooms of "Green Chimneys" and (*above, right*) the west wing of the house, with a 1936 Ford phaeton.

Right: The former stable of the house became the chauffeur's quarters and is now a separate (and extended) cottage called "Pomme de Mer."

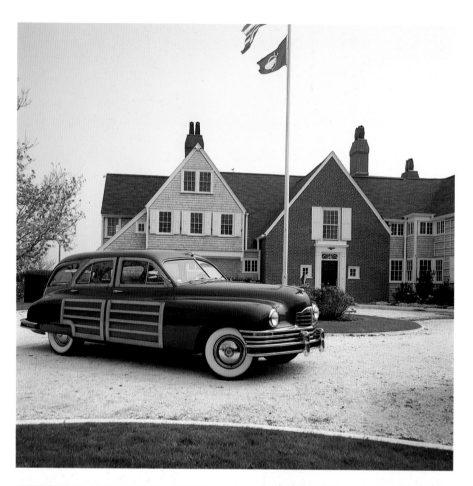

Above: The Harold Burrage house, One Ocean Avenue (1922), copied from a house in Wales. *Left:* "Atlantic House," 27 Main Street (1848), the first structure built in 'Sconset as a hotel (and now a private residence). *Opposite:* "Sheiling," 41 Ocean Avenue (*ca.* 1830) whose Irish name refers to a restful haven for seafarers.

The south bluff of 'Sconset was divided into building lots in 1872 by Charles Robinson and Franklin Ellis. They called the area "Sunset Heights," laying out Ocean Avenue and displaying their plans in Macy's window in Nantucket. Robinson connected "Sunset Heights" to Broadway with a 90-foot bridge and built the large "Ocean View House" where the "Summer House" is today. Unfortunately, the project did not get underway until the advent of the automobile after World War I. Then the more affluent built pretentious homes that were copied after the Newport cottage style spreading across the mainland's resort communities.

Roses decorate the homes now as they have for centuries before. The rose is one of the oldest cultivated shrubs, consisting of approximately 200 species and thousands of varieties. They are divided into two main camps: old roses (such as apothecaries' rose, cabbage rose, rugosas and tea roses, known for their tea-leaf fragrance) and new roses (hybrid teas, floribundas, ramblers, climbers and miniatures). The Persians, Chinese, Greeks and Romans were all familiar with the rose and used it as decoration. But with the fall of Rome it went out of favor as the early Christians disassociated themselves from pagan symbols. Its beauty could not be covered for long and eventually Charlemagne ordered a garden of roses. The Virgin Mary became associated with the rose (rosary beads, for example) and Crusaders returned with new specimens while herbalists discovered their medicinal qualities. During World War II scientists proved there was more vitamin C in rose hips than oranges, and the fruit is now widely used in vitamin pills. A rose is not necessarily just a rose.

Above and *right*: Union Chapel (1883). This was built by developer Charles Robinson at a cost of $1,680 and since its beginnings has been shared by all denominations. Prior to the opening of the Siasconset Casino in 1900 it was also used for concerts.

Above: The Sankaty Head Golf Club, organized in 1921 and laid out on 276 acres of land donated by summer resident David Gray. The car is a rare 1949 Mercury Eight, built during the last years of the Truman Administration when gasoline was 25¢ a gallon. This was Mercury's (and Ford's) totally new post-war model. Its wide beam gave it a chubby-checked appearance, accentuated by two large doors. With three seats, there were a lot of tilted seat backs to access the rear quarters. In 1952 four doors were reinstated.

Left: The Siasconset Casino Association was organized in 1899 by a group of tennis-minded Bluff residents. It opened with great fanfare on August 4, 1900, at an evening celebration that included selections by the 'Sconset Hungarian Orchestra, two short plays, Japanese and Spanish dancing, and a Negro song and dance. Ladies were requested to remove their hats during the performance and special trains were scheduled to bring people back afterwards. By 1909 the Casino had six tennis courts and two bowling alleys. It had begun tennis matches with Nantucket and won the first round in 1907. Movies began in 1915 with a hand-cranked projector (which was stopped every 20 minutes in order to thread a new reel), a piano for suspense music and hard seats. Nothing much has changed.

Above and *left:* The clubhouse of the Sankaty Head Golf Club. The site was called Mayflower Hill and was purchased and donated by David Gray of Detroit in 1921, with the provision that it forever remain a golf club. Much of the terrain was covered with scrub oak and required teams of tractors, mules and Bravas (New Bedford and Cape Cod descendants of Cape Verde Islands immigrants) to clear. The first nine holes were ready for play in September 1922, with a second nine available in 1923. It is one of the premier courses now, with 18 holes fashioned after Scottish seaside links courses, and a long membership waiting list. The Club runs a caddy camp, one of the last in the country, which accommodates approximately 40 boys.

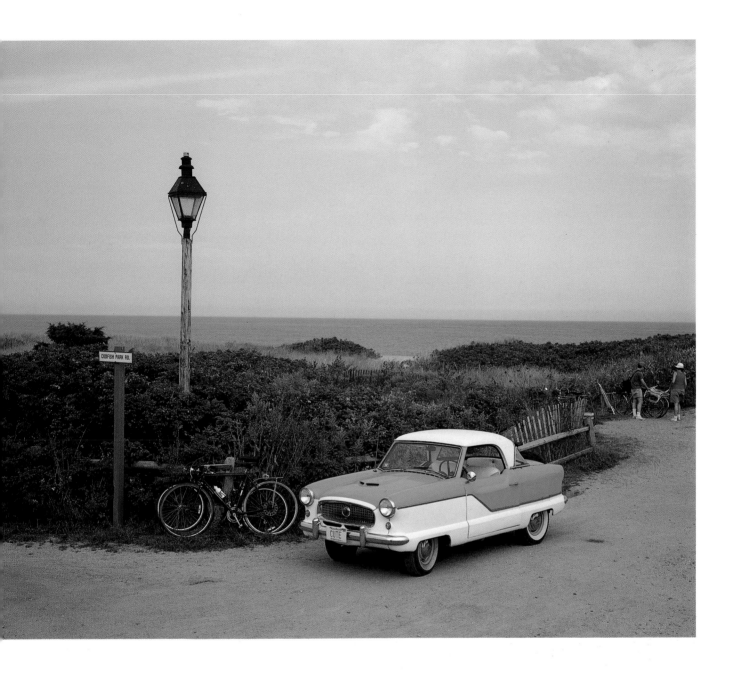

Codfish Park. This is a popular residential area and public beach nestled under the 'Sconset Bluff. When this Nash Metropolitan was a baby in 1954 there was a shop here, past twin houses called "Tweedledum" and "Tweedledee," which was named "Wander Inn" and sold bathing suits and caps as well as towels and toys.

Originally used to store dories and fishing gear, this area has grown up due to the accumulation of a large sand dune and subsequent sprouting of summer cottages. Until 1870 gales were strong enough to send the surf right to the edge of the bank and even eliminate a street along the Bluff. The currents changed, however, and the area below the bank actually began to widen. By 1886 Henry Coffin acquired a deed to the property. Cottages have since been built and the village, acceding to Neptune and Nature, has paved the area and added utilities while the attorneys try to determine who really owns the formerly submerged land.

The little 1954 Nash Metropolitan was smaller than the Volkswagen Beetle, had an Austin engine and sat three people. It was one of the company's many premature attempts at economy cars. Charles Nash ran Buick Motors in 1910 and became president of General Motors in 1916. He formed Nash Motors which merged with Hudson in 1954 to become American Motors. Both the Nash and Hudson names were dropped in 1958 in favor of Rambler, an old name in the Nash stable. The company slid into Chrysler in 1990 carrying its best seller, the Jeep, with whom it merged in 1970. The latter is America's most popular, least accounted-for vehicle—being made successively by Willys-Overland, Kaiser-Frazer, American Motors and presently Chrysler.

Left: The Sankaty Head Beach Club (1945, 1991). This swimming club was organized as a separate entity by Walter Beinecke, Sr. in 1945. It is now part of the Golf Club which made extensive renovations in 1991. It presently has 24 cabanas (rented for the season), a pool and four tennis courts, all overlooking the Atlantic Ocean.

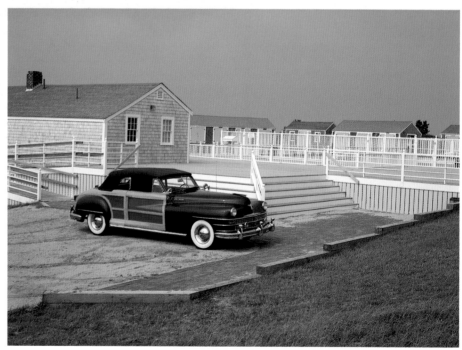

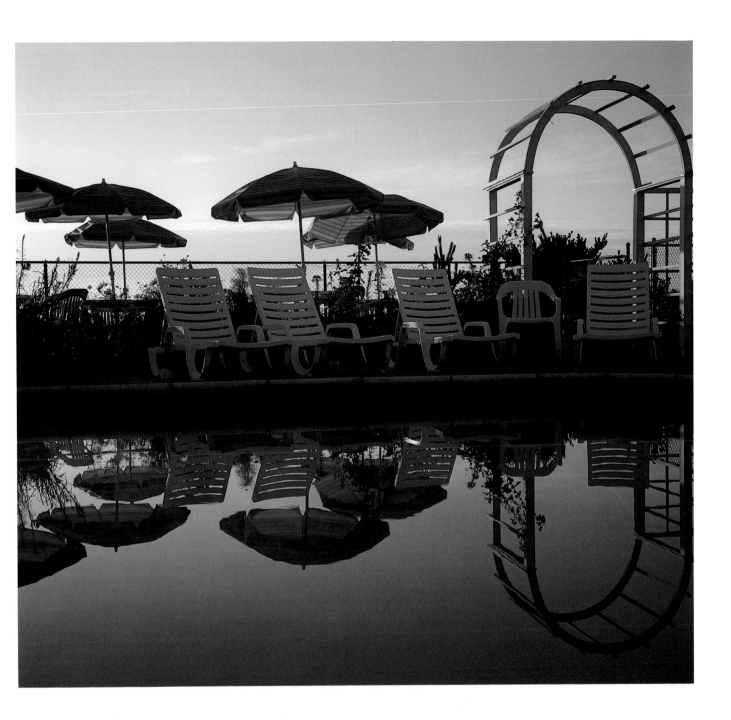

Above: The pool of the "Summer House." Located down from the Bluff near Codfish Park, this is close to the original terminus of the Nantucket Railroad which made its last run in 1917. After the Surfside spur was abandoned to Nature, the railway was straightened and 'Sconset became a popular destination, especially due to the newly-opened tennis casino.

Left: A 1947 Chrysler Town & Country straight eight convertible at the Sankaty Head Beach Club. This lovely car offers more show than go. It has a gyro-matic transmission with Fluid Drive. The car starts up in second gear and at 20 m.p.h. it slips into third. First gear is rarely used. Slow to get underway and difficult to maneuver, this yacht nevertheless presents an all-flags-flying experience. Two heaters and two spotlights were standard equipment.

Walter Chrysler wore many hats in Detroit's automotive world.

He was production manager for the Buick Motor Co. in 1912, rising to become president in 1916 and then president of General Motors after Charles Nash. He sold his shares and was a millionaire at the age of 45. In 1920 he returned to the business as manager of the Willys-Overland Corp. He produced his own car in 1924, organized Chrysler Corp. in 1925 and was on his way again with the acquisition of the Dodge Brothers operations in 1928. Chrysler introduced numerous innovations such as the high-compression engine, torsion-bar suspension, power steering and the alternator. A 1952 ad in *Life* for the DeSoto Fire Dome Eight features a rotary telephone (black of course) with the caption that steering the car is as easy as "dialing a 'phone." Good basic engineering rather than elegant design has been the company's strength for years.

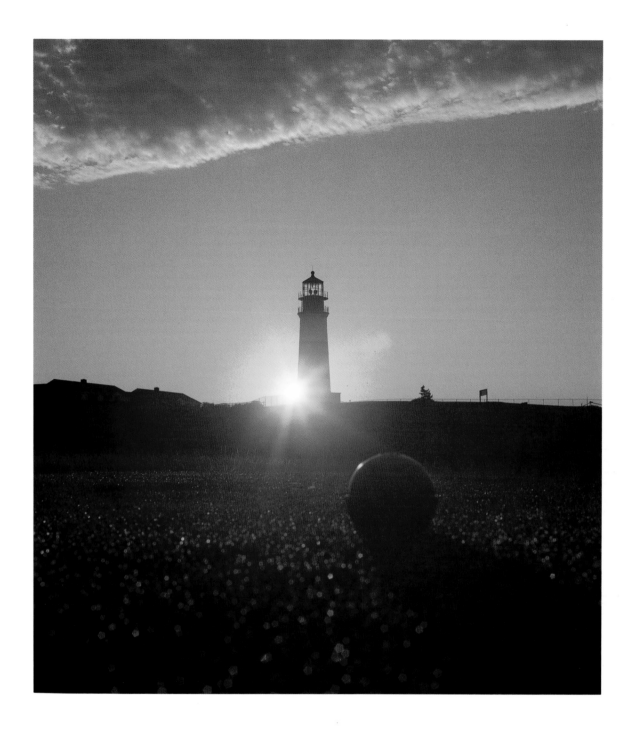

Sunrise at Sankaty, one of the Northeast's premier golf clubs named for its overseeing beacon. This course was laid out in 1921 although the first golf course was established in Edinburgh in 1744 and at St. Andrew's in 1754. The players then used leather balls stuffed with feathers. The rubber-cored ball was invented in the United States in 1898. By 1880 golf was being played in this country and three clubs all claim to be the oldest: Dorset, Vermont; Foxbury, Pennsylvania; and St. Andrew's at Hastings-on-Hudson, New York. Whatever their claims, Sankaty Head Golf Club has the oldest and finest of the three courses on the island (a fourth, the Nantucket Golf Club on Cliff Road, has since closed and its spacious clubhouse now serves as headquarters to the Nantucket Conservation Foundation). When my parents first played here, cast iron shafts were *de rigeur* and spoons, mashees and niblicks were used on the links, not in the dining room.

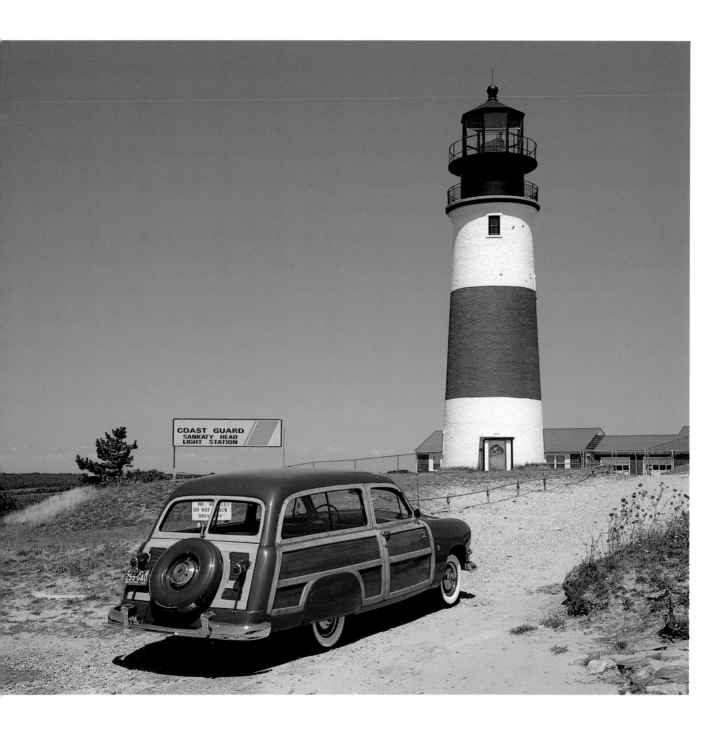

The Sankaty Head Lighthouse (1848). The lamp is 158 feet above sea level and has a nominal range of 29 miles. There are actually four lamps making a complete rotation every 30 seconds and therefore a flash appears every 7.5 seconds. Sankaty means "cool bluff" and this is the highest point on the island at 111 feet above sea level, surpassing Altar Rock at 103 feet and Folger Hill at 109 feet. Sankaty Light is now an endangered species due to replacement with stronger beacons and its proximity to the eroding bluff. Both the U.S. Coast Guard and Mother Nature have a set of keys to its future.

The car is a 1951 Ford, the last all-wood station wagon made by them (even the interior is wood). Its curvilinear design is reminiscent of today's Taurus and Sable models. Since 1941 Ford (and Mercury) have offered more designs with a rounded look than any other brand, and they even eschewed the ubiquitous tail fins that swept across the other manufacturers including DeSoto, Packard and Hudson (not to mention Cadillac, who started it all) in the 1955–1960 period. Even dowager Mercedes Benz sprouted embryonic fins which Stuttgart denied.

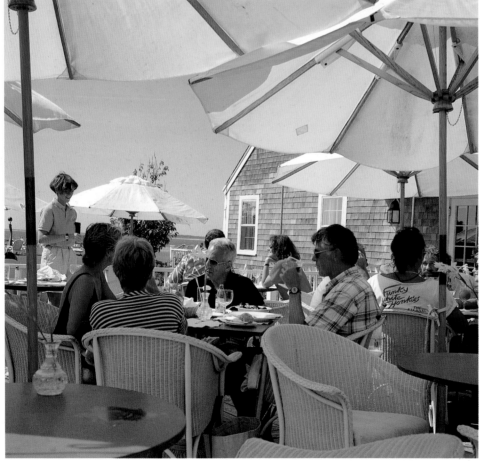

Above: The Wauwinet's station wagon meets guests the old-fashioned way. *Left:* Lunch on the patio at Topper's.

Wauwinet

The Wauwinet House (1876, 1988). Located at the head of the harbor is an area named after the sachem or chieftain of Nantucket's northeast and central territories, Wauwinet. In the mid-1800s, as whaling was declining, increased attention was paid to fishing, and especially to the fertile areas east of the island. The shortest way to this spot was by way of the narrow strip of sand separating the head of the harbor from the ocean called the "Haulover." The task was not easy. The boats were large wooden dinghies, rowed up harbor and then dragged across the sand on their oars (two oars parallel to the boat and a third one perpendicular) over to the Atlantic and back at the end of the day. In 1876 two Harwichport men, Capt. Asa Small and Capt. Reuben Kenney, purchased land in the Haulover area and built a large inn where guests could select harbor or ocean bathing, neither of which they really wanted. It was an era when inns and resorts were sprouting up around the country as destination points for workers new to vacationing but not yet into swimming.

Above and *opposite:* Interior views of the new Wauwinet. These rooms have been extensively remodelled by the firm of Martin Kuckly using American folk art as the principal theme. Painted floor rugs, primitive wall hangings and an organized eclectic look give a new appearance to a 100-year-old inn which now draws visitors from overseas as well as from the United States. The old restaurant has been closed but the popular Casino has reopened as Topper's (named for the owner's family dog), with a four-star menu.

The original Wauwinet House contained a large entertainment room filling the ground floor. It had walls on hinges that could be opened to catch the breeze. For the inauguration on June 14, 1876, a special invitation was extended to the Masons, Odd Fellows and Daughters of Rebekah. In addition to an elaborate shore dinner, there were polkas, waltzes and quadrilles. Two steam yachts began regular daily service to Wauwinet in 1876 and the larger catboat *Lilian* joined in 1888.

Beginning in 1900 rental cottages were being built by the hotel with basic conveniences but no kitchens as all meals were to be taken in the Wauwinet House dining room. The inn continued to prosper and expand under the Backus family ownership and was extensively remodeled in 1934 under the direction of Alfred Shurrocks who also had worked on "The Oldest House" as well as the homes of Gladys Wood and Erica Wilson. A separate Casino was started in an adjoining building, featuring elaborate but modestly-priced seafood dinners and dancing to a full orchestra. The inn reopened in 1936 with Kenneth Taylor as head of the management company. An article in *Hotel and Restaurant News* of August 26, 1936, praised the newly-redecorated Wauwinet House, its refined gray-shingled Colonial lines and porch reminiscent of Mount Vernon. The writer also extolled the virtues of the area with these words:

"But to enjoy the sea wind's gifts you must go where the winds can find you, and they are shy of dusty corners and land-heated streets. One of their favorite places is the island of Nantucket, and out there they frolic at their best on that fascinating stretch of land at the island's eastern tip—called Wauwinet." Could this also have been written today?

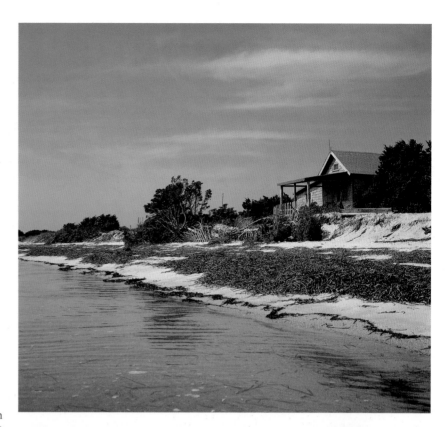

Above: A beach house on Coatue. The Indian name means "pine tree place" or "place of sharp points." The trees have gone, but the long stretch of land on the north side of the harbor has five distinct points: First, Second, Third, Bass and Wyers Points.

In 1883 the Wauwinet House developers opened the Cedar Beach House here with extensive bathing facilities and amusement rides. Nearby was the 275-lot development site of the Coatue Land Company. In 1896 a storm broke through the northern part of Wauwinet making an island of Great Point, Coskata and Coatue, the cut spreading northward until it hit the iron ore in the Coskata soil. For ten years it was an active channel to the fishing grounds east before it eventually closed up. The Cedar Beach House then lost its popularity, fortunately was abandoned and finally burned down in 1908.

Right: The distinctive mallow rose at Squam Pond, an August-blooming member of the hibiscus family. Squam means "beautiful water" and is located halfway between Wauwinet and Quidnet.

Opposite: Great Point Lighthouse (1784, 1818–1984, 1986–). Nantucket's second lighthouse after Brant Point was originally a wooden tower built in 1784 at Nauma or "Sandy Point," which is now known as "Great Point." It used spermaceti oil in its light and burned down in 1816. A stone lighthouse was built two years later, 70 feet high, the same height as Sankaty Head (1849–1850). It collapsed with the encroaching sea in 1984 and a replacement was erected farther to the west in 1986.

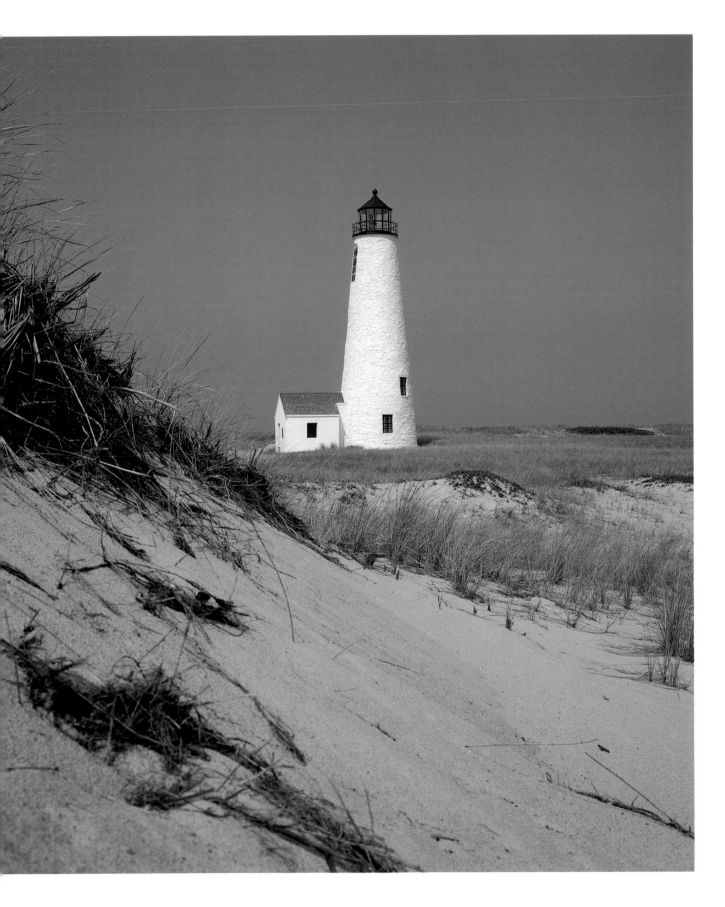

343

At the western end of Nantucket, offshore from Madaket, are two larger islands, Tuckernuck ("loaf of bread") and Muskeget ("grassy land"). Tuckernuck was once connected to Nantucket and was a popular spot for cattle, turkeys and chickens because there were no foxes or wolves to prey on them. There were three permanent farmhouses there as early as 1770 and eleven by 1829. It even had its own school. Today there are twenty-six houses along with a few old cars and jeeps in various stages of retirement. There is no electricity and only emergency radio telephone service on this private island. Access is by boat and invitation.

Madaket

Above and *right:* Weathered structures at Madaket which means "poor land" or "sandy soil." This was the site where the original nine settlers landed on Nantucket in 1659. Its poor soil and wind-swept terrain allowed it to sleep until 1871 when 3,000 building lots were laid out. Another 1700 were laid out along the south shore between Hummock and Long Ponds. Even the Cliff area and Surfside were going to be extensively subdivided. Fortunately the pro-moters (both native and off-island) were unable to raise much enthusiasm for their ventures. Only the controversial Tristram's Landing managed to get aloft in 1969, the unregulated style of which prompted the island-wide jurisdiction of the Historic Districts Commission.

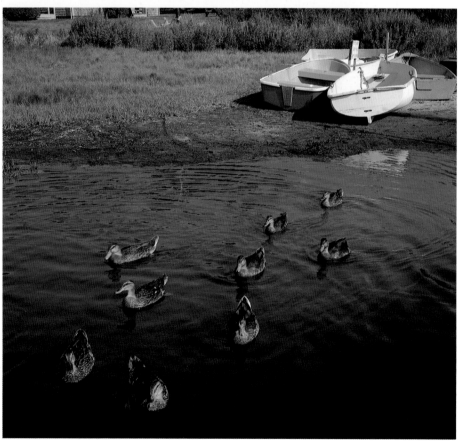

Hither Creek at Madaket (*above, right* and *opposite*). The rowboat is a reminder of the first journey in 1659 when the original nine full-share partners and their half-share colleagues arrived and settled here in Madaket. By the next year there were over 60 settlers, and they moved to more fertile sites near Capaum and Hummock Ponds.

Land's End at Madaket. This marks the beginning and the end of our story. Hither Creek is where the first settlers landed almost 350 years ago. It is now a place where islanders seek a tranquil refuge from the activity in town.

The 1936 four-door Ford phaeton is one of the prettiest convertibles Ford made and they certainly made a lot of them over the years. This was definitely for those who liked the yachting feeling of wind in their hair. The Packards and Cadillacs added a second windshield so their rear-seat passengers could see where they were going. These were dual cowl phaetons (the cowl referring to the hooded section between the engine cover and the windshield). The last four-door convertible was the Lincoln Continental of 1964 to 1967. Chevrolet may have made more cars (on average) over the years but Ford clearly has outsold them in both convertibles and station wagons, offering a variety of innovations such as a removable hard top on its 1955–1957 Thunderbirds and even an attached hard top on its full-sized 1957 Skyliner that disappeared into the trunk.

Two pennies overboard (one will suffice) assures a return trip to Nantucket. Lucky visitors often have family and friends gathering at Brant Point for a farewell salute. Rather than simply saying "goodbye," most Europeans say "until we see you again," (*au revoir, auf wiedersehen, tot ziens*). . . . For Nantucketers it is "until next summer."

Index

GLOSSARY OF INDIAN NAMES

Nantucket Indians were members of the Wampanoag people. The following interpretations are based on a 1910 article by Henry Barnard Worth, "Nantucket Lands and Land Owners," in the Vol. II Bulletin of the Nantucket Historical Association. Some of the translations have been verified and some have not. Therefore these are not definitive translations but rather are the popular meanings that have been guessed at over the years.

Capaum	Enclosed harbor	*Quaise*	Place of tall reeds
Coatue	Pine tree place; place of sharp points	*Quidnet*	At the point
Consue	Extensive bog	*Sankaty*	Cool bluff; around the bluff
Coskata	Place of broad woods	*Sesachacha*	Blackberry grove; place of dark berries, snakes
Hummock	From Nana Huma, one of the sachems	*Siasconset*	Place of the great bone or many bones (referring to whale bones)
Madaket	Poor i.e. sandy soil; land's end		
Miacomet	Place where we meet	*Shawkimo*	Middle field of land
Monomoy	Rich soil	*Shimmo*	A spring
Muskegat	Grassy land	*Squam*	Beautiful water
Nantucket	Land far out to sea; faraway island	*Tuckernuck*	Loaf of bread
Nauticon	An early variation of Nantucket	*Wanacomet*	Good field
Nobadeer	Good fishing grounds	*Wauwinet*	One of the sachems
Polpis	Divided harbor	*Wescoe*	At the white stone